1981

THE WORK OF ATGET

OLD FRANCE

Springs Mills Series on the Art of Photography

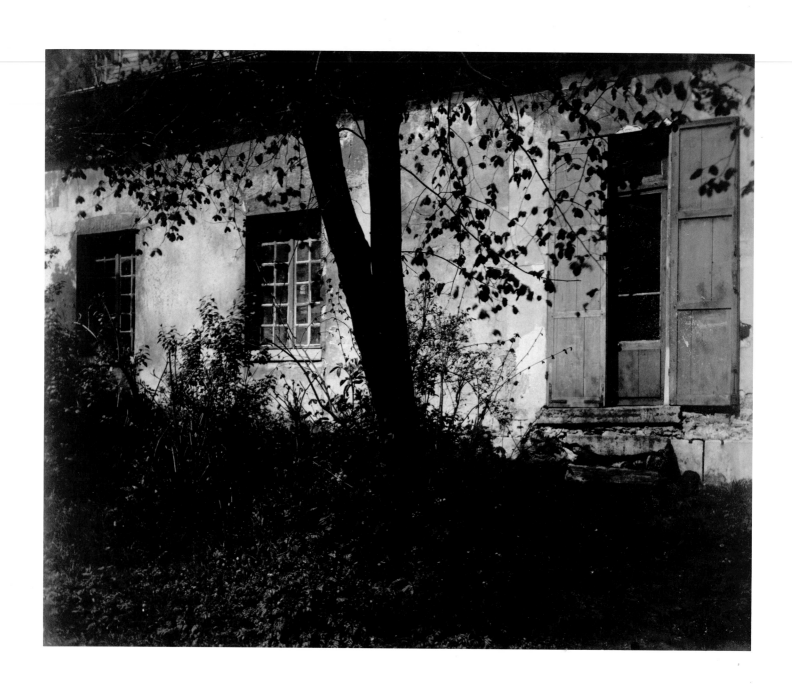

Sceaux, ancien château. 1923

THE WORK OF
ATGET

───────◆───────

VOLUME I

OLD FRANCE

JOHN SZARKOWSKI

MARIA MORRIS HAMBOURG

THE MUSEUM OF MODERN ART NEW YORK

Distributed by New York Graphic Society, Boston

The Museum of Modern Art
11 West 53 Street
New York, N.Y. 10019

Printed in the United States of America

Contents

TO BERENICE ABBOTT

Preface

It is difficult to name an important artist of the modern period whose life and intention have been so perfectly withheld from us as those of Eugène Atget. He lived a long and active life, the last half of which was spent in Paris, the capital of Western art; among his acquaintances were men of influence and substance. Yet his very existence is attested to by a very slender file of documents. He wrote good French, in a cultivated hand, but if he ever wrote a letter to a friend, parent, lover, colleague, or enemy it has not survived, or not yet surfaced.

It would seem that Atget and history conspired to preserve his anonymity, and would probably have succeeded had it not been for the intervention of the young American photographer Berenice Abbott, who saw his work as an unprecedented achievement and a profound lesson. After Atget's death in 1927, when the greater part of his work seemed destined for discard or casual dispersal, she purchased the contents of his studio from his executor, André Calmettes. During the next forty years she preserved this collection almost intact, and dedicated much of her own energy to advancing the appreciation of Atget's work.

In 1968 the Abbott-Levy Collection (Julien Levy had acquired an interest in the collection in 1930) was purchased by The Museum of Modern Art. The decision to buy the collection was made by the Museum's Board of Trustees, with the enthusiastic support of the late James Thrall Soby, a vice president of the Board and co-chairman of the Photography Committee, the late Dr. Henry Allen Moe, a vice chairman of the Board and co-chairman of the Photography Committee, and Alfred H. Barr, Jr., former director of the Museum collections and counselor to the Trustees, and with the generous financial assistance of Shirley C. Burden. It is worth noting that the Museum's decision was not only to purchase the collection, but to accept the greater obligation of undertaking its proper preservation and cataloging.

The problem of organizing the collection to a point where its structure might be visible, and of understanding it well enough to undertake serious publication, proved (of course) to be greater than anticipated. During the past twelve years a great deal of patient sifting and ordering—both routine and speculative—has been done by the Department of Photography, in order to achieve the tentative understanding of Atget's work that is reflected in the four volumes now in process of publication. The people directly responsible for this work at the Museum have been Yolanda (Hershey) Terbell, Barbara L. Michaels, and my co-author Maria Morris Hambourg, each of whom has contributed essential study and original insights to this work. The nature of their serial collaboration has been very complex, and any simple definition of their individual contributions would do injustice to each of them. In broad outline, the work fell into three phases. The collection of some five thousand prints plus duplicates had first to be sorted and organized to a point where its content

7

was available for analysis and study. Formal cataloging was then undertaken, so that specific pictures, or pictures of given subject matter, might be retrieved with relative ease. Beginning in 1974 this work was assisted by grants from the National Endowment for the Arts. As these essential prior functions approached completion it was possible to attempt a reconstruction of Atget's complex and periodically revised file, and to assign a chronology to his eccentric system of numbering negatives. The latter problem seemed the basic prerequisite for an objective and systematic study of Atget's work: without knowledge of its chronology, interpretation depended largely on the precarious supports of intuition and connoisseurship.

Building on the previous work of Mrs. Terbell and Mrs. Michaels (who had identified several categories of Atget's catalog and their approximate numbering sequences), Mrs. Hambourg essentially completed the solution to the difficult puzzle of Atget's file and its relationship both to his professional practice and his numbering system. Thus we can, for the first time, date with reasonable accuracy almost all of Atget's work, and speculate, with some objective support, as to the function that individual pictures were meant to serve.

Mrs. Hambourg's researches have extended well beyond the Museum's own collection and archives; she has studied most of the substantial collections of Atget's work, the promising sources of biographical data, and the earlier traditions of pictorial documentation to which Atget's work is, in some of its functions, related. Her dissertation, "Eugène Atget, 1857–1927: The Structure of the Work," establishes an objective, historical framework on which future Atget scholarship and criticism will inevitably depend. The essentials of this work will be included in her essays in the second and third volumes of this publication. Mrs. Hambourg's scholarship and intelligence have strongly influenced my own understanding of Atget's work,

in even more ways, surely, than those of which I am aware.

The four volumes of *The Work of Atget* correspond to the authors' sense of the principal issues, defined in terms of subject matter, that Atget's work considered. Mrs. Hambourg and I agreed at an early date that a chronological arrangement would be arbitrary, and would separate pictures most usefully seen together, especially those derived over a period of many years from the same or similar motifs. The division that we have elected corresponds in part, and approximately, to the major sections of his more complex and variable cataloging system. The volumes of this book are:

I. *Old France.* As a photographer Atget did not travel widely, and most of the pictures in this first volume were made within the Ile-de-France, the country's ancient core. They seem nevertheless to represent what is basic and pervasive in the substance and style of the broader French tradition.

II. *The Art of Old Paris.* Much of Atget's work was directed to the prospect of recording, and perhaps in part preserving, the Paris of an earlier age. This volume is selected from Atget's description of the official and the vernacular architecture of the old city.

III. *The Ancien Régime.* This volume is devoted primarily to pictures made in the parks of the great seventeenth- and eighteenth-century châteaux, especially those of Versailles, Saint-Cloud, and Sceaux.

IV. *Modern Times.* Atget's sense of history was not restricted to the past; throughout his career he was alert to ordinary contemporary things, the importance of which was camouflaged by their commonness: window displays in the new department stores, the contents of simple rooms, the techniques of commerce and of popular amusement, and the omnipresent, invisible people of the street.

The research and thought that have shaped

these volumes have been assisted by a very large number of people. On behalf of the Museum, Mrs. Hambourg and I would like to thank the following for their contributions:

The evidence of those few who had actually seen Atget was especially precious. Berenice Abbott, the late Man Ray, and the late Julien Levy, in addition to their invaluable published words on Atget, contributed generous personal interviews, in which they shared their memories and understandings. The recollections of Valentin Compagnon (the grandson of Valentine, Atget's common-law wife), Mme Demoulin (the daughter of Atget's concierge), André Klein (who knew Atget and Valentine), and Jean-Jacques Grüber (whose father was a friend and client of Atget) were also of exceptional interest. The Museum is additionally indebted to M. and Mme Klein for their generous gift of one of the few extant Atget paintings.

We are grateful to Ernst Halberstadt for the gift of the extensive notes of Ferdinand Reyher, whose early critical assessment of Atget's work was original and just, and whose manuscript novel based on a fictional photographer not unlike Atget was tragically lost shortly before Reyher's death.

Many museums, libraries, and archives have made their collections and supporting documents available for study. To their administrators and staffs we are deeply grateful. Special thanks must be paid to Jean Adhémar and Bernard Marbot of the Bibliothèque Nationale, Paris; Philippe Néagu, Alain Pougetoux, and Mlle Vinceau of the Service Photographique des Monuments Historiques, Paris; Mark Haworth-Booth and David Wright of the Victoria and Albert Museum, London; Marie de Thézy of the Bibliothèque Historique de la Ville de Paris; Françoise Reynaud of the Musée Carnavalet, Paris; Maddy Aries of the Musée de l'Ile-de-France, Sceaux; Micheline Agache-Lecat of the Musée Boucher-de-Perthes, Abbeville; James Parker of The Metropolitan Museum of Art, New York; David Travis of The Art Institute of Chicago; J. Ballet of the Société Lumière, Lyons; and G. Caillat and his fellow researchers in the Mayor's office of Libourne.

This book's debt to previous interpreters of Atget's work is, of course, great. In addition to those writers already named, we gratefully acknowledge the value to this study of the prior work of Pierre MacOrlan, Camille Recht, Jean Leroy, Yvan Christ, Beaumont Newhall, Romeo Martinez, Leslie Katz, Arthur Trottenberg, John Fraser, Gerry Badger, and Margaret Nesbit.

For their deeply valued advice, ideas, and criticism, we would like to thank André and Marie-Thérèse Jammes, Eugenia Janis, Kirk Varnedoe, Peter Bunnell, Theodore Reff, Van Deren Coke, and Peter Galassi.

For a wide variety of information and valuable assistance, we would like to thank Marcel Bovis, André Fildier, Gérard Lévy, François Lepage, Edouard Pécourt, Alain Brieux, Hank O'Neal, Daniel Wolf, Harry Lunn, and Carlton Willers.

As volunteers in the Department of Photography, Shari Rossmann, Lisa Gilden, Catherine Copp, and Christopher Saxe provided precise and responsible assistance with work relating to the cataloging of the Museum's Atget Archives.

In more personal terms, I would like to express my affectionate thanks to Jean-Pierre and Claudine Sudre, whose hospitality made it a special pleasure to write about Atget in his own country.

In a number of cases, the Museum's holdings include original Atget plates of great interest, but no satisfactory print from his own hand. By extraordinary good luck, our problem coincided with what one might fairly call the reinvention of the albumen print, by Joel Snyder and the Chicago Albumen Works. The skill and understanding of Mr. Snyder and his collaborators have given a new life to photographs by Atget and other important photographers that would have otherwise been lost, or preserved only through translation

into the distorting processes of modern photographic techniques.

Atget's own prints were made over a period of many years, on a variety of photographic papers. Many of these prints have shifted subtly in color or tonality, in ways more apparent to the lithographer's camera than to our own eyes. This factor has exacerbated the already extremely difficult problem of translating into a screened image the sense of the photograph's continuous tone. The Museum is extremely fortunate in having been able to place this problem in the skilled hands of Richard Benson, who has worked in close collaboration with the craftsmen of Meriden Gravure.

The exhibition which accompanies this volume has been made possible by the generous and essential support of Springs Mills, Inc. Additional support from Springs Mills for the subvention of the book has made it possible to publish it as a work of uncompromised quality, available to a broad audience. Without the continuing belief of Springs Mills in the importance of the art of photography, the content of this book would still be the secret preserve of specialists. For the Museum, and on behalf of photography's audience, I would like to express the deepest appreciation.

JOHN SZARKOWSKI, Director
Department of Photography
The Museum of Modern Art

Atget and the Art of Photography

As a way of beginning, one might compare the art of photography to the act of pointing. All of us, even the best-mannered of us, occasionally point, and it must be true that some of us point to more interesting facts, events, circumstances, and configurations than others. It is not difficult to imagine a person—a mute Virgil of the corporeal world—who might elevate the act of pointing to a creative plane, a person who would lead us through the fields and streets and indicate a sequence of phenomena and aspects that would be beautiful, humorous, morally instructive, cleverly ordered, mysterious, or astonishing, once brought to our attention, but that had been unseen before, or seen dumbly, without comprehension. This talented practitioner of the new discipline (the discipline a cross, perhaps, between theater and criticism) would perform with a special grace, sense of timing, narrative sweep, and wit, thus endowing the act not merely with intelligence, but with that quality of formal rigor that identifies a work of art, so that we would be uncertain, when remembering the adventure of the tour, how much of our pleasure and sense of enlargement had come from the things pointed to and how much from a pattern created by the pointer.

To note the similarity between photography and pointing seems to me useful. Surely the best of photographers have been first of all pointers—men and women whose work says: I call your attention to this pyramid, face, battlefield, pattern of nature, ephemeral juxtaposition.

But it is also clear that the simile has flaws, which become obvious if we consider the different ways in which the photographer and the hypothetical pointer work. The formal nature of pointing (if the notion is admissible) deals with the center of an undefined field. The finger points to (of course) a point, or to a spot not much larger: to the eyes of the accused, or a cloud in the sky, or a finial or cartouche on a curious building, or to the running pickpocket—without describing the limits of the context in which that spot should be considered. An art of pointing would be a conceptual art, for the

subject of the work would be defined in intellectual or psychic terms, not by an objective physical record. The pointing finger identifies that conceptual center on which the mind's eye focuses—a clear patch of the visual field that one might cover with a silver dollar held at arm's length—outside of which a progressive vagueness extends to the periphery of our vision.

The photographer's procedure (and his problem) is different, for whether he means to or not he will make a picture of sorts: a discrete object with categorical edges.

<p align="center">* * *</p>

Eugène Atget was a commercial photographer who worked in and around Paris for more than thirty years. When he died in 1927, his work was known in part to a few archivists and artists who shared his interest in the visible record of French culture. Little is known about his life, and less about his intentions, except as they can be inferred from his work.

In his lifetime Atget made perhaps ten thousand photographs; almost all of these describe the historic character of French life, as indicated by its architecture, its landscape, its work, and its unconsidered, vernacular gestures. To many photographers today his work stands not only as a heroic and original achievement, but as an exemplary pedagogical lesson, the full implications of which are even now only intuitively perceived.

One might say that the mystery of Atget's work lies in the sense of plastic ease, fluidity, and responsiveness with which his personal perceptions seem to achieve perfect identity with objective fact. There is in his work no sense of the artist triumphing over intractable, antagonistic life; nor, in the best work, any sense of the poetic impulse being defeated by the lumpen materiality of the real world. It is rather as though the world itself were a finished work of art, coherent, surprising, and well constructed from any possible vantage point, and Atget's photographs of it no more than a natural and sweetminded payment of homage.

<p align="center">* * *</p>

In the end, form and content are inseparable and indistinguishable, for it is not possible to say precisely the same thing in two different ways. Nevertheless, for convenience (while keeping at arm's length the unwelcome presentiment that the pictures will not give up their secrets to analysis), we may pretend that fact and aspect can be cut asunder. In this spirit we can consider the varieties of things to which Atget pointed—the kinds of facts to which he gave his intellectual and moral attention.

When we first consider Atget's work, its variety and density and the largemindedness of its ambition persuade us that he was an artist without prejudices, omniv-

orous in his tastes, who took as his material and his responsibility whatever his world presented to him. Greater familiarity with his collection, however, suggests that this view is unsatisfactory. In spite of the range and broad sympathy of Atget's work, its concerns are not catholic. They are indeed, to a degree, tendentious. A better definition of his interests might be begun by identifying some of the things that Atget never photographed. To begin the list, it is interesting that Atget did not, during more than thirty years of work in Paris, photograph the Eiffel Tower. He did not photograph the Arch of Triumph, or Garnier's Opera, or except peripherally, the great boulevards of Haussmann. It would be an exaggeration to say that he eschewed the nineteenth century completely, but his central concerns focused on the more remote and more glorious past, and on the eternal present, as revealed in the prototypical functions and vernacular expressions of his own day. Even his people seem chosen as the actors of ancient, surviving roles: street merchants, ragpickers, prostitutes, gypsies.

Within his broad compass, Atget's artistic success was not uniformly high. In 1920 he wrote to the Ministry of the Beaux-Arts to offer for sale a substantial part of his life's work. Among the important parts of this collection he lists his documentation of the principal churches of Paris. He had indeed recorded these buildings in considerable detail, but in comparison with the best of his work these pictures seem routine in conception and casual in execution, as though done out of a sense of duty to an essential part of the story, but a part for which he had little spontaneous sympathy. How different —how lively and affectionate—are his churches of the country villages, which seem to belong to the landscape and its people, rather than the authoritarian Church.

There is in Atget's work an interesting pattern of class bias. The higher bourgeoisie are absent from his document, except to the degree that they may now be the invisible owners of the châteaux and hôtels that had been built by the aristocracy. Symbols of contemporary authority—either architectural or human symbols—are rare. (Among Atget's posed typological street portraits there are no priests, policemen, military officers, or landlords.) The aristocracy—at least the dead aristocracy—are honored by the homage paid to their great works. But it is the anonymous people, those whose authority lay in their skill or their tenacity, who received Atget's most affectionate and imaginative attention. It is true that he did not often photograph the people themselves; he photographed instead their conscious and unconscious works—the marks that they left on their site.

It might be said that Atget made no portraits—that his pictures of window-washers, knife-sharpeners, peddlers, postmen, etc., describe the generic role, not the individual player. It is remarkable that Atget's collection, when acquired by Berenice

Abbott, contained not a single portrait of even one of his friends and associates: none of Valentine, his common-law wife of more than thirty years; none of Calmettes, his friend since youth, when both were students of acting at the Conservatory; none of any of the collectors and artists who bought and presumably admired his work. It would seem that he was not profoundly interested in the uniqueness of individual personality, directly considered; or perhaps he was interested, but considered the issue to lie outside the scope of his own calling, or beyond the reach of his own talent.

In his early work Atget, like most intelligent beginners, tried many things. Many of his early pictures attempt a direct reportage of ephemeral contemporary life: groups of people at work or play, the bustle of the street, events of topical interest, etc. Most of these pictures seem merely circumstantial, and insufficiently formed, but a few succeed very well. These successes, to a photographer of appropriate temperament, would have been adequate encouragement; this line of exploration could have been profitably pursued, preferably with one of the splendid new hand cameras rather than the ponderous and refractory stand camera that Atget used. There was, however, an opposing strain in Atget's early work which—we must assume—pleased him more. These pictures are still, simple, and poised, and concern themselves not with reportage but with history. Very early in his career Atget stopped trying to catch the world unaware.

By 1899 Atget had begun his famous series of *petits métiers*—portraits of the traditional street merchants who already verged on obsolescence. These subjects were seen almost as mannequins—starkly posed with the paraphernalia of their trade against the cobblestone background of the street. This series was not large, and was complete by 1900. After that date, excepting his series on ragpickers, and the brief series of prostitutes, done on commission, Atget rarely made a photograph that directly described a human presence.

*　　　*　　　*

It is now clear that Atget built his collection not through the random accumulation of subjects that interested him, but rather by the systematic exploration of topics that were consciously chosen for their relevance to one abiding idea: the creation of a body of photographs that would describe the authentic character of French culture.

Throughout his career, Atget added new topics to those already in process. Some of these were pursued briefly or fitfully; others were continued throughout his lifetime. The most rewarding topics evolved and changed their nature through the years, accommodating themselves to the growing simplicity and gravity of Atget's perceptions. The subjects that fulfilled these topics became with the years less categorical, more plastic and relative, their meanings dependent on growth and decay, season, quality

of light, point of view, on the unreplicable reality of a given moment. Subjects of this kind were in their nature inexhaustible, as long as the photographer's attention held.

The intensity of Atget's attention might be measured by the frequency with which he returned to certain families of subject matter. He loved dooryards, with their climbing vines, window boxes, caged canaries, and worn stone doorsteps; and courts with neighborhood wells in them, immemorial centers of sociability, news, and contention. Atget's pictures describe such places with a sharp but tactful scrutiny. They define a meeting ground between domestic and civil life, the innermost plane of the private person's public face.

To pictures such as these Atget often assigned the general term *coin*, a word, in Atget's meaning, for which "corner" is too bald and geometric a translation and "nook" or "cranny" too quaint. Of these options "corner" is perhaps the best, if one thinks of that word as meaning a place where one turns and changes one's orientation, not necessarily to a different point of the compass, but to a different human pace and atmosphere. These pictures describe sites of social transition and transaction, places where we might meet a friend or a stranger, and say a graceful or a gauche thing.

An extraordinary number of Atget's pictures have to do with doors and doorways. In the quarters of Old Paris where Atget did so much of his work, there were of course many doors that were of interest to archivists or amateurs of the old city, because these doors had been designed by the architect X, or because they bore a fine knocker by the craftsman Y, or because Racine or Richelieu had often passed through them. But it is difficult to believe that the market demand for photographs of anonymous country doorways was nearly so large as Atget's supply. Perhaps the simplest explanation of the known facts is that Atget photographed doorways because he found them interesting, both for their artifice and for their meaning. A successful doorway announces itself to be both an entrance and a barrier. If it is true that the value of privacy is better understood and better respected in France than in other Western countries, this may explain why French doors seem more expressive and various than doors elsewhere, defining as they do so many varieties and degrees of discrimination and privilege.

There are of course aspects of an artist's subject matter that are so thoroughly in solution that they will not be filtered out by the finest screen, aspects that will be invisible to the artist himself, since they reflect knowledge and predilections as unconscious as his gestures and his accent. Nevertheless we may occasionally see a little further than before into the mystery of choice. Thus Atget's picture reproduced as plate 36 is a picture of a door in the countryside, but it is also true that the dark shape of the vines climbing above the wall is very much like the shape of a great chestnut tree in the park

of Saint-Cloud that appears repeatedly in Atget's pictures made during the same period, and that the two shapes serve a similar pictorial function. It is not necessary to believe that Atget made the connection consciously; the most important of such correspondences are pursued neither consciously nor systematically, but enter unbidden and unmarked into the photographer's sense of the possibilities of the visible world.*

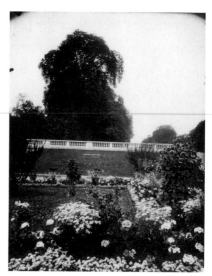

Saint-Cloud. (1919–21.)
LD:974. MoMA 1.69.495

Throughout his career Atget was fascinated by trees of all types and functions; on many occasions he revisited the same tree or grove in different years and seasons, knowing that a tree would not twice propose the same problem. Perhaps more clearly than any other segment of Atget's work, these pictures illuminate Atget's original and profoundly photographic understanding of the idea of the pictorial subject.

The history of Western painting, as perceived by recent generations, has led us to assume that the subject exists prior to the picture, that it is a point of departure, a known given, the raw material on which an artist acts, violently or subtly, in order to produce a work of art. We know that there are no two Crucifixions or still lifes with apples or abstractions that share the same content; nevertheless we refer to these approximate iconographic categories as the subjects of specific pictures.

We will better understand the art of photography if we approach the question differently. Let us say that the subject of the photograph is not the photographer's starting point, but his stopping place. Let us say that the true subject of the photograph is the same as—is identical with—its total content. Then the photographer's problem will be seen to be not the revision of a received model, but the discovery and precise definition of a new subject—a coherent idea, plucked from an inchoate sea of subject matter.

The photographer seeks his subject in what seems promising cover. The boundaries that encompass his search can be formal, intellectual, or psychic; they can be broad or narrow; they can be defined intuitively, to meet the needs of the photographer's spiritual life, or intellectually, to meet his understanding of a social or cultural role. On the record of the past, no one of these options would seem more likely than the others

* In a less literal way, plate 47, also of the same period, is another variant of the same pictorial scheme: a simple architectural arrangement with regular geometrical elements is crowned with the dark shape of an efflorescent organic form.

to assure either success or failure. Alfred Stieglitz (like Thoreau, who boasted that he had traveled much in Concord) found ample range within limits circumscribed by the reach of his private affairs. Atget worked within boundaries defined in rigorously impersonal terms. But the success of each man's effort depended finally not on the superiority of his concept, but on the grace of his intuition. In the hands of smaller talents, Stieglitz's idea has grown large market gardens of indistinguishable narcissus, and Atget's, desiccated catalogs of archeological data. No philosophical rubric will lead the photographer to an image that describes a new subject; at best it will tell him when he has arrived at his own proper hunting ground.

<div align="center">* * *</div>

Atget's project seems the most ambitious, perhaps even the most presumptuous, ever chosen as the life's work of a single photographer. The photographer Tod Papageorge, thinking of Atget alone with his vast assignment, was reminded of Dr. Johnson and his dictionary. But Johnson, in spite of bad health and near-blindness, was superbly prepared for his work by virtue of his learning and linguistic skills. Atget, in contrast, would seem to have been overcommitted. His learning, if perhaps fairly broad, was surely in most areas superficial. As a photographer he began his project as little more than a novice; thirty years later he would not have been considered, by conventional standards, a remarkable craftsman or a versatile technician.

In compensation he brought to his work a quality that one might describe, inadequately, either as an original eye or an original mind. It is useful to consider that by no means all of Atget's pictures are beautiful—in the sense that all of those of Clarence White, for example, are. On the other hand, all of Atget's pictures are informed by a precise visual intelligence, by the *clarté* that is the highest virtue of the classic French tradition. This quality was achieved not by impeccable technique, but by discovering precisely what one meant to say, and saying neither more nor less.

The idea was once prevalent (although strenuously contradicted, most clearly by Berenice Abbott) that Atget was a primitive, in the popular sense of that term—a kind of idiot-savant, who made splendid pictures that were beyond the reach of his own comprehension. Atget studies of the past decade have gone far toward replacing that mythic Atget with a historical one. These studies have placed him in a cultural context, and have shown that the broad outlines of his concept, and much of his work, served perceived needs of the France of his time. Atget can now be seen to represent not the ahistorical principle of the lonely and eccentric genius, but a flowering of coherent traditions of nineteenth-century French photography and French intellectual life. Atget's antecedents can be traced back to the beginnings of French photography, and

include the great calotypists Bayard, Nègre, Le Secq, and Le Gray, who used photography to study and record the great and the representative architecture of the French past. As early as the 1850s Charles Marville had photographed with superb sensitivity and skill old Paris neighborhoods that were expected to be soon destroyed to make room for Napoleon III's new imperial city. Setting aside differences in photographic craft, this writer might easily mistake some of Marville's street scenes for some of Atget's. By Atget's own time, the photographing of architectural monuments and places of historic or cultural resonance was a firmly established professional specialty, and several excellent photographers in Paris competed with Atget for the favor of the same clients. When they photographed similar subject matter, their work sometimes looked much like Atget's.

Atget was not a primitive—except perhaps in his most advanced work, which may indeed embody the beginnings of a new idea. He was, in the main, a photographer of talent, intelligence, and character who belonged to, and who extended, a rich and valued tradition.

And yet, after he has been thus clearly placed, the best of his pictures remain as mysterious as before, transcending both the categorical functions that they presumably served and the past out of which they grew. The character of his oeuvre, taken as a whole—for the breadth and generosity of its imagination and the precision of its intelligence—can be confused with that of no other photographer.

Nevertheless, to our eyes it would seem simpler and more reasonable if Atget's work had been done by at least two photographers—one who worked with a perceptive but rather pedestrian intellect and another who saw the world with the sure intuitions of a great lyric poet. For us, perhaps 20 percent of Atget's work attains the kind of formal surprise or original grace by which we identify a successful work of modern art. Another, larger segment of the work is deeply nourishing in terms of the subtlety and responsiveness of its photographic sensibility. This leaves us with something like half the work which, viewed alone, we might guess to be the product of a representative, if somewhat eccentric, professional photographer of that time and place.

There are a number of ways to interpret this apparent incoherence. We could assume that it was Atget's goal to make glorious pictures that would delight and thrill us, and that in this ambition he failed as often as not. Or we could assume that he began photographing as a novice and gradually, through the pedagogical device of work, learned to use his peculiar, recalcitrant medium with economy and sureness, so that his work became better and better as he grew older. Or we could point out that he worked both for others and for himself and that the work he did for himself was better, because

it served a more demanding master. Or we could say that it was Atget's goal to explain in visual terms an issue of great richness and complexity—the spirit of his own culture—and that in service to this goal he was willing to accept the results of his own best efforts, even when they did not rise above the role of simple records.

I believe that all of these explanations are in some degree true, but the last is especially interesting to us, since it is so foreign to our understanding of artistic ambition. It is not easy for us to be comfortable with the idea that an artist might work as a servant to an idea larger than he. We have been educated to believe, or rather, to assume, that no value transcends the value of the creative individual. A logical corollary of this assumption is that no subject matter except the artist's own sensibility is quite worthy of his best attention.

Whether or not it is morally good for an artist to place his work in the service of an issue larger than self-expression, larger perhaps even than the shared, intuitive longings of his own artistic guild, is a question that our period would prefer not to answer in the abstract. We would want to know the work first, and trim our moral judgment to fit our aesthetic response. But on practical grounds, the idea of artistic service to an artistically extraneous cause does have much to recommend it, for it invites the artist to confront interesting questions to which there are no known artistic answers. If he accepts the challenge of problems that lie partly outside the known reach of his medium—beyond the conventions of its established rhetoric—then he may make new mistakes, produce original failures, some of which will define new opportunities.

It is possible that Atget's habit of revisiting a given motif began with the need to correct such failures. To a photographer for whom subject matter is of no intrinsic importance, failure can be regarded as a statistical issue: some pictures work and others don't, and those that don't can be discarded and forgotten. But a photographer whose work serves ideas independent of photography cannot forget his failures and must attempt to correct them. Even if the second try is also a failure, it will presumably fail in a different way, and thus enlarge slightly the photographer's sense of his medium's possibilities. Atget's retakes were not always successful. Sometimes he would attempt a motif two or three times without producing a picture that could be called interesting, except perhaps by archeological standards; but the several tries were inevitably different. From such experience the photographer might reason that if failure is allowed such variety, why should success have only one face? In later years Atget would repeatedly return at twilight to the pools of Saint-Cloud, confident that he would not exhaust their potential meaning.

*　　　*　　　*

It is now finally possible to study Atget's work with an objective knowledge of its chronology; thus we can now ask whether there is in his work a coherent change and growth or whether he was one of those peculiar geniuses who are born whole and play the same game in the same way throughout their lives.

A tentative and partial answer to this question might be inferred from the analysis of the exhibition of Atget's work held at The Museum of Modern Art in 1969, at which time the dating of Atget's pictures had scarcely begun. Without an understanding of the design or chronology of the oeuvre, the exhibition was selected simply to show what seemed the most interesting and successful photographs. It thus offers an intellectually unstructured and ahistorical selection from the collection as a whole.

The pictures in that exhibition can now be dated with a high degree of accuracy. It is interesting that one half of the exhibition is now known to have come from the first twenty-five years (or more) of Atget's career; the other half from his last six years of work. The two years most heavily represented in the exhibition were 1925 (fourteen prints) and 1926 (fifteen prints), before Atget was stricken ill in the spring of 1927.*

It is not suggested that Atget's development proceeded in a clear and simple way. Its path might be charted as a coil of overlapping loops, the return of each loop reclaiming earlier ideas and the forward reach exploring new ones. Such a pattern is familiar from the lives of artists in many fields, but it seems especially appropriate to the character of a photographer's development. To repeat what has been said many times, the making of a photograph is technically quick and easy. On a comparative scale of artistic investment it requires no major commitment of time, money, thought, or reputation. Experiment and risk are cheap; whim can be entertained; failure is easily hidden in the file. Photography encourages the taking of chances.

To these considerations it should be added that in a photograph failure is final. To the degree that we believe in a photograph as factual, it cannot escape far from its first conception. It cannot be significantly revised or recast except by beginning again. Thus for a photographer every decision of high consequence begins with an empty sheet, and the process of revision is carried forward not on the physical body of a single picture, but in the photographer's mind, during the interstices between pictures.

For these reasons a photographer's oeuvre, if studied from too close a viewing

* The point that I think is clearly demonstrated here is not that Atget's work grew stronger with time (although I believe it did), but that it changed substantially. In these terms the chronological imbalance of the 1969 exhibition is significant even if interpreted simply as the result of the personal tastes of those who chose it. The exhibition was selected by this writer and Yolanda (Hershey) Terbell.

distance, may, like a tapestry, appear to form an irresolute or random pattern. But if we step back we may see another pattern, composed of broader forms.

It is traditional to study the distinctive changes that occur in an artist's development by comparing earlier and later versions of what is called the same subject. Since I have proposed above that there cannot be, precisely speaking, two different versions of the same subject, I cannot now claim great faith in the utility of this procedure. If, for example, we compare the two pictures reproduced as plates 94 and 95, we will surely agree that their subjects are very different, even though the camera's placement is almost identical. The early picture is concerned with the solid structure and the bold graphics of midday; the late one with the sweet and private atmosphere of early morning. So different are these pictures, in their visual structure and their mood, that it is conceivable the photographer made the second picture without remembering that he had, a quarter-century earlier, made a splendid and very different picture from almost the same vantage point. It is even conceivable that the second picture began not with an interest in the architectural setting, but with an appreciation of the perfect placement of the horse droppings on the back-lit street. In any case one can say that the subject of the second picture is the more typical of Atget's later work, by virtue of the simplification of its informational content, of the more active role of light, and of the elegiac quality of its mood.

Such comparisons are perhaps more useful if they include broader, more inclusive families of subject matter, rather than specific motifs. Thus if one placed in chronological order all of Atget's many pictures that conspicuously include fruit trees as part of their subject matter, one could make about this group the following general observations: the earlier pictures (represented in this volume as plates 1, 8, 9, and 16) show the tree as complete and discrete, as an object against a ground; as centrally positioned within the frame; as frontally lighted, from behind the photographer's shoulder. The later pictures (plates 15, 30, 31, 42, and 43) show the tree radically cut by the frame, asymmetrically positioned, and more obviously inflected by the quality of light that falls upon it.

It is clear that Atget's most successful work emphasizes different sorts of subject matter during different periods of his career.* Nevertheless it is suggestive that both the 1969 survey and the present volume are rich in early and late work and relatively thin in their representation of the middle years.

* For example, the 1969 survey exhibition included seventeen pictures made during 1907–14, all of which were made in Paris—none in its environs, which figure so strongly in his earlier and later work.

It has often been said that Atget stopped working during the Great War out of frustration at the bureaucratic controls that were imposed on photographers for security reasons. It seems likely, however, that Atget had become less active as a photographer well before the war, and that his slower pace lasted until about 1920.* The difficulties of working during the war years would certainly have provided the excuse for photographing less, if the taste for work had flagged for other reasons.

These other reasons may have included competing intellectual and artistic ambitions. Maria Morris Hambourg has established that Atget was a frequent lecturer at the Universités Populaires between 1904 and 1911, reading and interpreting the plays of Molière, Hugo, Musset, and others, and that he continued to make similar lectures at least until 1913. Mrs. Hambourg's researches also indicate that several of Atget's surviving paintings (which were formerly supposed to have been done before he took up photography) date from the decade of the war.

An alternative (or perhaps parallel) explanation for the relative scarcity of superior work during much of the war decade might be found in the character of Atget's professional practice during this period. It was during these middle years that Atget devoted much of his energy to the systematic and detailed recording of certain quarters of Paris, and of architectural ornament. Much of this work was apparently done on assignment— a manner of working which, according to Berenice Abbott, Atget regarded with some distaste. By 1916 he had finished one large project done in this spirit, and by 1920 he had succeeded in selling another major segment of related work to the Monuments Historiques.

This important sale may have been for Atget the occasion to begin again with renewed vigor. The purchase price was, in terms of Atget's needs, not a negligible sum, and the sale surely allowed him to resume work relatively free of immediate business pressures. But perhaps equally important was the fact that the plates for a major portion of his public work of a quarter-century were now safely in the hands of public archives. He might now consider this part of his work finished, and in good conscience turn his full attention to the more personal part of his document.†

* * *

As Atget grew older he made his pictures out of less and less. In his last years he seemed

* Maria Morris Hambourg's analysis of Atget's numbering system indicates that his productivity declined in each of the five years from 1910 through 1914. See the dating chart in her dissertation, "Eugène Atget, 1857–1927: The Structure of the Work" (Columbia University, 1980).

† The shift in Atget's work from the prewar to the postwar periods was first closely studied and interpreted in Maria Morris Hambourg's dissertation, op. cit.

often to make them out of almost nothing. These pictures seem to concentrate everything that he had learned about his world and his art in an imagery of grave simplicity, as though there was no longer time or need for complication.

Much of Atget's most beautiful and original work was done in his last years, as he approached seventy. This is exceptional in the history of photography, which generally shows a very different and cruel pattern of success. With few exceptions, the best photographers have completed their original contribution within a very short time—often within a decade. There have of course been many photographers who have sustained a high level of achievement over extended periods, but their work has rarely grown in concept, and extended its grasp of photography's creative potentials, for more than a few years.

Two photographers who might seem the most conspicuous exceptions to the general rule—Alfred Stieglitz and Edward Steichen—did indeed escape the common pattern, but they did so not by sustaining and developing a single, coherent impulse, but rather by being repeatedly born again—by living a series of almost independent careers, one after the other, as though each man was his own dynasty. Perhaps a more telling exception is Edward Weston, whose mature work grew in stature and richness, and changed in spirit, over more than twenty years, without self-contradiction or fracture of continuity, until it was finally slowed and stopped by illness.

But exceptions do not repeal the rule. David Octavius Hill, Julia Cameron, Fenton, Le Gray, O'Sullivan, Peter Henry Emerson, Jacob Riis, Rodchenko, Moholy-Nagy, Man Ray, and many others did the work for which we honor them—and often all their work—within a decade, more or less. Walker Evans made photographs over a span of more than forty years, many of them good years, but terrible havoc would be done to the Evans canon if one excluded the years before his thirty-third birthday.

Much of this might be explained in terms of opportunity, financial security, personal freedom, access to one's proper subject matter, etc., but these factors are also real for painters, writers, and composers, who seem less likely to expend their creative capital so quickly. In the case of writers, a tentative exception might be made of lyric poets. Even excluding those who die early from consumption or sailing accidents, it would seem that most superior poets write their lyrics early in life, and then proceed to epic, dramatic, or philosophical works. In these forms, acquired skills, knowledge, and experience perhaps compensate for a falling off in sensibility.

Or one might compare the talent of a superior photographer to that of a superior athlete. The latter does not comprehend the nature of his excellence. He does what we can all do; he runs and jumps, throws and catches a ball, tests his strength and quickness

against another. We have all done these simple essential things; the athlete is just better at them. If gifted enough he may retain his excellence into his mid-thirties, and then, still in the prime of life, suddenly lose it. It is not strength, or stamina, or general good health that he has lost, but the fine edge of his exceptional animal perception—a quality closely related, perhaps, to the one which in artists we call talent.

Talent is of course not the only important part of an artist's equipment: skill, knowledge, experience, intelligence, sympathy, and passion are also useful, but it must be obvious that the proportion in which these qualities are necessary varies from one art to another. In the case of architecture, or the writing of operas, skill and knowledge are surely more necessary than talent. In the case of song writing, or photography, talent and desire are often enough.

They are, at least, enough in the short run. For the longer run, for the years after a new talent has first displayed its unique, pubescent charm, then intelligence, knowledge, and dedication to an idea larger than self-expression may be useful. When photography has served such larger ideas, it has on occasion become an art capable of considering the darker, more ambiguous perceptions of aging men and women, as well as the quick, shining intuitions of talented youths.

For those who would wish such an ambition for photography, Atget might be a proper model to study. We may agree that Atget was an artist of high talent, but we cannot really know how much of his achievement was the function of talent and how much the function of a moral intelligence—a principled idea defined simultaneously in terms of his art and his world.

One writer suggested something of the sort as early as 1931. "The charm of Atget lies not in the mastery of the plates and papers of his time, nor in the quaintness of costume, architecture and humanity as revealed in his pictures, but in his equitable and intimate point of view. It is a point of view which we are pleased to call 'modern' and which is essentially timeless. His work is a simple revelation of the simplest aspects of his environment. There is no superimposed symbolic motive, no tortured application of design, no intellectual ax to grind. The Atget prints are direct and emotionally clean records of a rare and subtle perception, and represent perhaps the earliest expression of true photographic art."*

Ansel Adams, the youthful writer of the paragraph above, suggests that we some-times claim for modernism whatever we find original and good. It is surely true that Atget's position is ambiguous in reference to the mainstream of modern art. In the sense

* Ansel Adams, *The Fortnightly* (San Francisco), vol. 1, no. 5 (Nov. 6, 1931), p. 25.

that his work is predicated on a view of history as purposeful evolution, available to the power of logic and design, it seems foreign to the spirit of modernism, which has based its own program largely on the principles of discontinuity, centrifugal movement, and the sovereignty of the individual. Atget's implicit confidence in the continuity and authority of culture was almost old-fashioned even in the time of his youth; the quality of this faith would seem more closely related to the speculative philosophy of the Enlightenment than to the systematic naturalism of nineteenth-century science. This orientation may have been formed, or at least confirmed, by Atget's education, which seems to have been classical in its perspectives, if eccentric in its pursuit. His few surviving letters—business letters—suggest an educated man who is conscious of his worth as a perceptive and knowledgeable chronicler of a great tradition.

Yet the character of the work itself (and the abruptness with which it revised the shared sense of photography's potentials) is profoundly modern. The other masters of early twentieth-century photography—even Stieglitz—seem in comparison old-fashioned in their dedication to fixed, Platonic verity, and timid in testing the camera's ability to explore freely, without formulation, the kaleidoscopic truths of meaningful aspect. In his later middle-age, Stieglitz postulated that a satisfactory photographic portrait might consist of many pictures, which together could suggest the richness and complexity of a single life, and he proceeded to make such a portrait of his wife, Georgia O'Keeffe. Stieglitz's concept, hard earned by decades of experiment, study, and thought, resulted in something related to, but less radical than, the results of Atget's intuition. It would not be to the point to say that what Stieglitz did in terms of one human being Atget did for an entire culture, not because both projects were impossibly difficult, and thus both failures if measured against their own extravagant goals, but because the difference between the best, mature work of the two great men derives from something other than the range of their preoccupations. One might better say that Stieglitz's version of modernism was similar to the formal concept of variations on a theme: alternate visions of a constant and comprehensible idea. In Atget the idea itself seems provisional and open, imperfect, unfinished: in the process of taking form from the facts of the image before us. Thus in Atget's work one's sense of the plasticity of reality does not depend on the comparison of different pictures formed from the same subject matter, but comes directly from the meaning of individual images, which express not the final order of stasis, but the vital order of equilibrium.

<div align="center">* * *</div>

There is at the heart of Atget's work a profound paradox. The premise on which the work was based and the function to which it aspired depend on our acceptance of the

objective reality of the past: we are to believe that these facts are not only true but significant, that each picture refers to events that were part of the meaningful narrative that we call history. And yet the photographs themselves, the means by which this past is reported to us, are formed not in accordance with disinterested and repeatable rules, but according to the mysterious promptings of an individual sensibility. The photographs in fact insist on demonstrating their own historical capriciousness, by showing us that an ancient tree or stone wall is never twice the same, and by delighting us with the recognition of this anarchistic truth.

Granting this, we are still not tempted to say of Atget that his subject matter was merely the material from which he invented a private world. The demeanor of his work—its air of rectitude and seriousness—and the quality in it of wonder and deep affection persuade us of Atget's untroubled faith in the coherence and logic of the real world. Poetic intuition was the means by which he served the large, impersonal truth of history. In artistic terms, if not in those of logic, this strategy would work, if the photographs themselves could resemble in their own lineaments, in their own invisible style and structure, the mute disinterest of ancient things.

J.S.

Plates

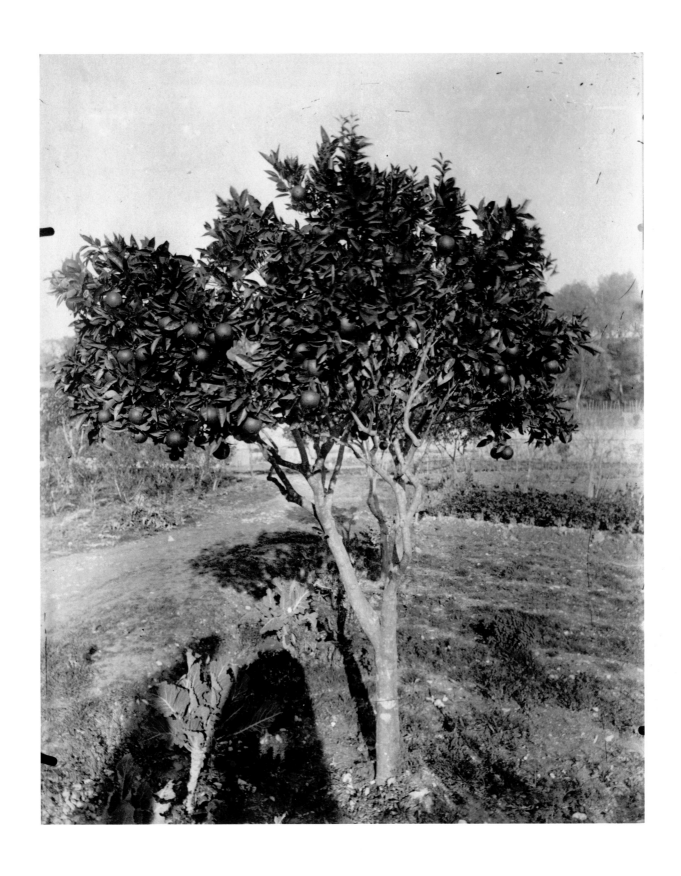

Pl. 1. Oranger. (Before 1900)

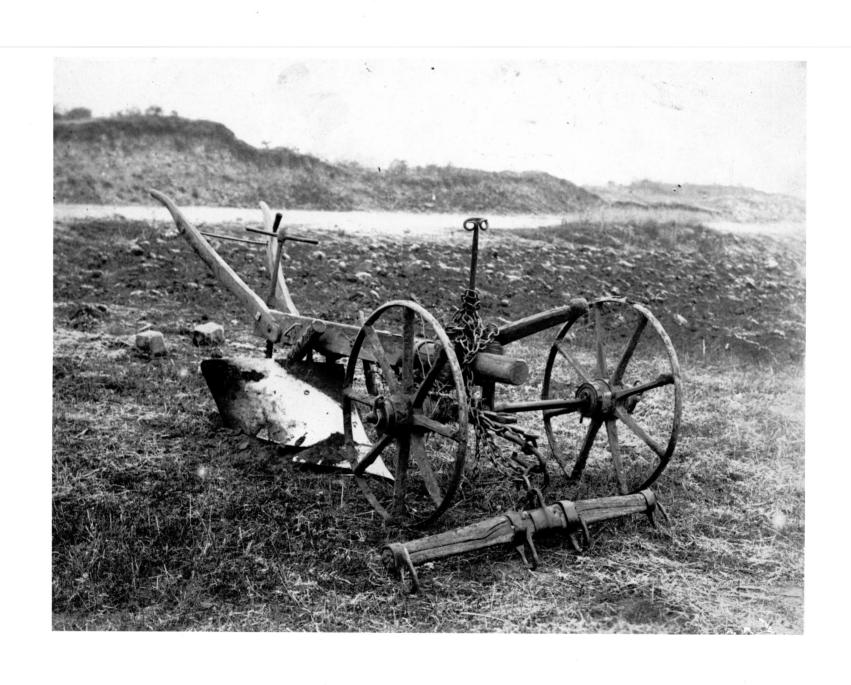

Pl. 2. Charrue. (*Before 1900*)

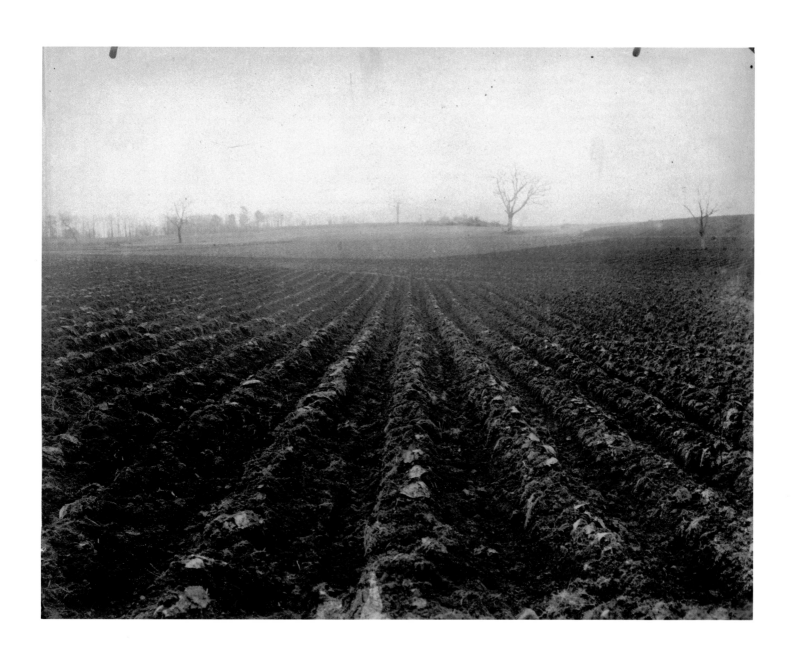

Pl. 3. Terrain (Limoges). (Before 1900)

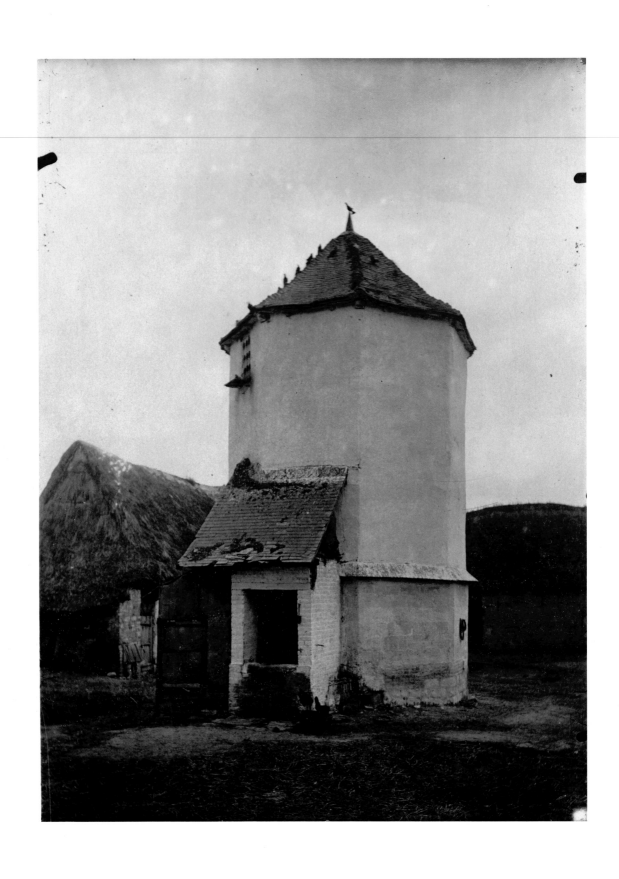

Pl. 4. Ferme, Abbeville. (Before 1900?)

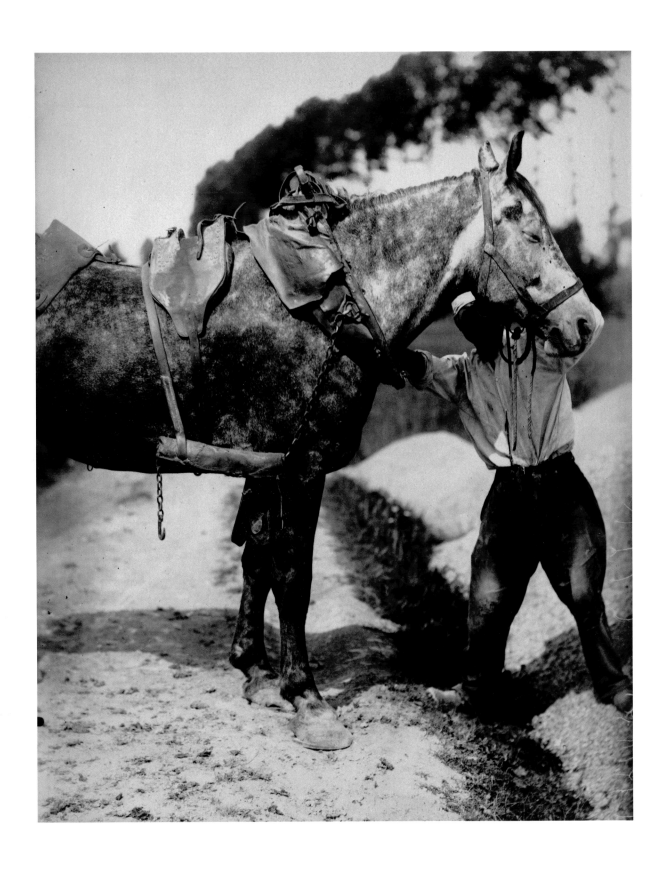

Pl. 5. Untitled [Harness on Horse]. (Before 1900?)

Pl. 6. Abbeville (Somme). (Before 1900)

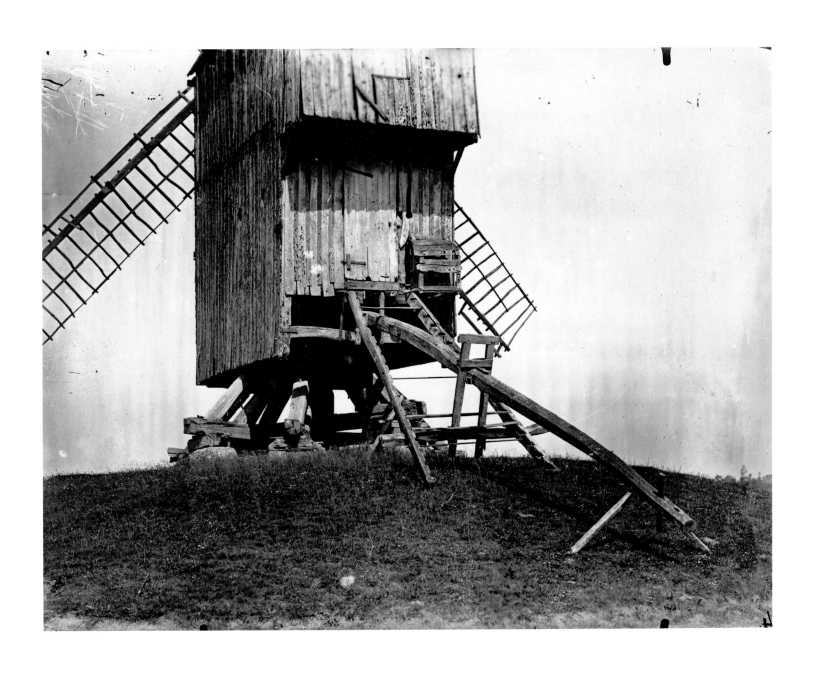

Pl. 7. Moulin (Somme). (Before 1900)

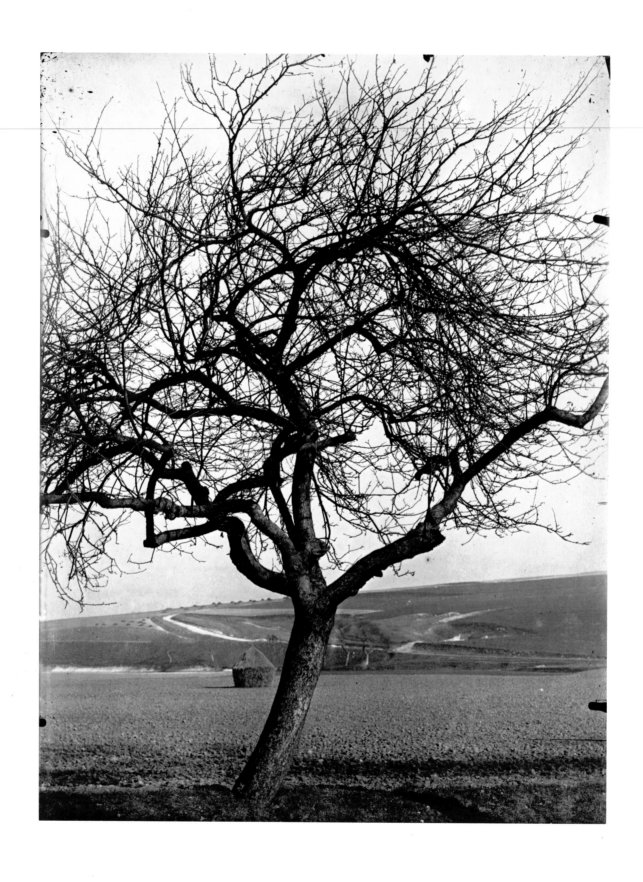

Pl. 8. Pommier. (1898 or before?)

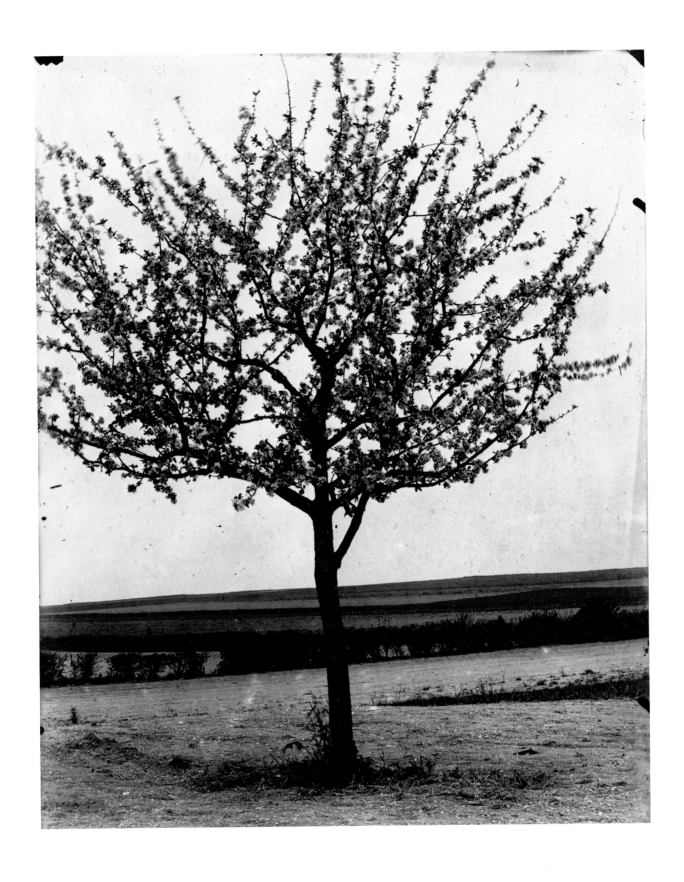

Pl. 9. Pommiers, fleurs. (Before 1900)

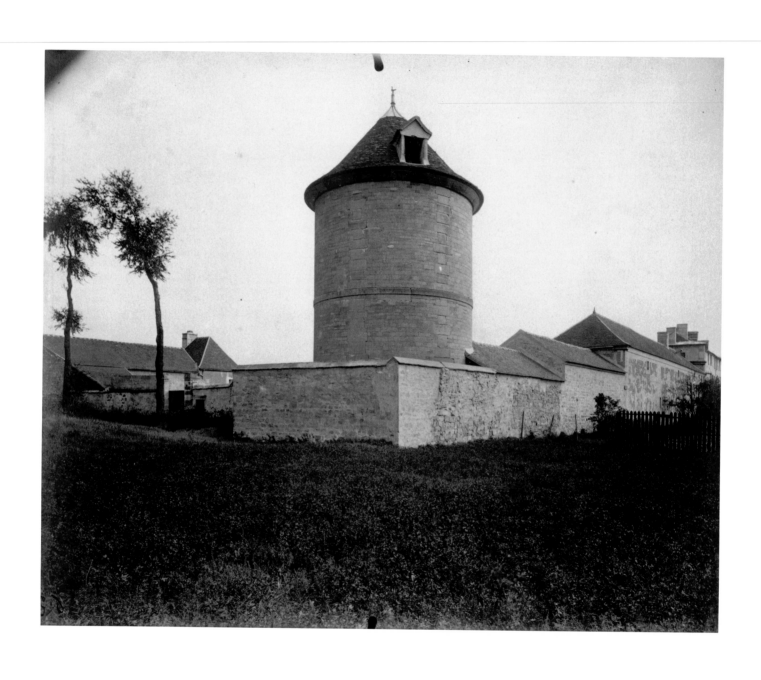

Pl. 10. Villejuif, ancien château des comtes de Saint-Roman. 1901

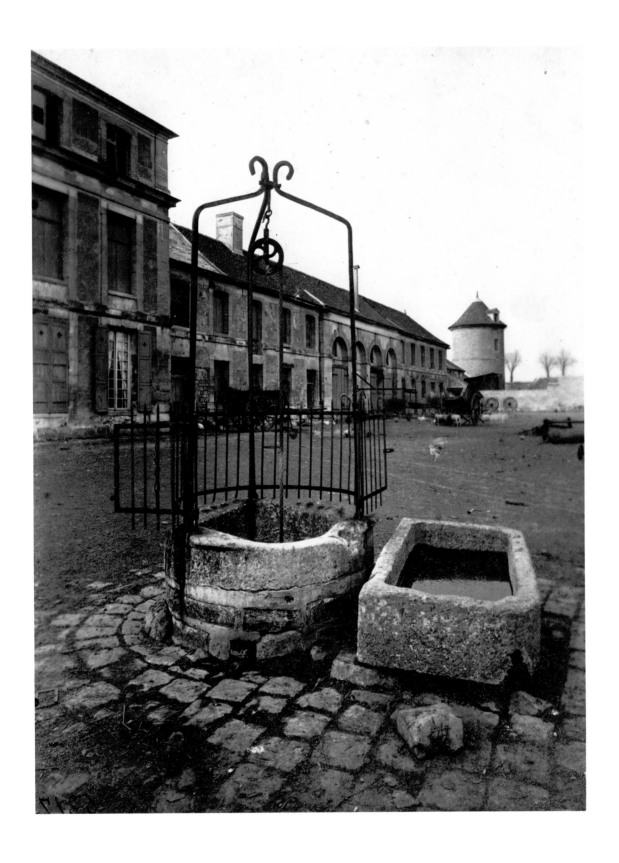

Pl. 11. Villejuif, ancien château du comte. 1901

Pl. 12. Chemin à Abbeville. (Before 1900)

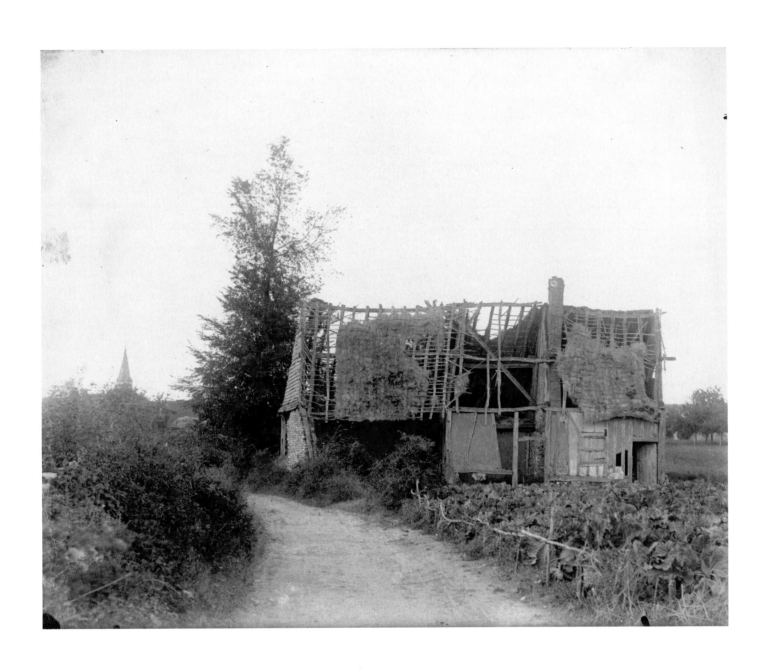

Pl. 13. Untitled [Roofless Farmhouse, Somme]. (1898 or before?)

Pl. 14. Abbeville (chemin). (Before 1900)

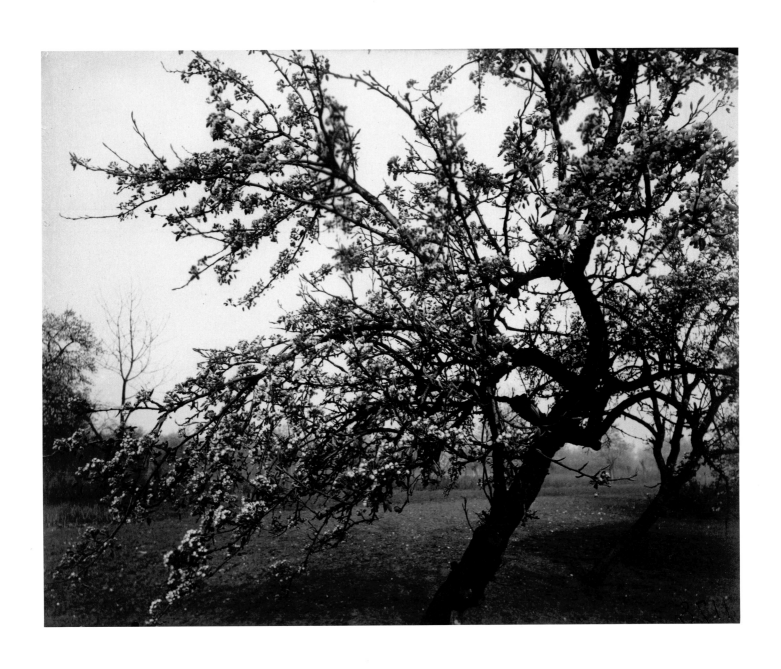

Pl. 15. Poirier en fleurs. (1922–23)

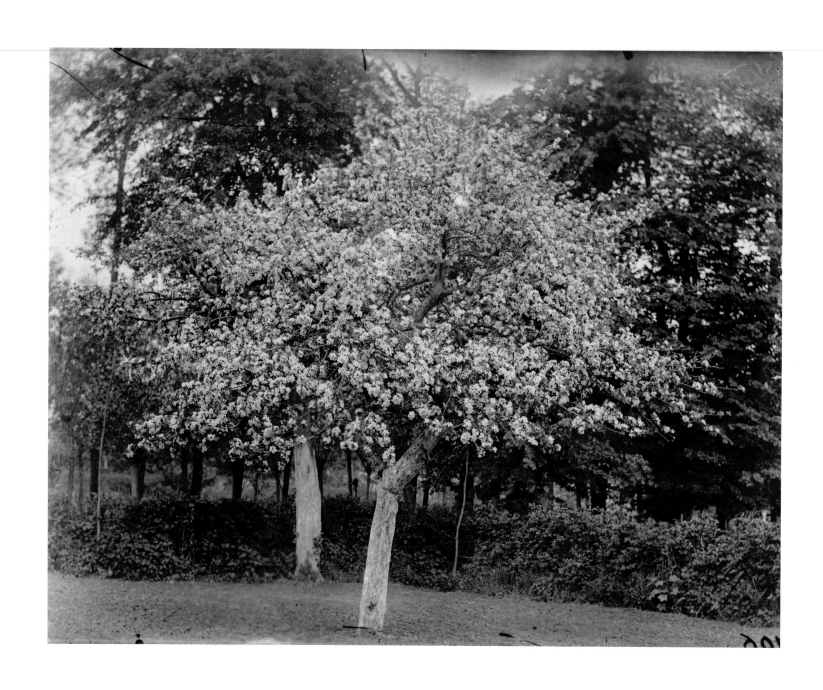

Pl. 16. Pommier. (Before 1900)

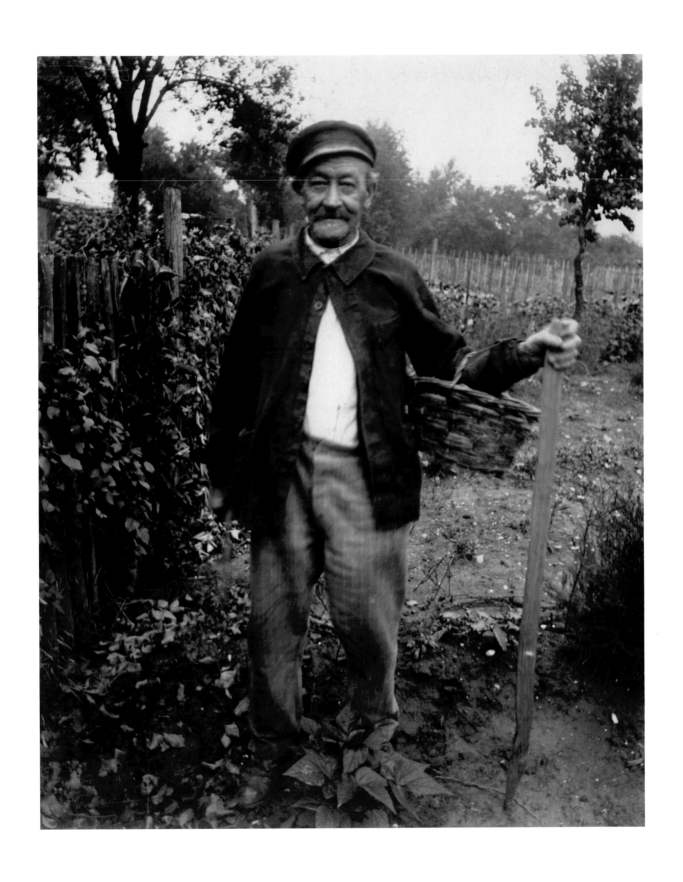

Pl. 17. Paysan de Châtillon. (1922?)

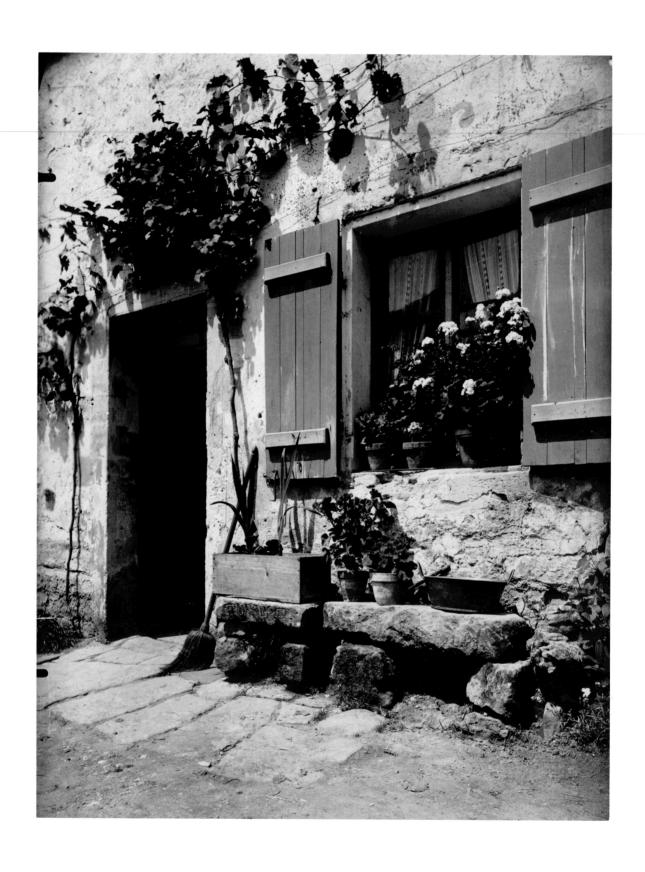

Pl. 18. Auvers (vieille maison). (1900–10)

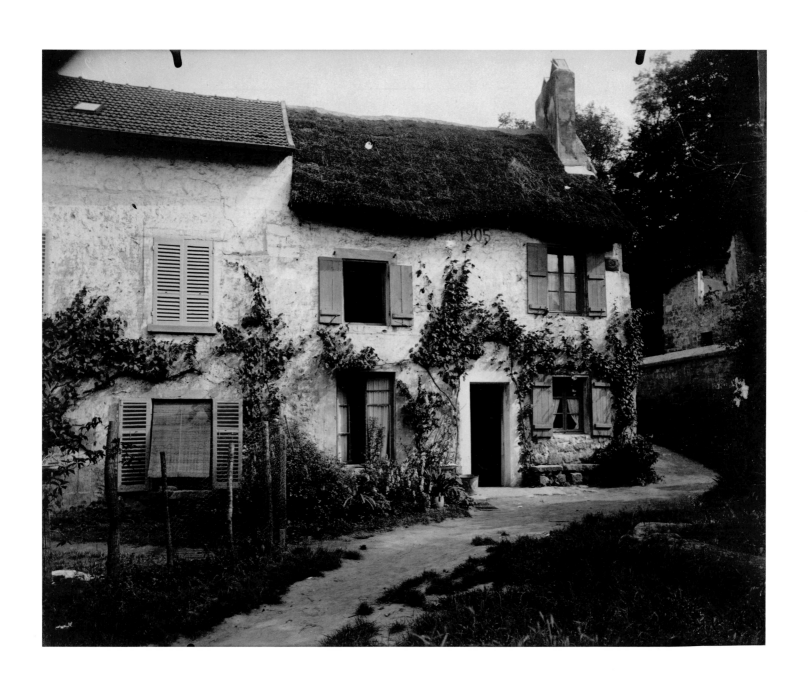

Pl. 19. Auvers-sur-Oise. 1922

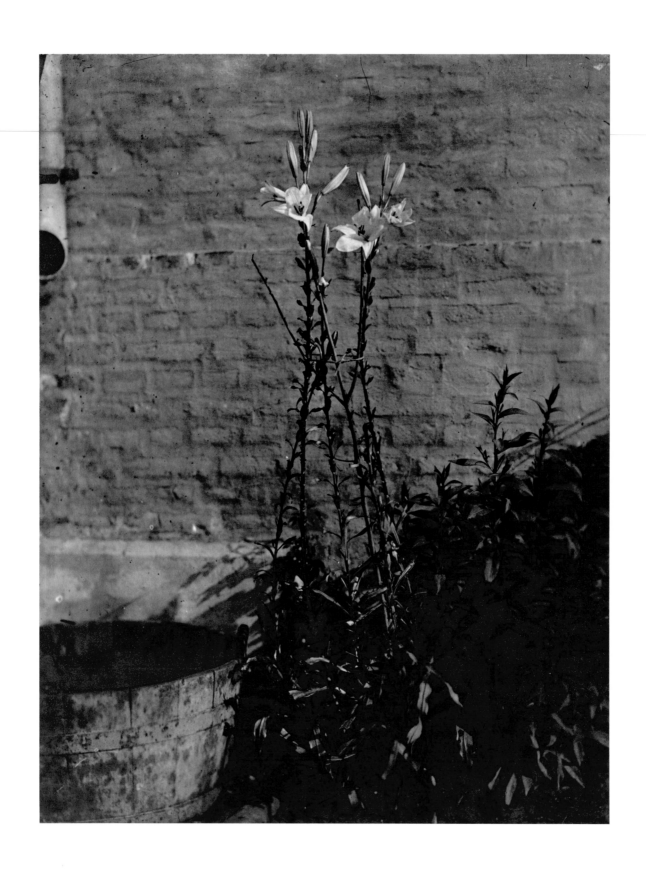

Pl. 20. Lys. (Before 1900)

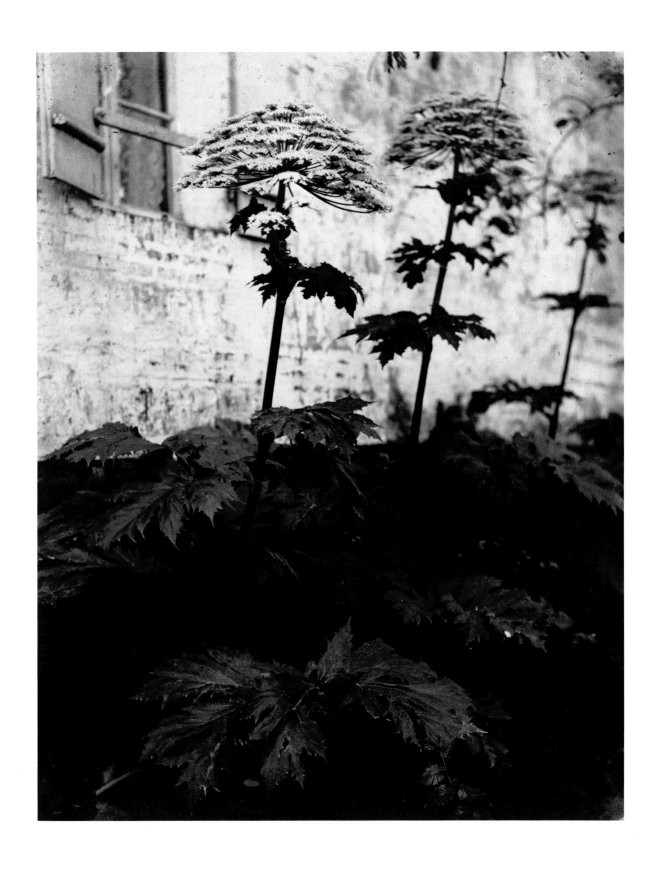

Pl. 21. Ombelles. (*Before 1900*)

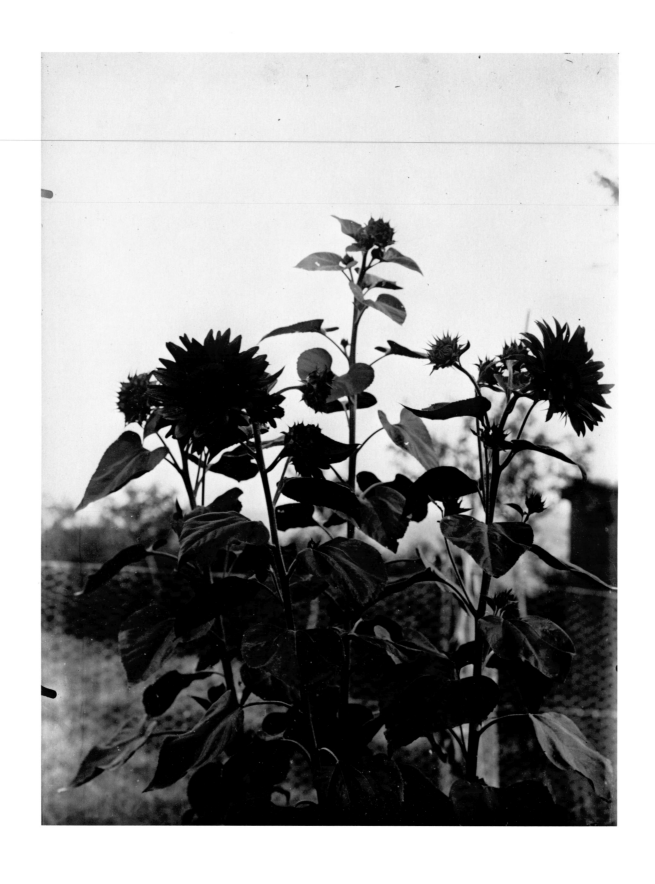

Pl. 22. Soleil. (1896?)

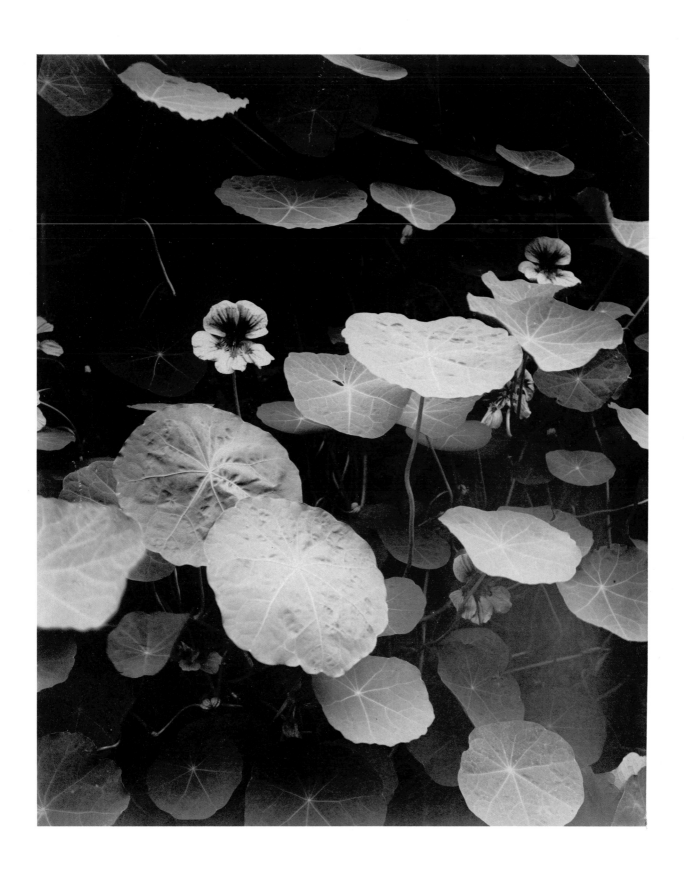

Pl. 23. Capucines. (1921–22)

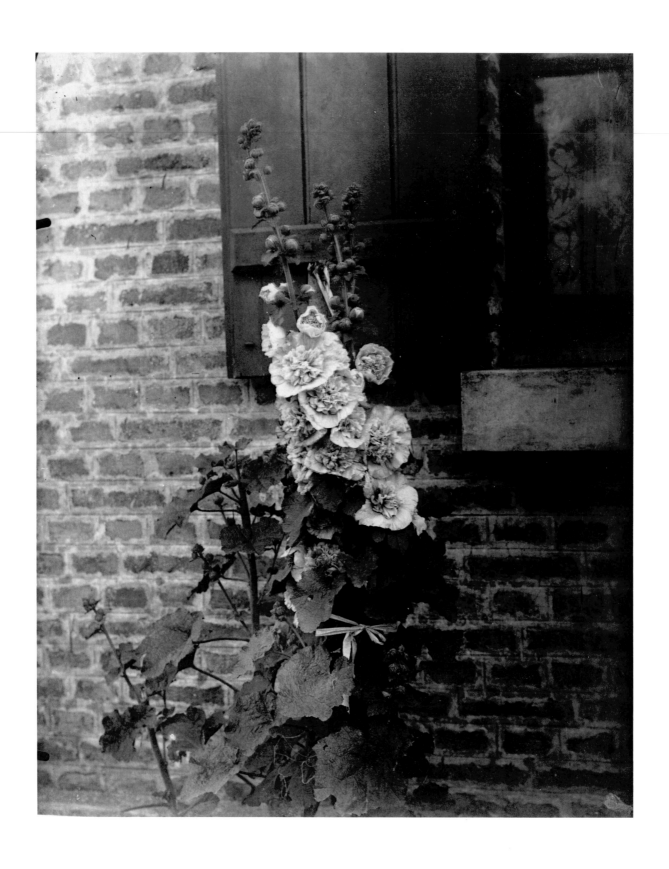

Pl. 24. Roses trémières. (Before 1900)

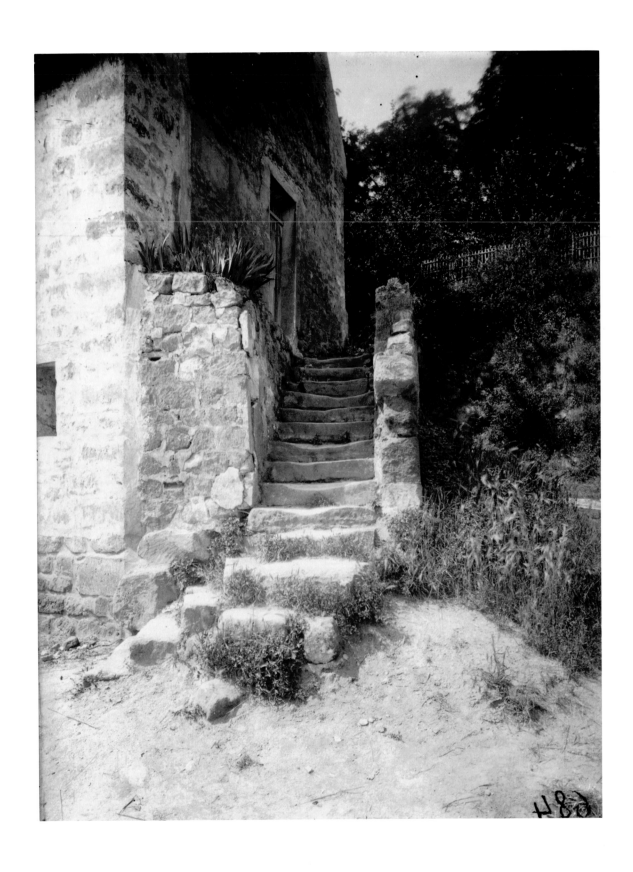

Pl. 25. Auvers-sur-Oise. (1900–10)

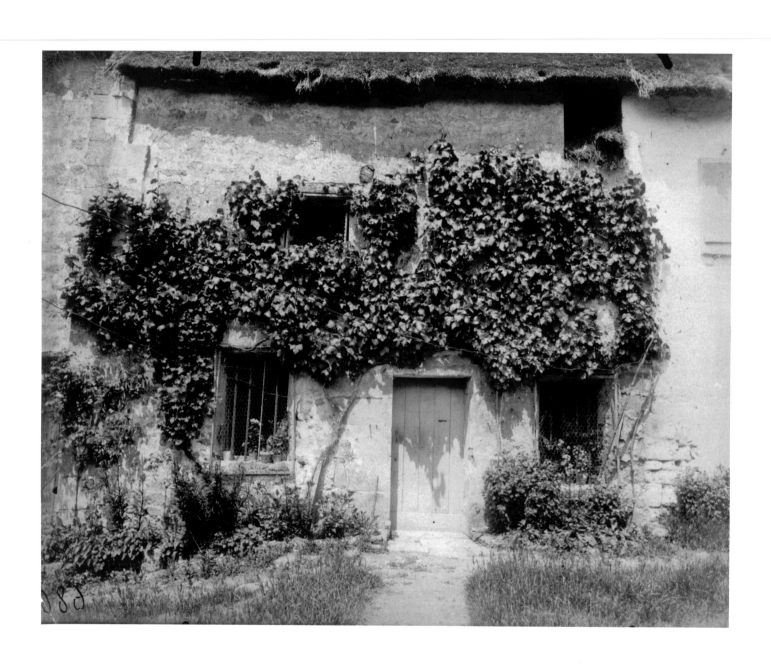

Pl. 26. Ferme, Auvers (Oise). (1900–10)

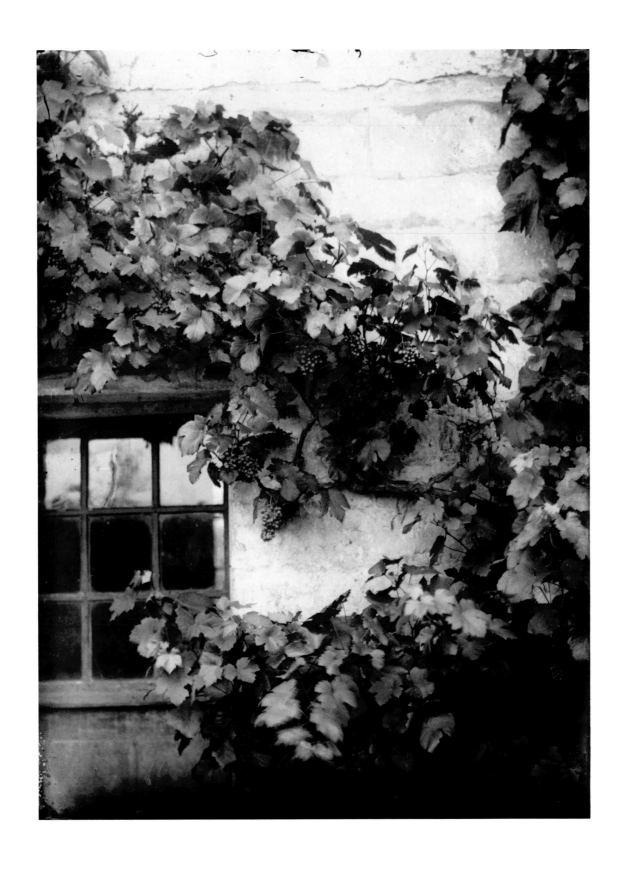

Pl. 27. Vigne. (Before 1900)

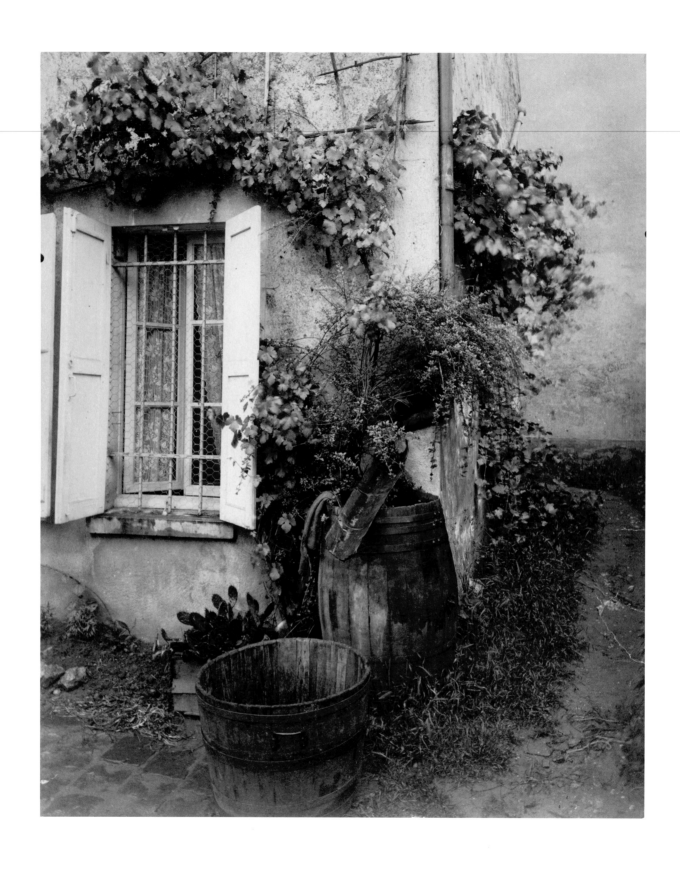

Pl. 28. Verrières, coin pittoresque. 1922

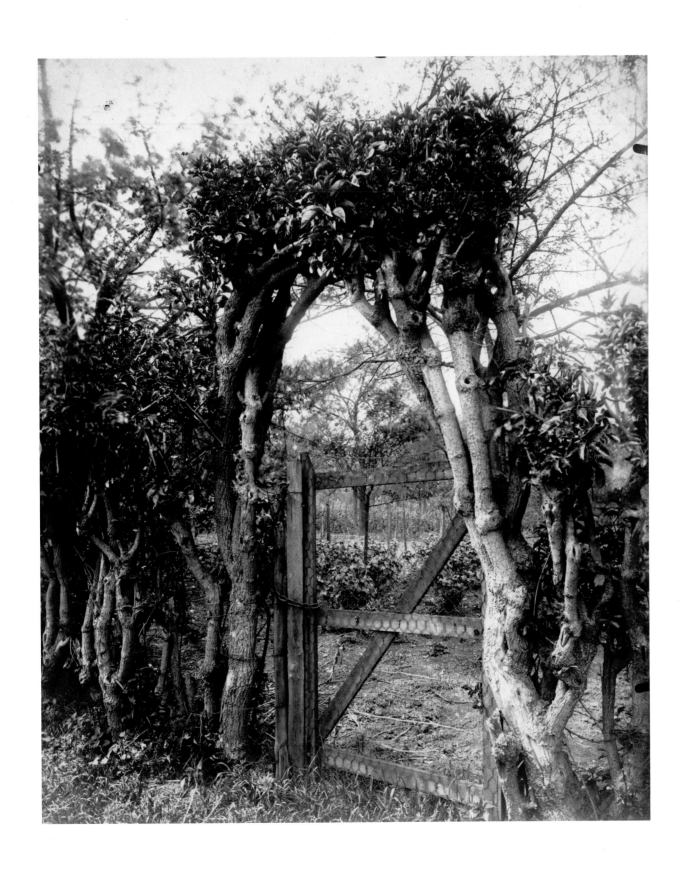

Pl. 29. Entrée des jardins. (1921–22)

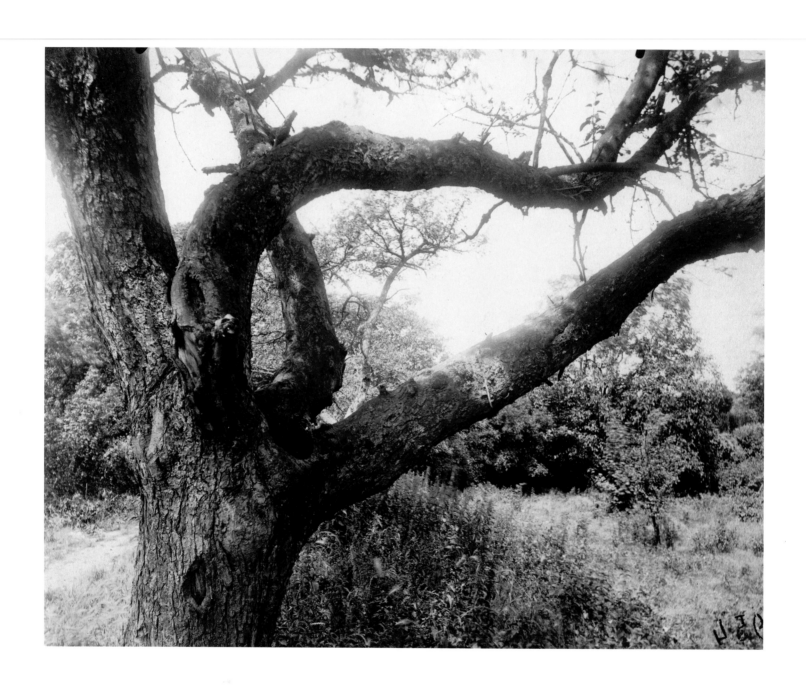

Pl. 30. Pommier (détail). (1919–21)

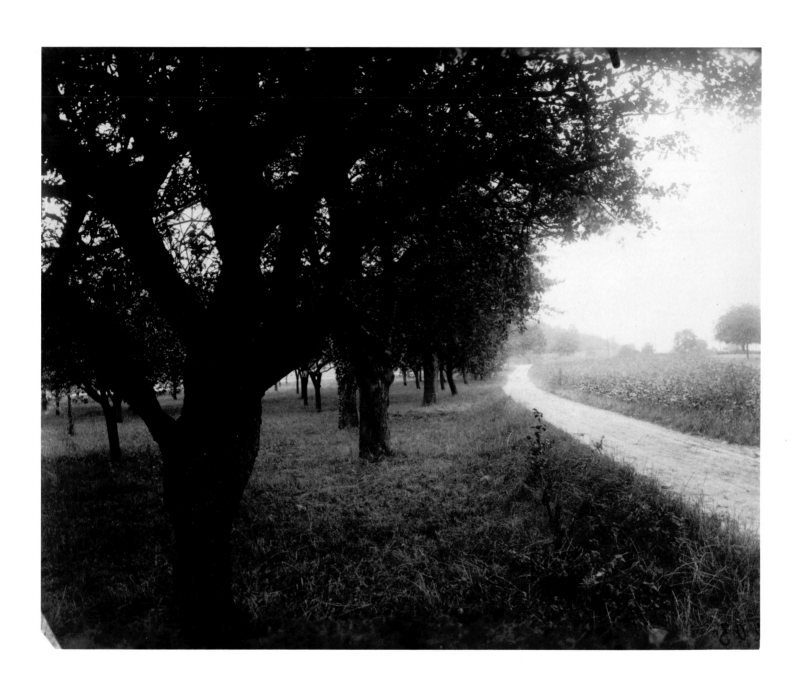

Pl. 31. Pommiers. Septembre 1923

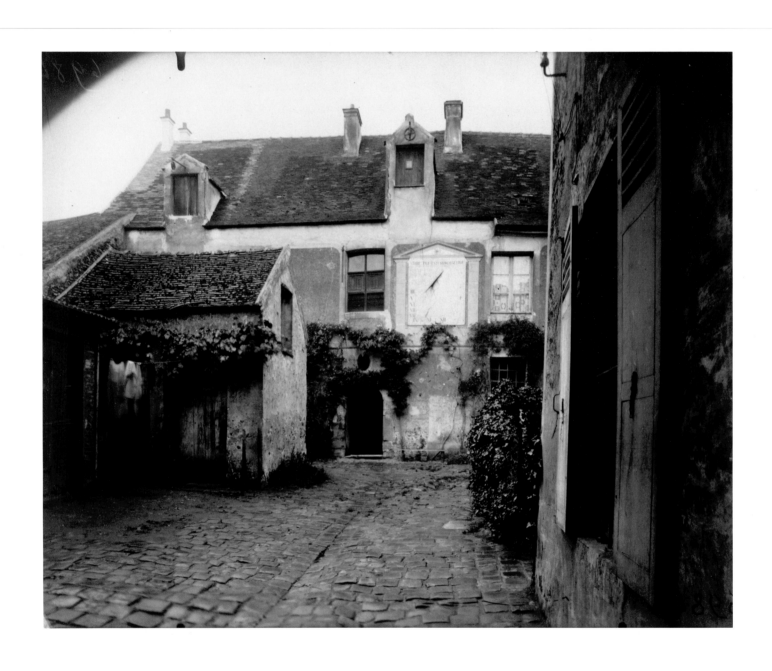

Pl. 32. Verrières, vieux logis. 1922

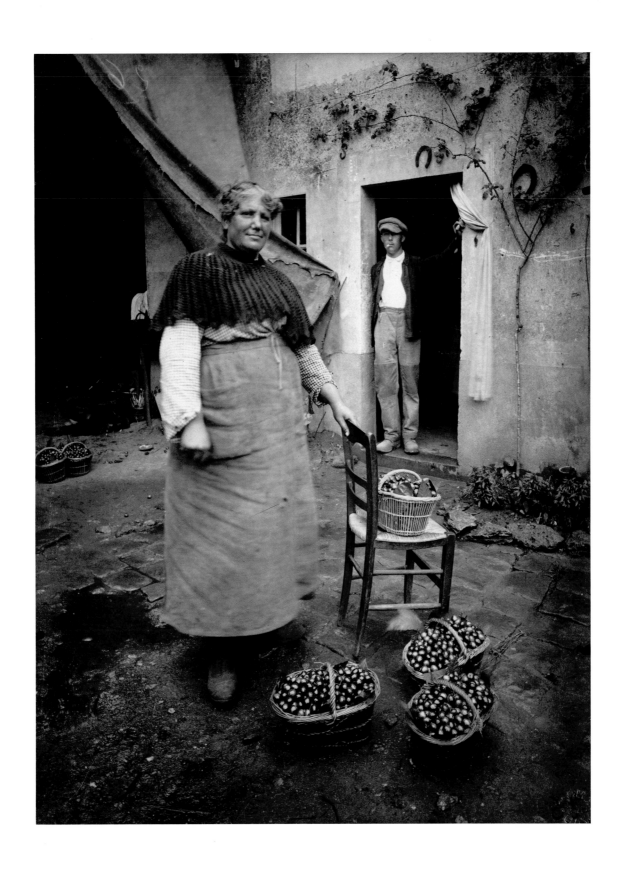

Pl. 33. Femme de Verrières. (1922?)

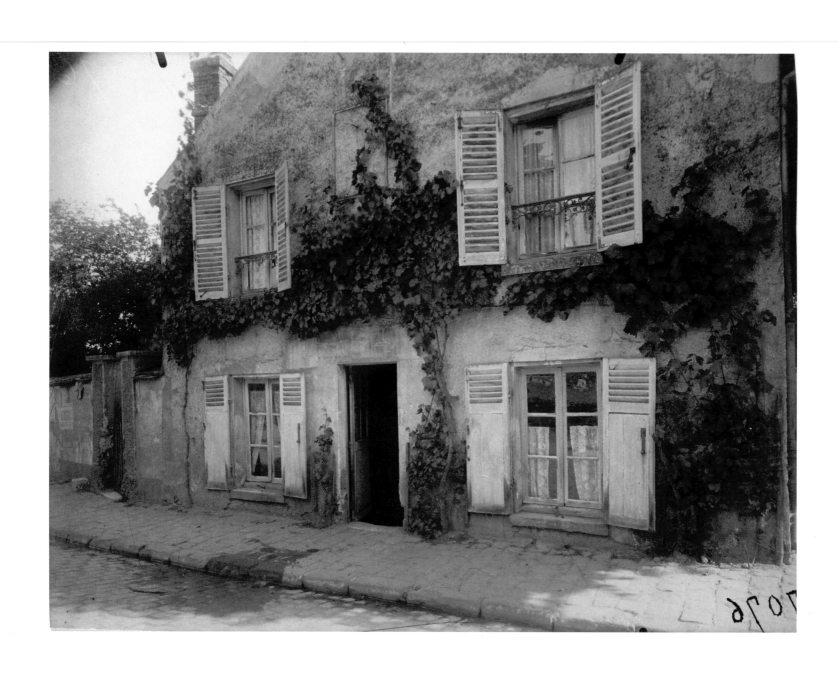

Pl. 34. Gif, vieille maison. 1924

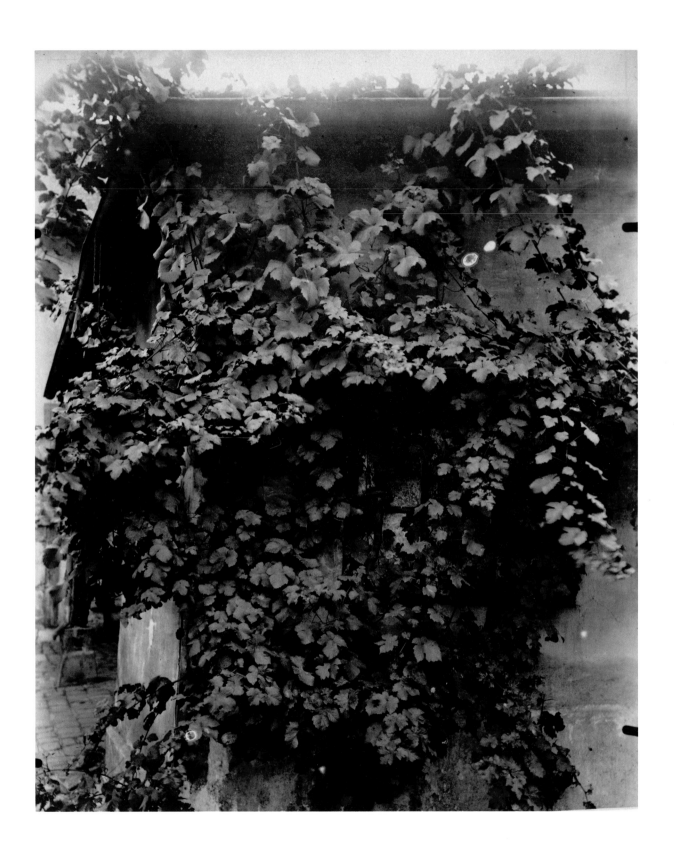

Pl. 35. Vigne. (Before 1900)

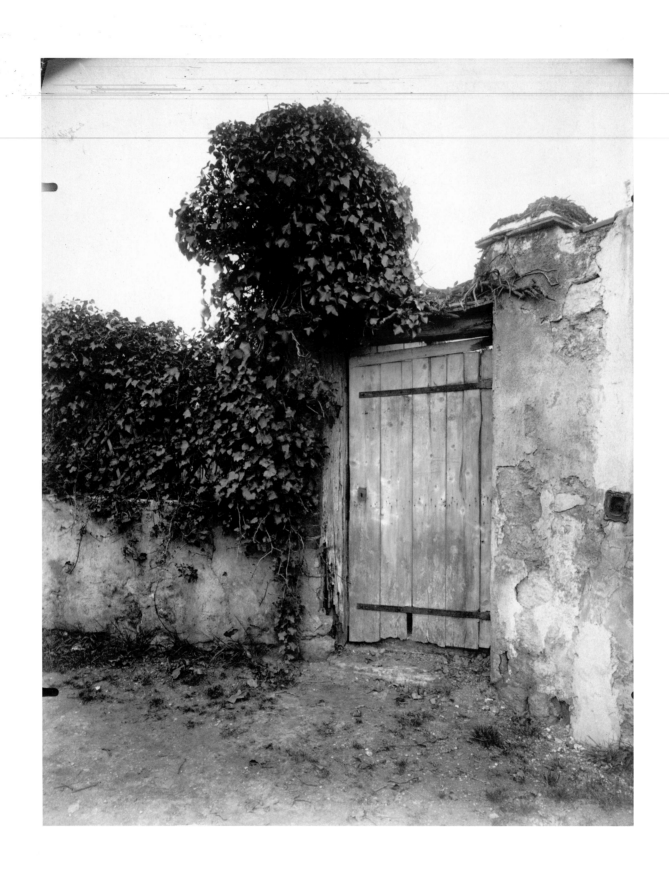

Pl. 36. Entrée pittoresque, Châtillon. (*1921–22*)

Pl. 37. Houblon. (1900–10)

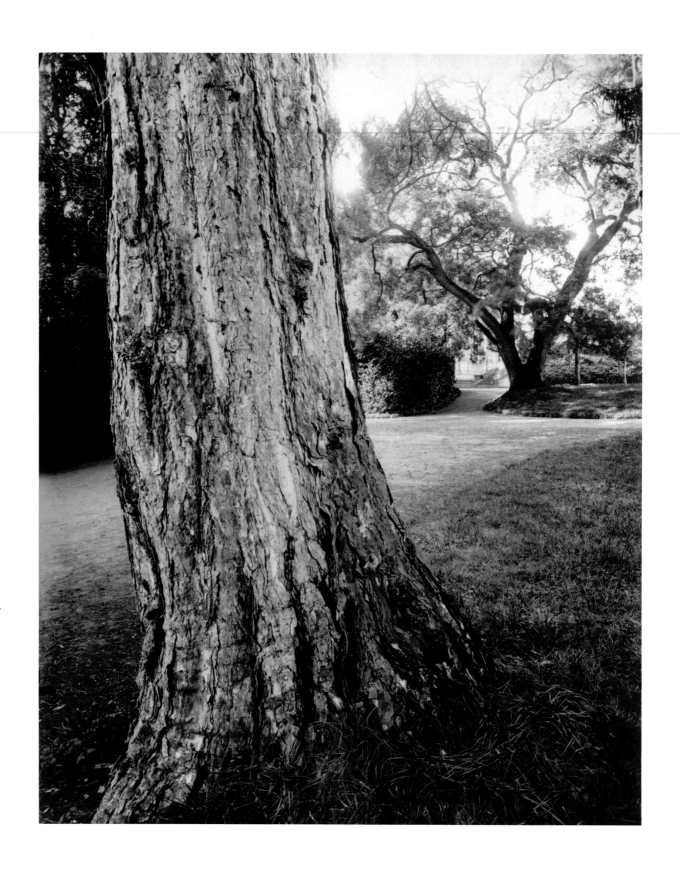

Pl. 38. Etude (sapin). (1900–10)

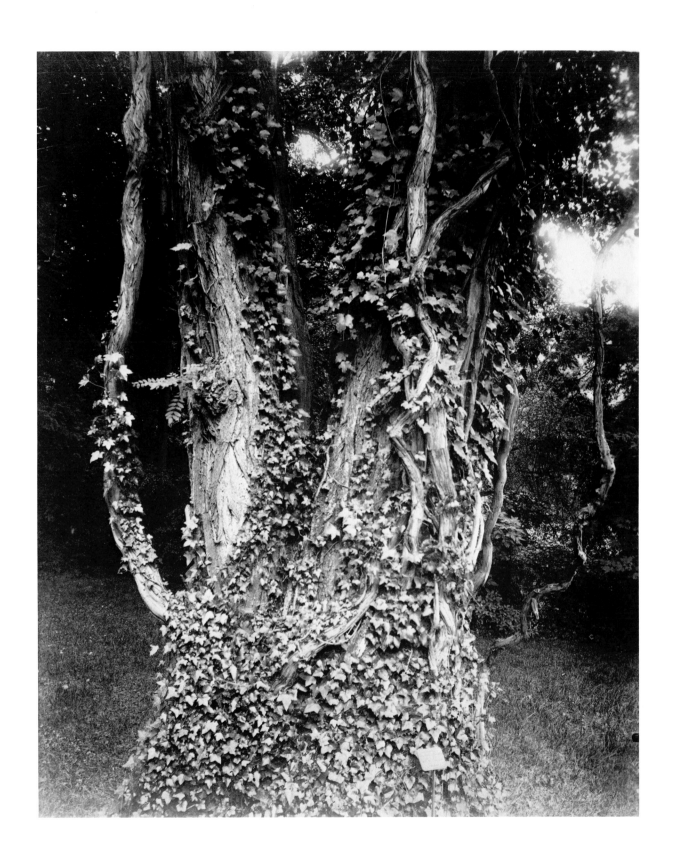

Pl. 39. Acacia. (1922–23)

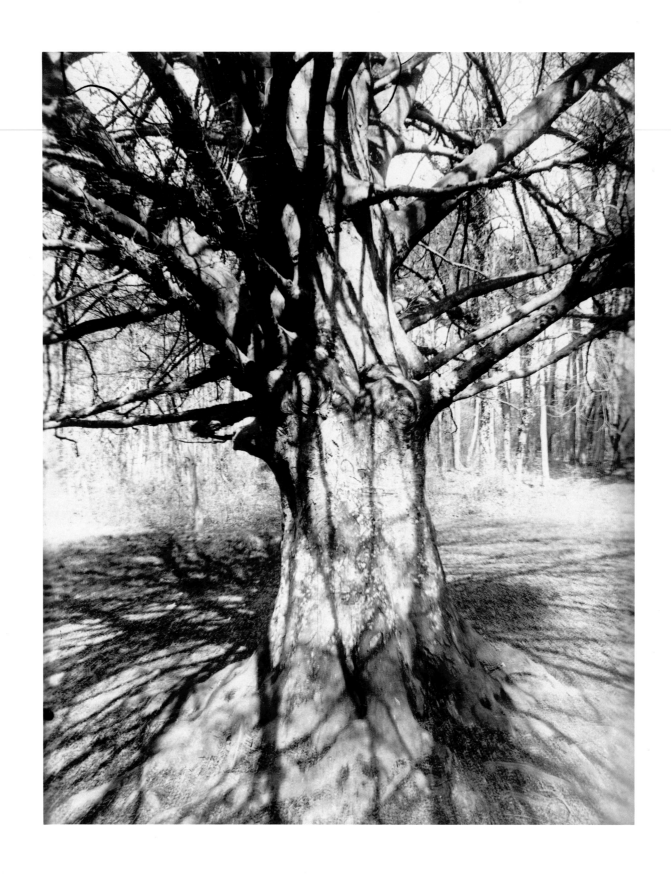

Pl. 40. Hêtre. (1910–15)

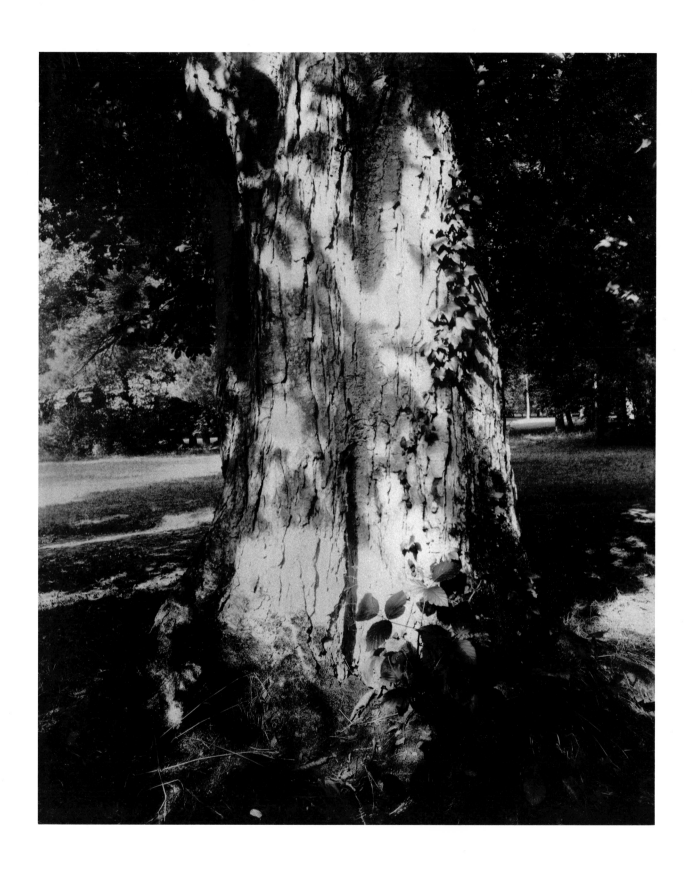

Pl. 41. Trianon, marronnier, effet de soleil. (1910–15)

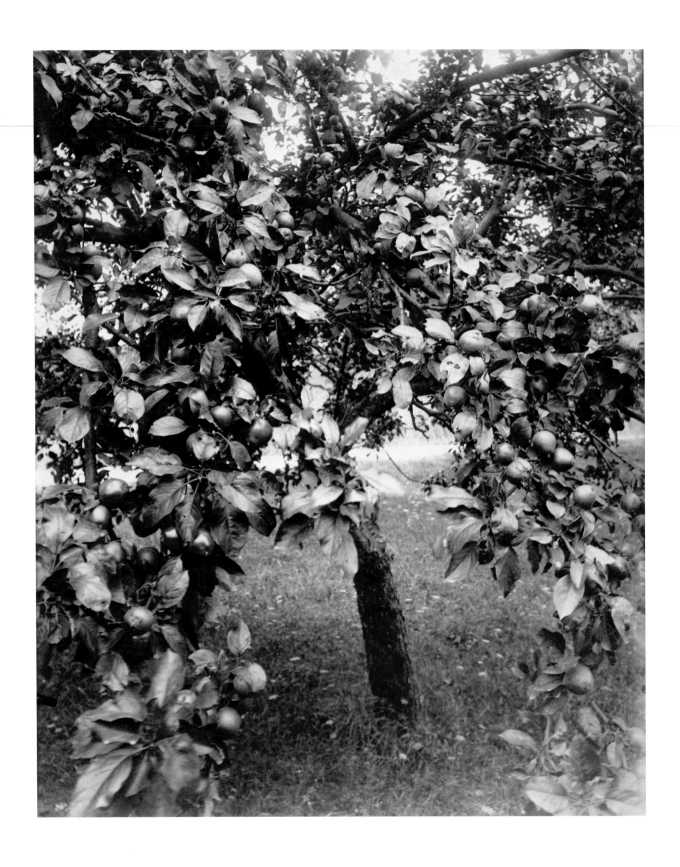

Pl. 42. Pommier. (1922–23)

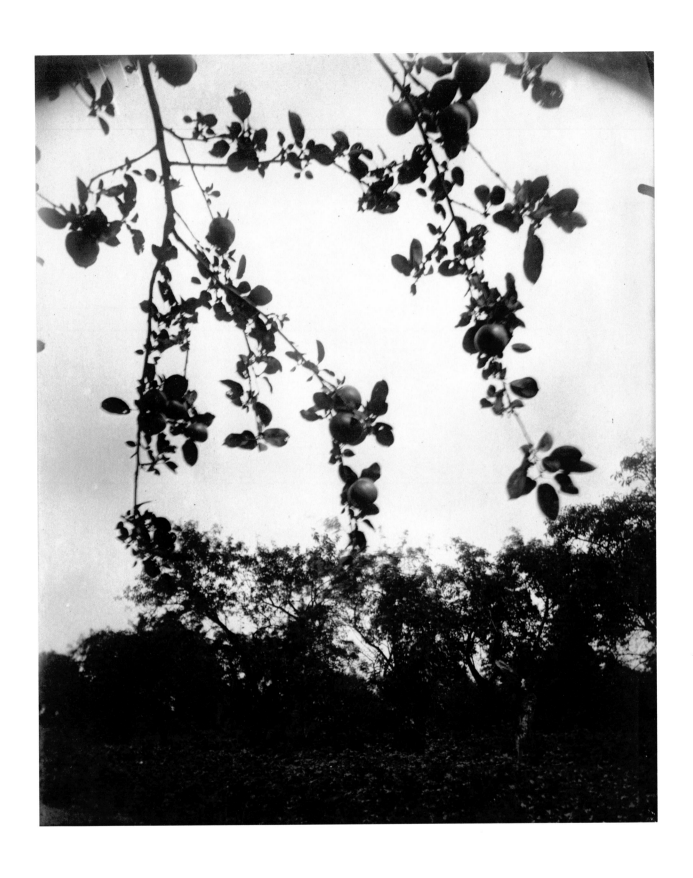

Pl. 43. Pommier (détail). (1922–23)

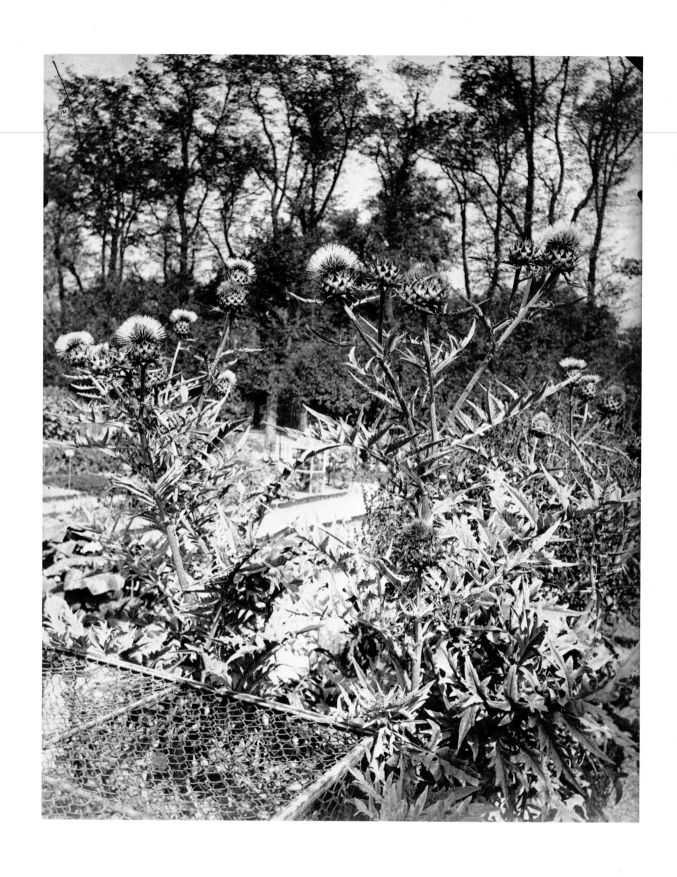

Pl. 44. Artichauts, fleurs. (Before 1900)

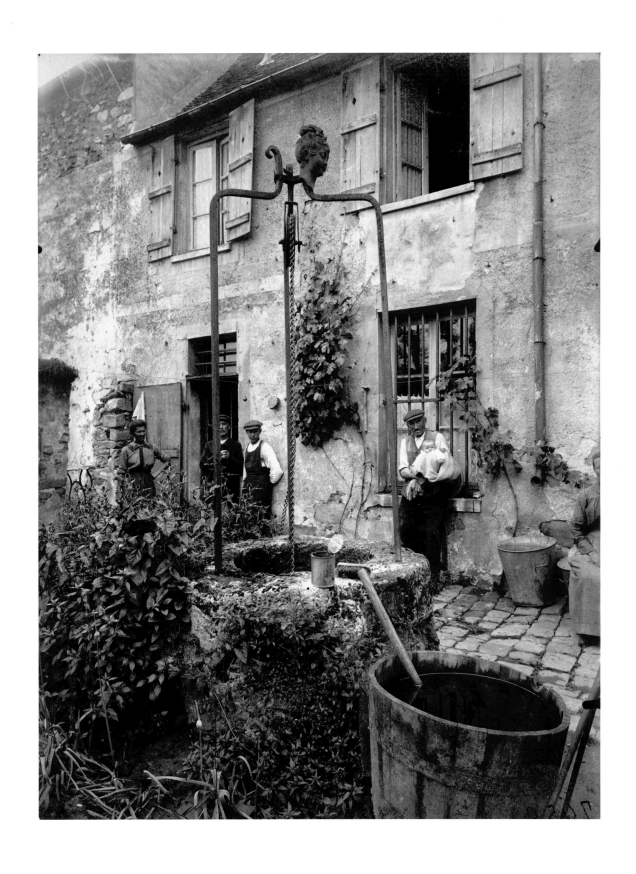

Pl. 45. Sceaux-les-Chartreux, ferme. 1924

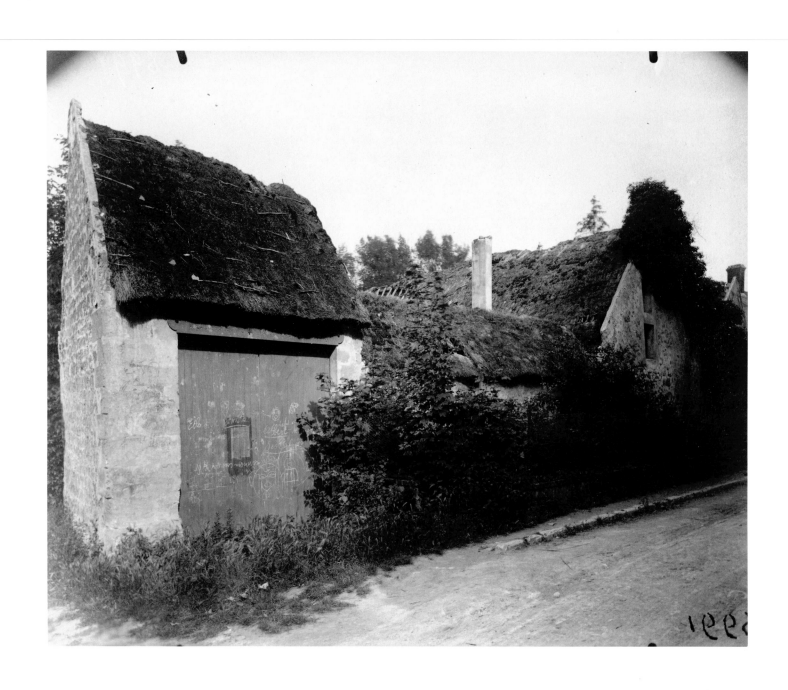

Pl. 46. Auvers-sur-Oise. 1922

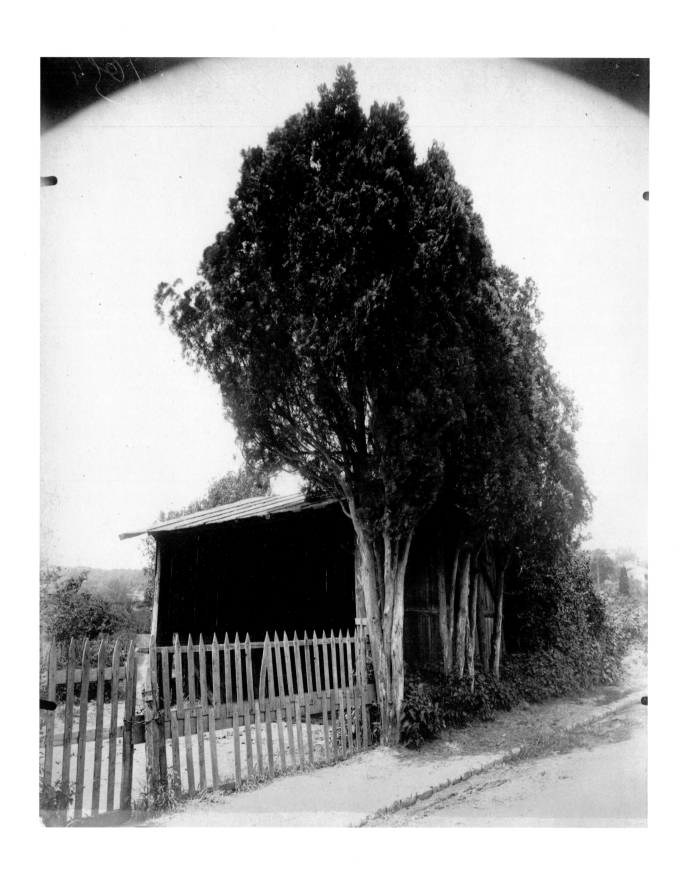

Pl. 47. Cyprès. (1921–22)

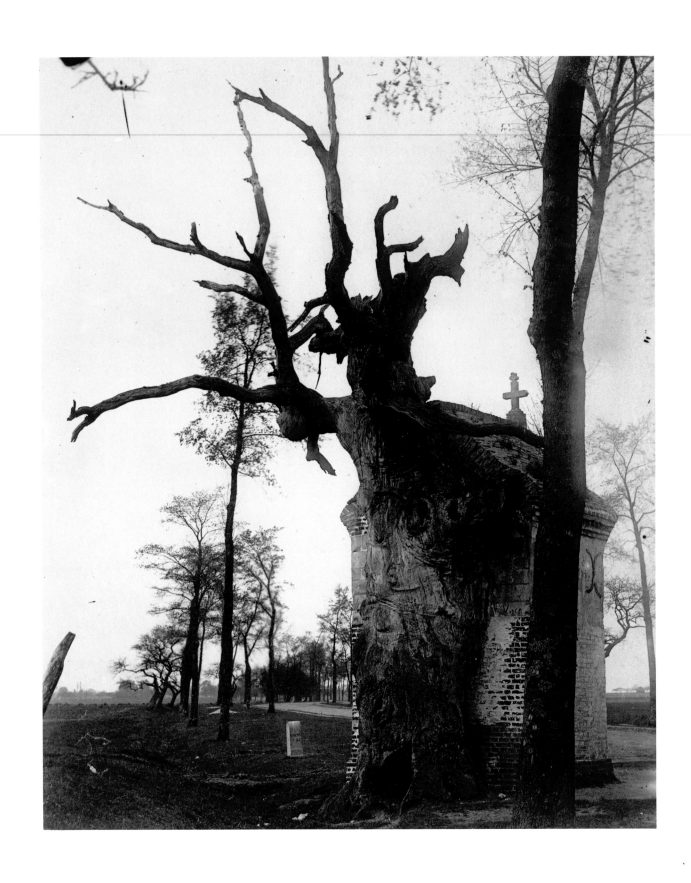

Pl. 48. Route, Amiens. (Before 1900)

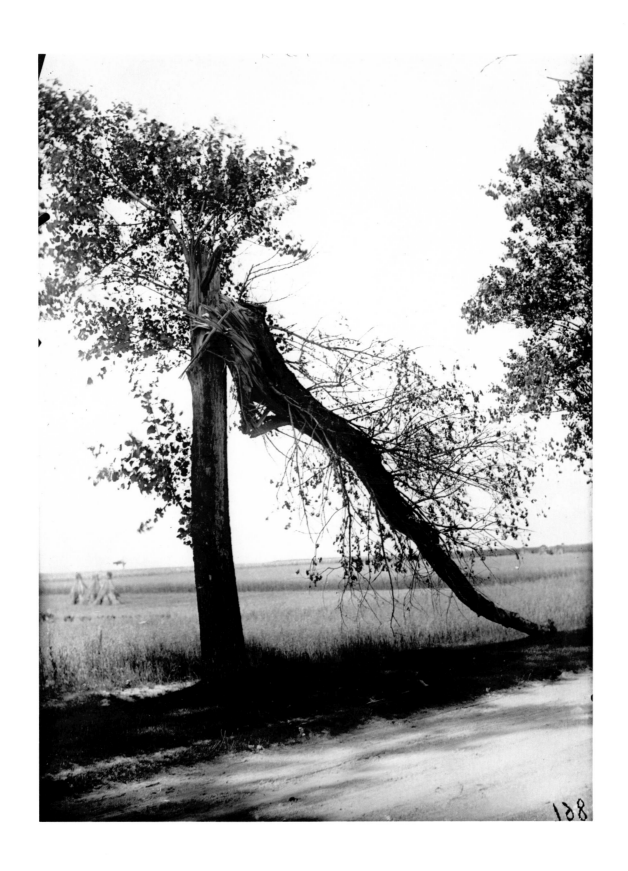

Pl. 49. Untitled [Broken Tree]. (Before 1900)

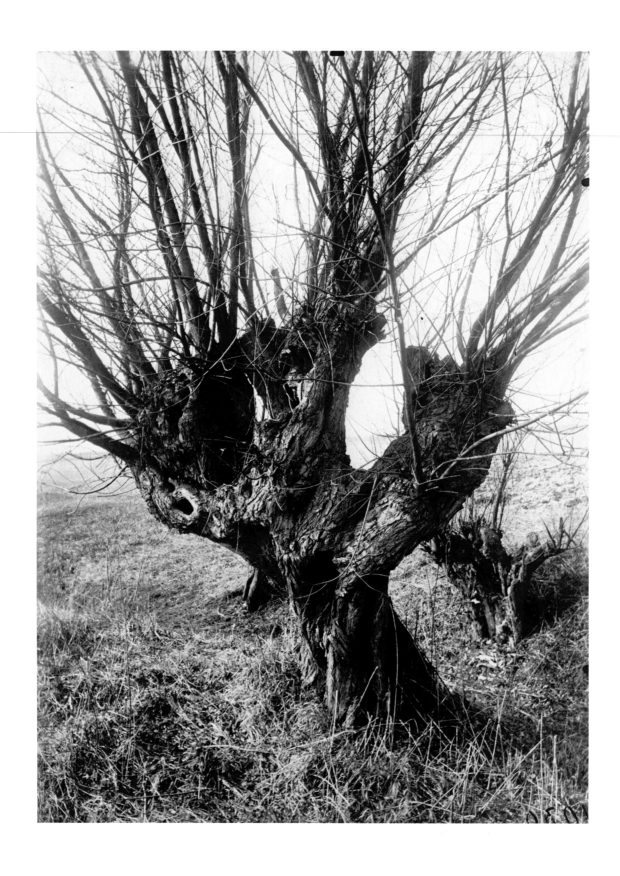

Pl. 50. Saules. (1919–21)

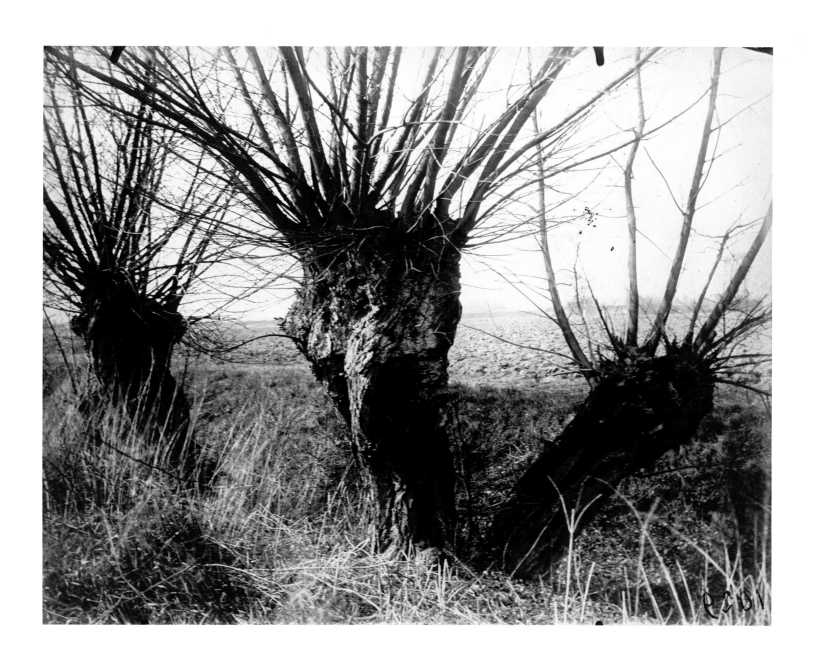

Pl. 51. Saules. (1921–22)

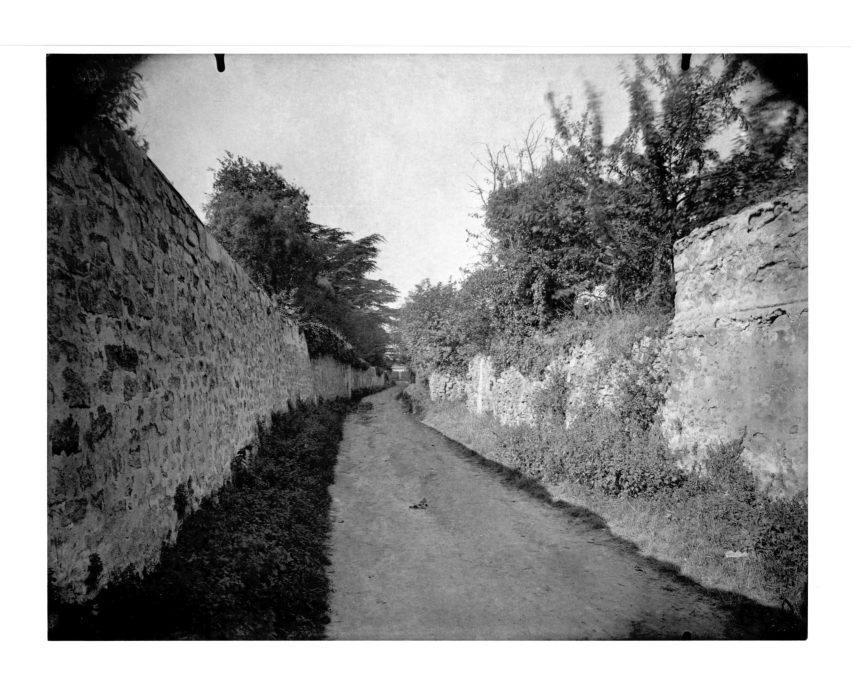

Pl. 52. Châtillon, chemin des Pierrettes. Août 1919

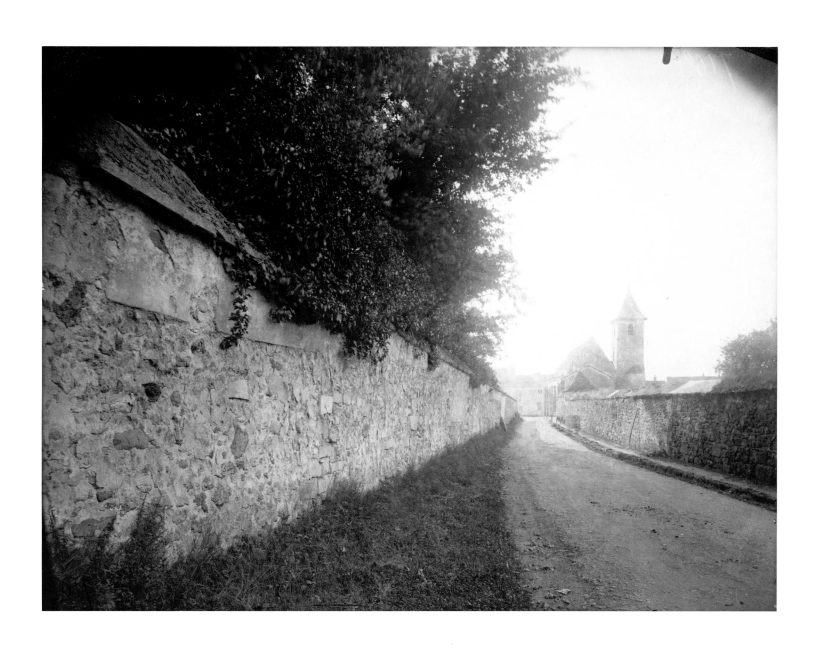

Pl. 53. Ballainvilliers, entrée du village. Juin 1925

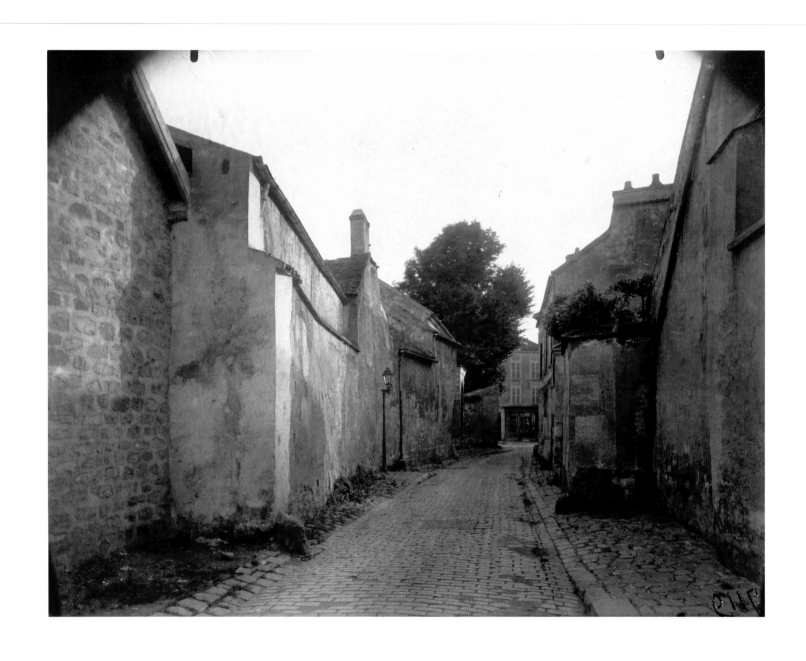

Pl. 54. Vitry. (1925–27)

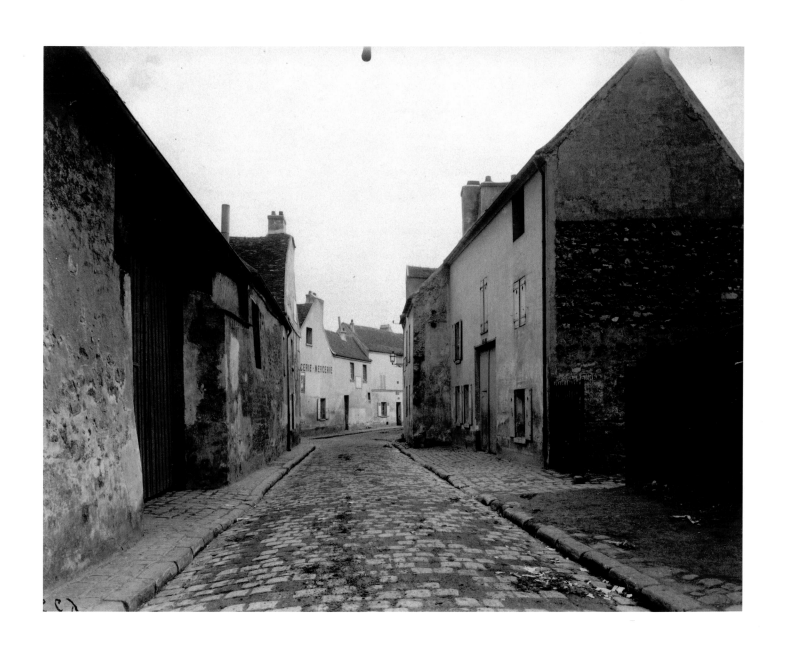

Pl. 55. Villejuif, vieille rue. 1901

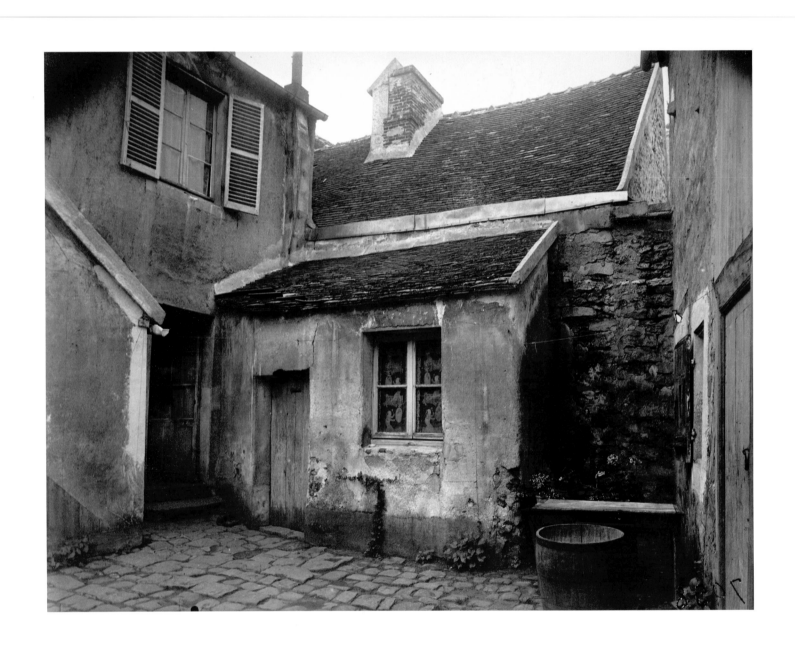

Pl. 56. Sceaux-les-Chartreux, coin. 1924

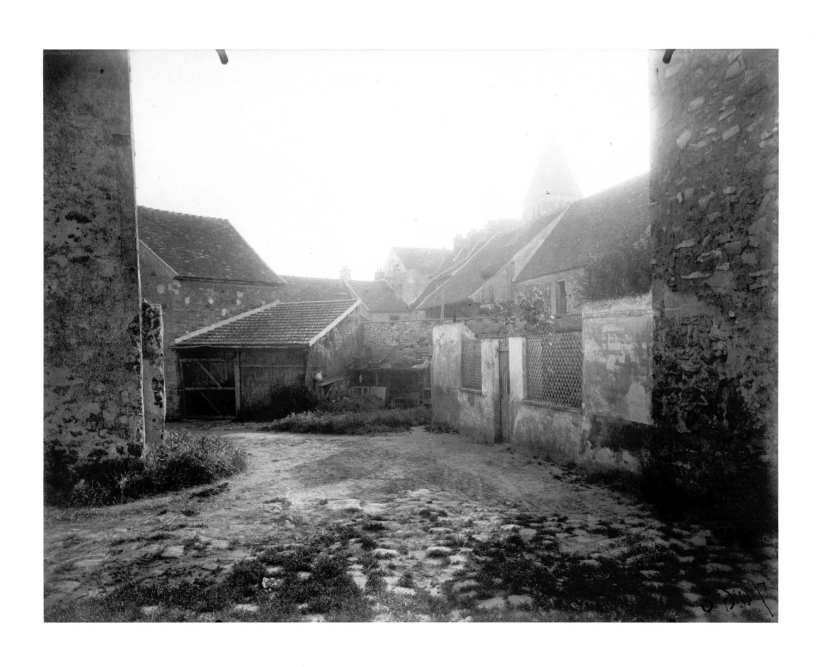

Pl. 57. Sceaux-les-Chartreux, ferme. 1924

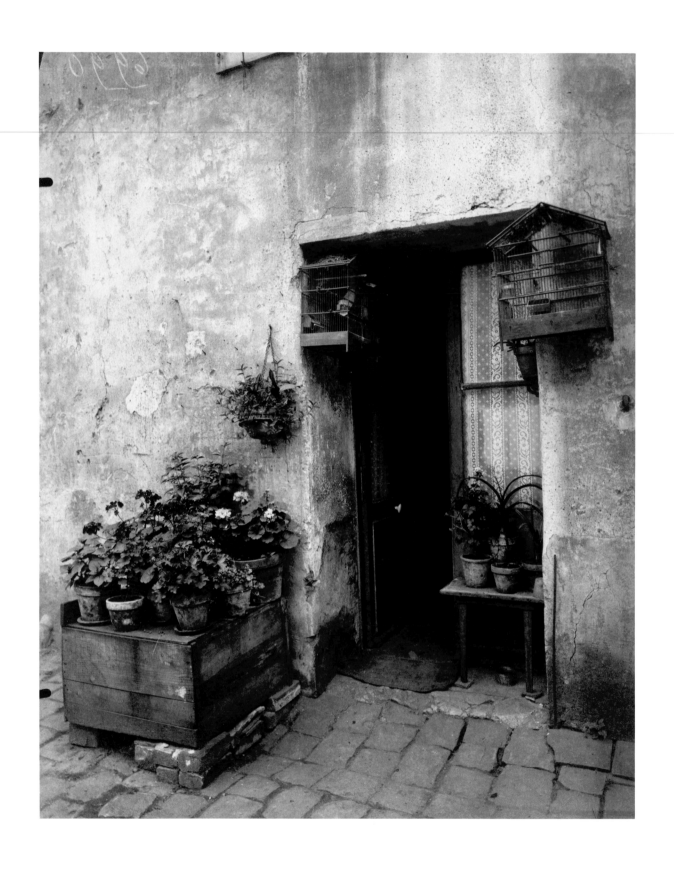

Pl. 58. Sceaux, coin pittoresque. 1922

Pl. 59. Dammartin-en-Goële, ancien Hôtel-Dieu. Juillet 1921

Pl. 60. Bièvres, place de l'Église. 1924

Pl. 61. Bièvres (église). 1924

Pl. 62. Provins, remparts. 1923

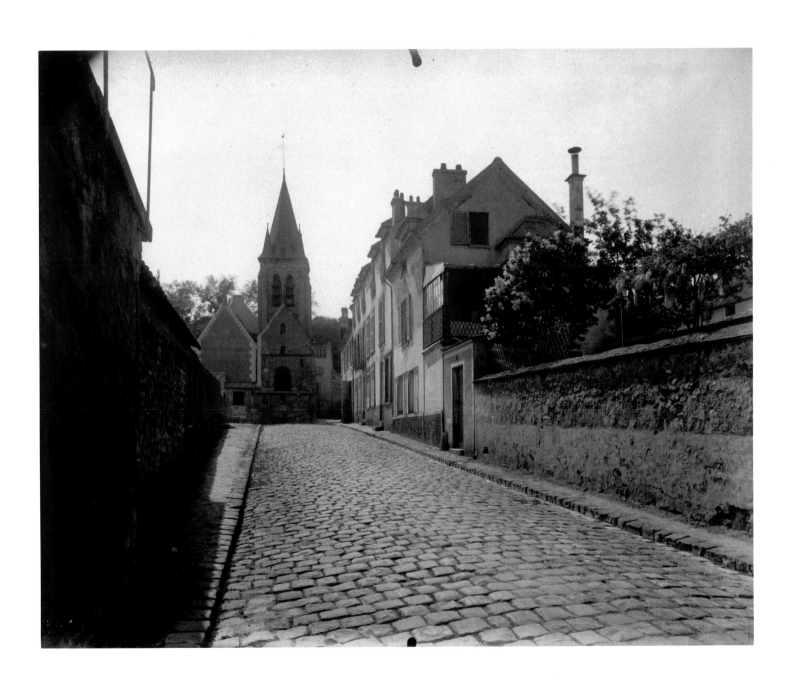

Pl. 63. Châtenay, rue Sainte-Catherine. 1901

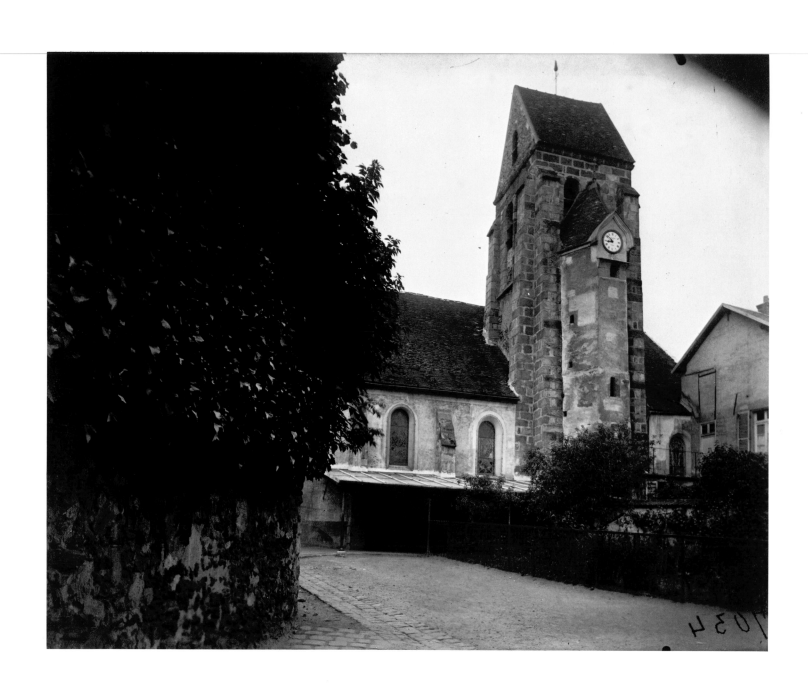

Pl. 64. Igny. 1923

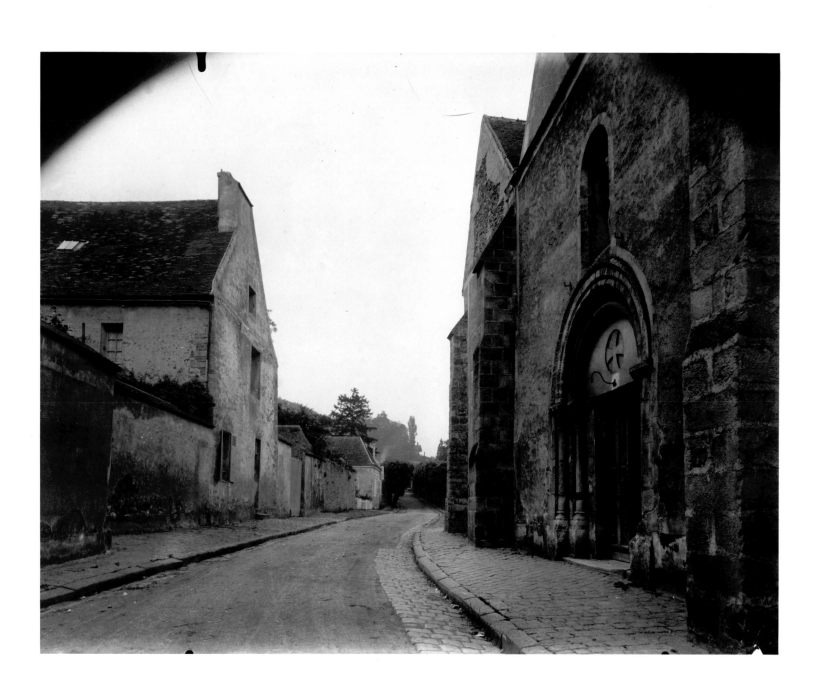

Pl. 65. Palaiseau. Juin 1925

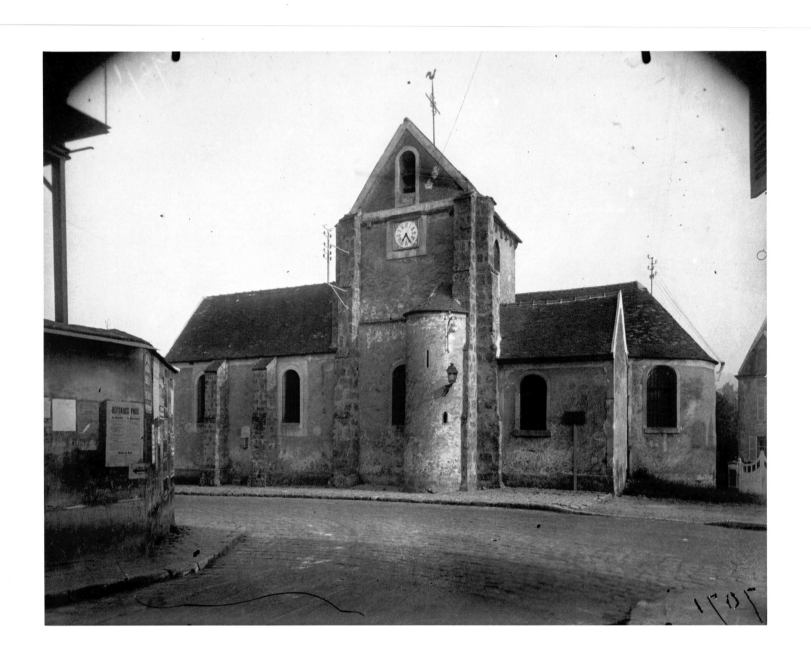

Pl. 66. Bures (église). 1924

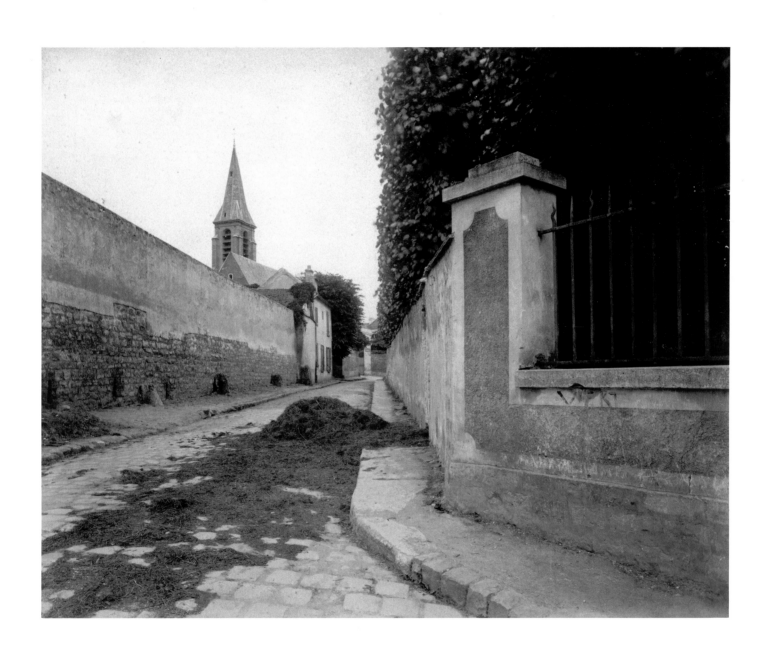

Pl. 67. Bagneux, vieille rue. Juin 1901

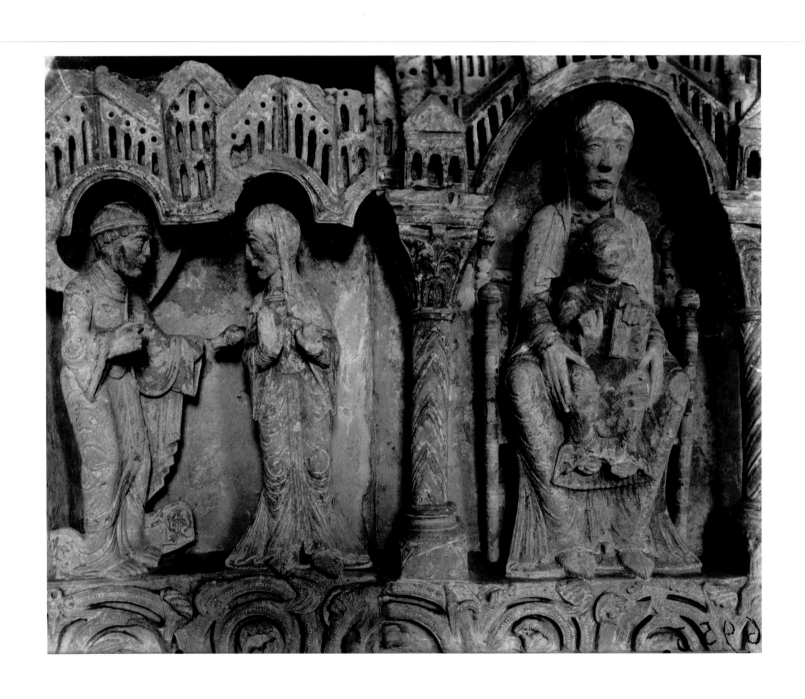

Pl. 68. Carrières-sur-Seine, retable, XIIᵉ siècle. Juillet 1921

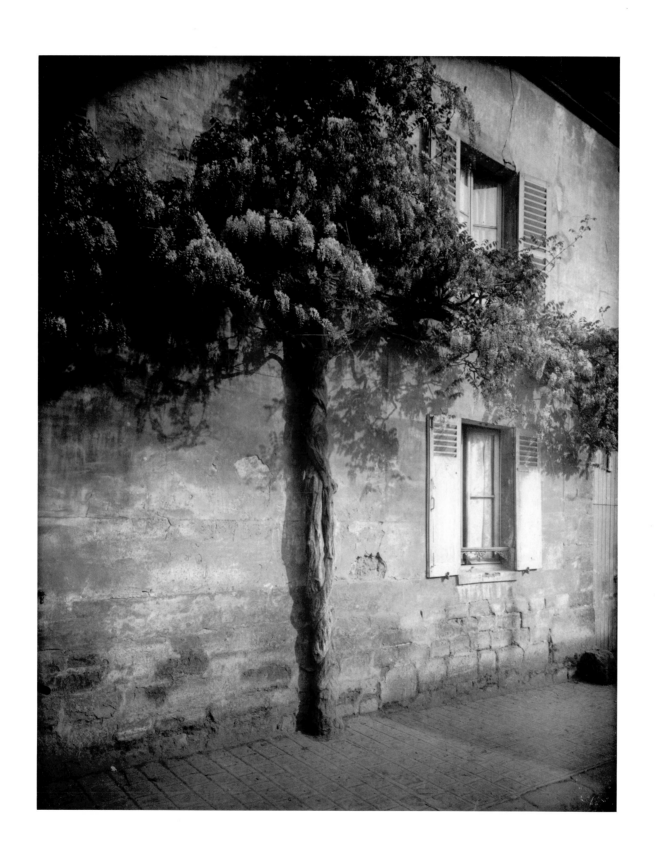

Pl. 69. Châtillon, glycine. (1919–21)

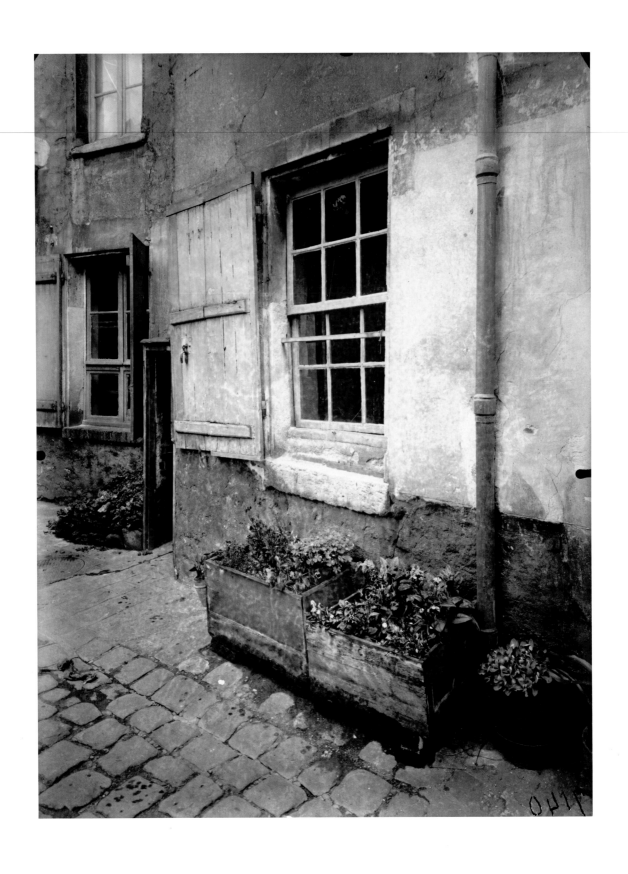

Pl. 70. Vanves, vieille cour. (1925–27)

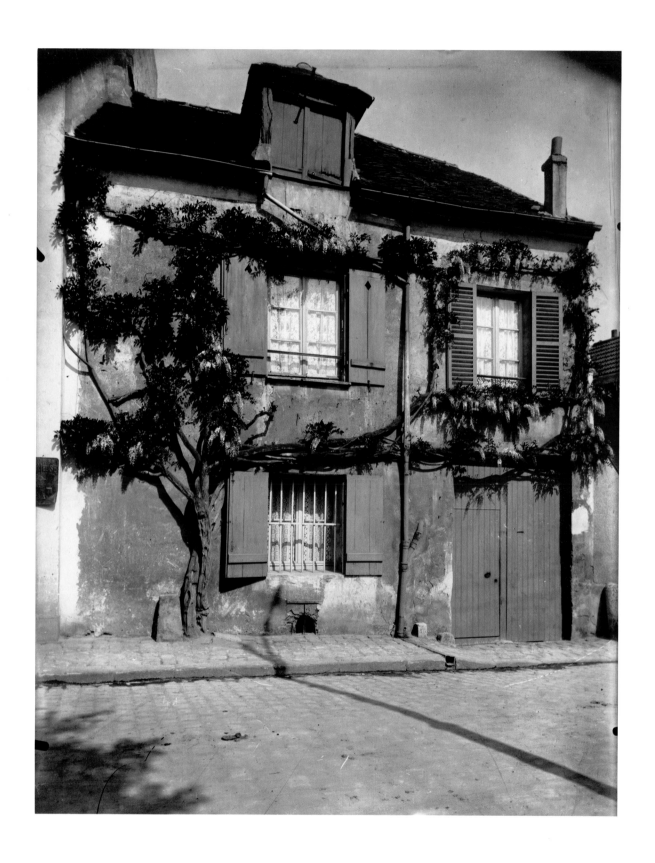

Pl. 71. Glycine. (1900–10)

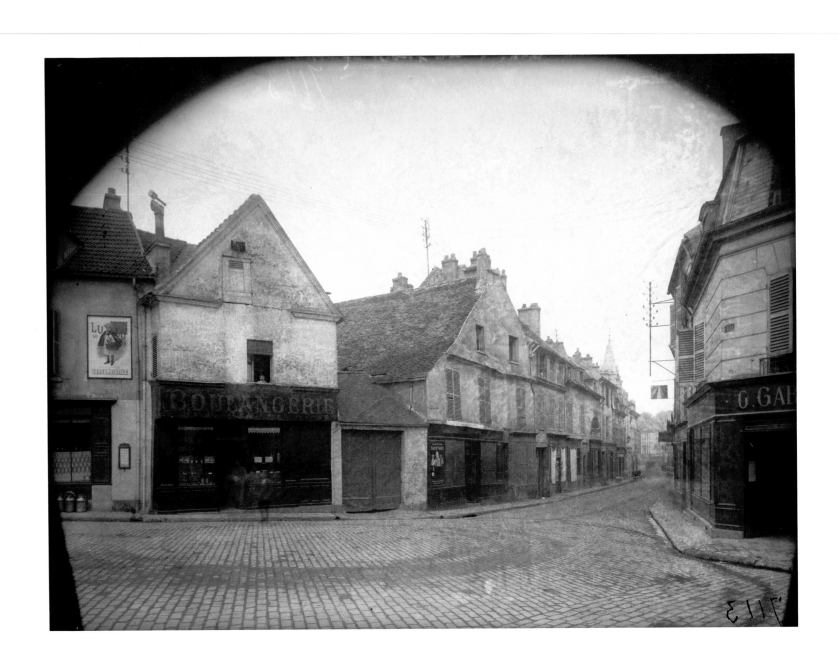

Pl. 72. Vitry, vieille rue. (June-July) 1925

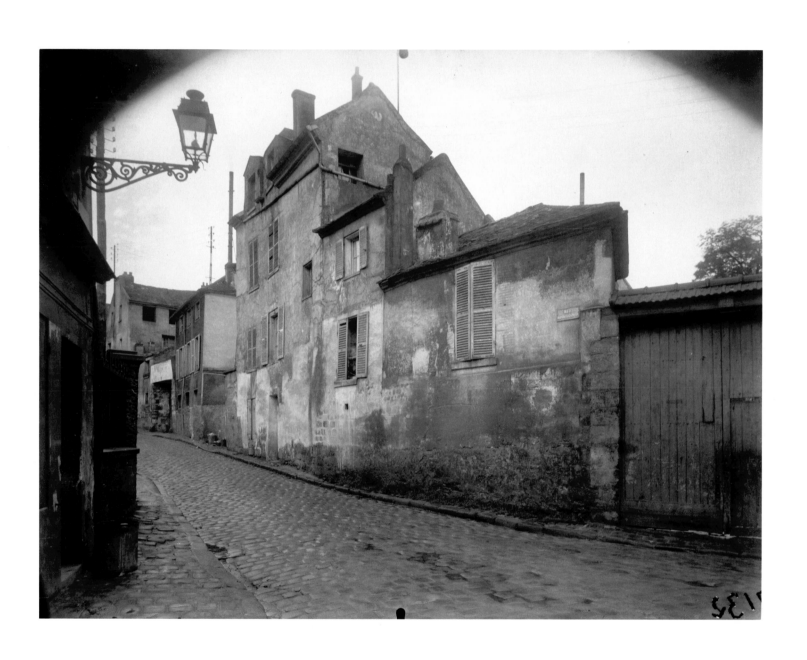

Pl. 73. Vanves, vieille rue. (1925–27)

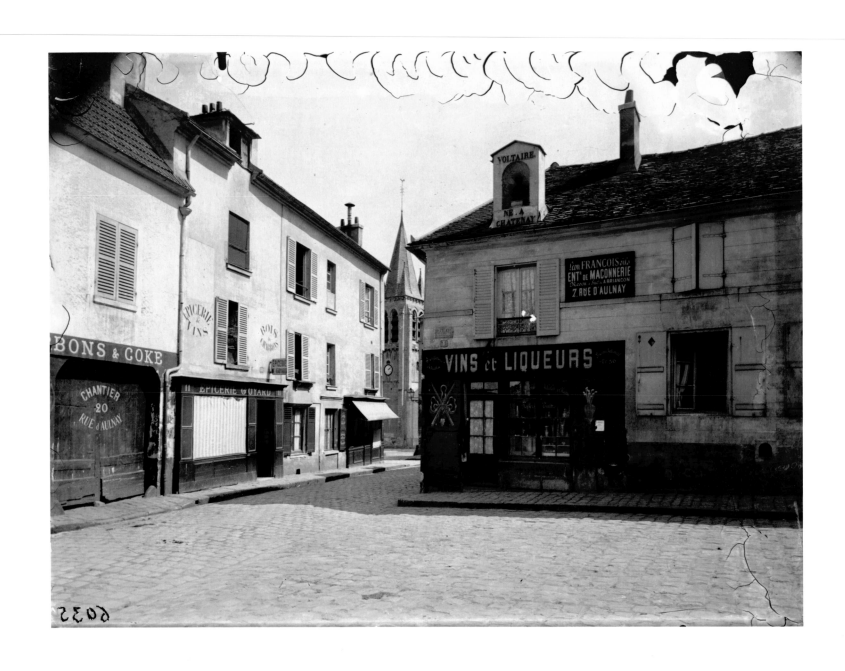

Pl. 74. Châtenay, place Voltaire, maison de Voltaire, né à Châtenay. 1901

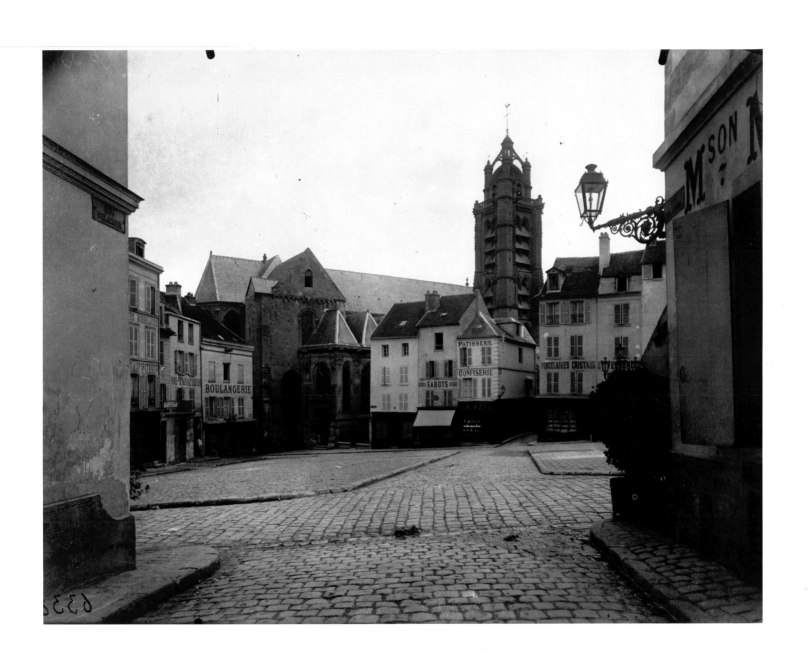

Pl. 75. Pontoise, place du Grand-Martroy. 1902

Pl. 76. Amiens, portail. Septembre 1921

Pl. 77. Arcueil–Cachan. (May–July) 1915

Pl. 78. Marly-le-Roi. (1922?)

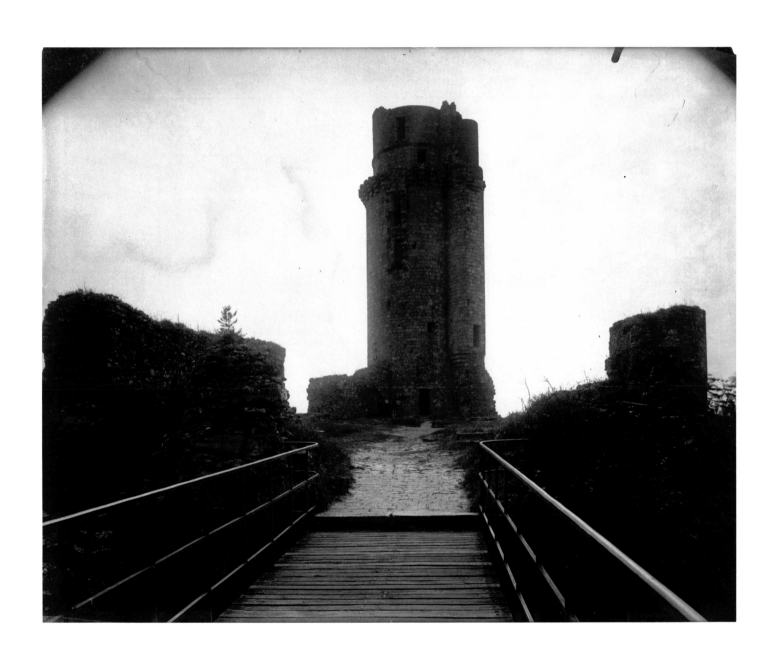

Pl. 79. Montlhéry. 1902

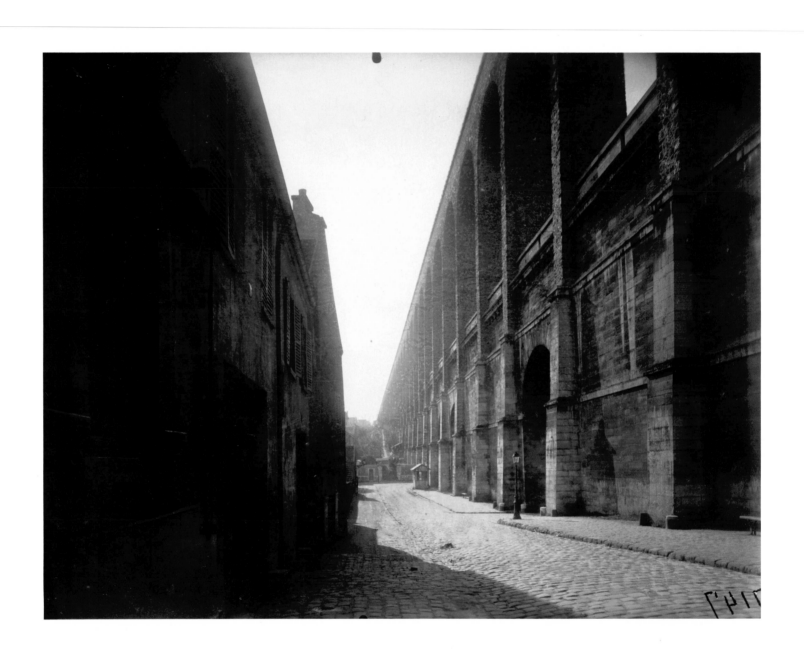

Pl. 80. Arcueil-Cachan. (*1925–27*)

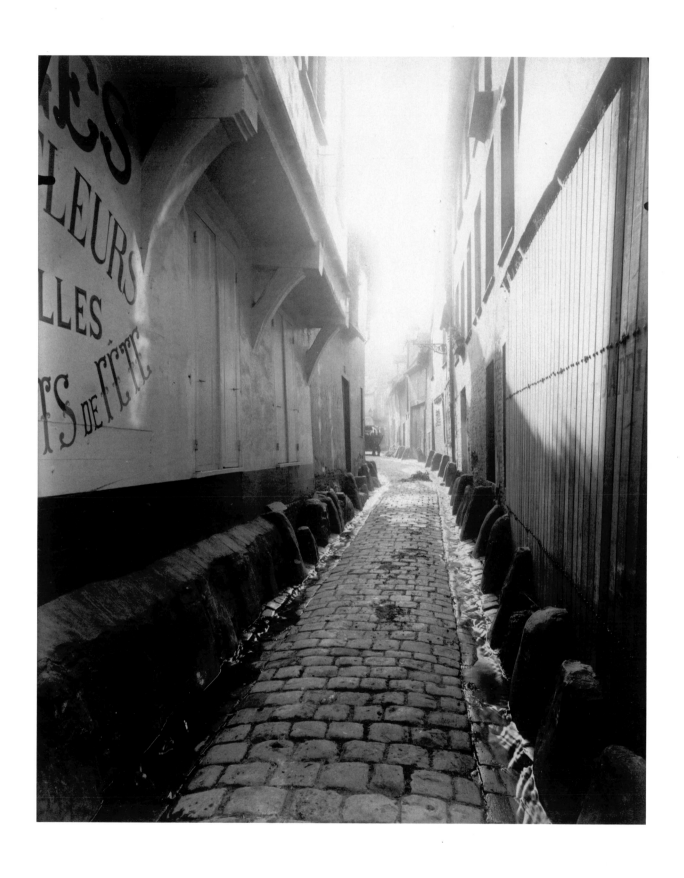

Pl. 81. Beauvais, ruelle Nicolas-Godin. 1904

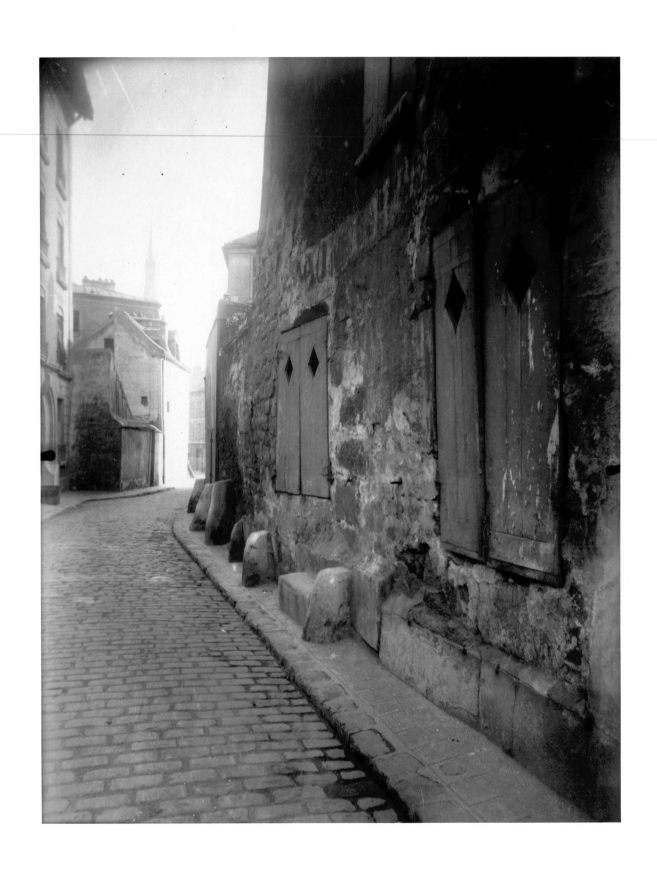

Pl. 82. Vanves, rue du Chariot. (1925–27)

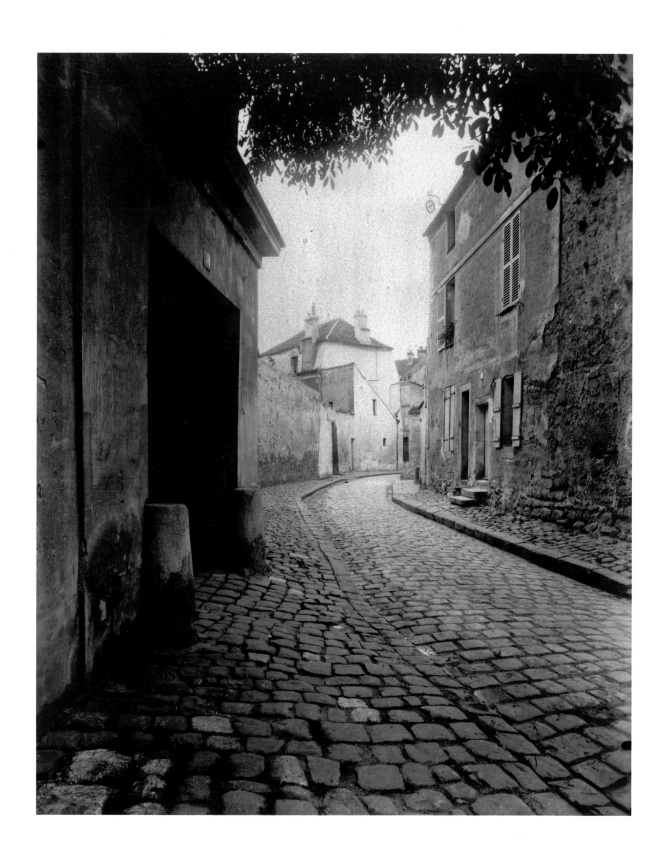

Pl. 83. Bagneux, vieille rue. Juin 1901

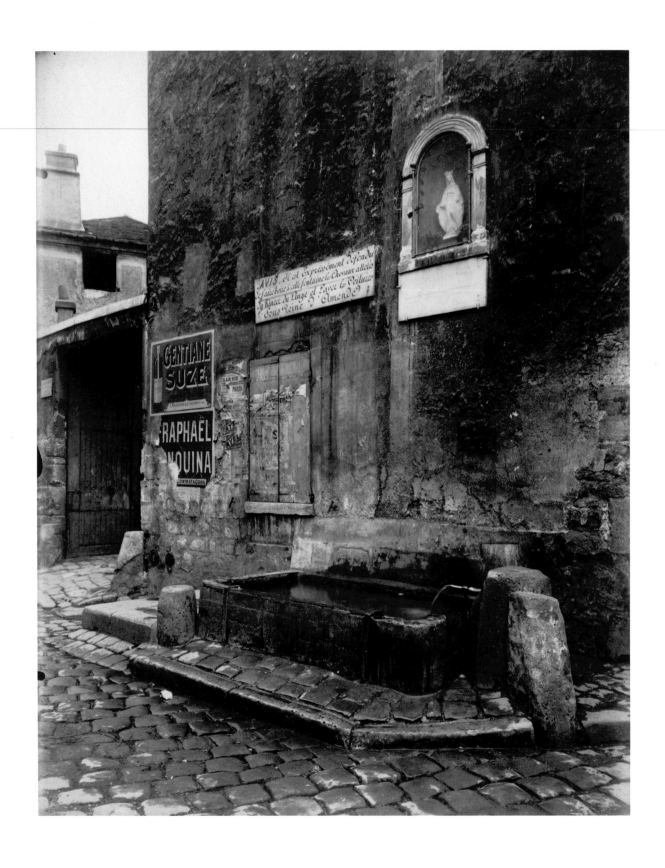

Pl. 84. Vanves, un coin de vieux Vanves. 1901

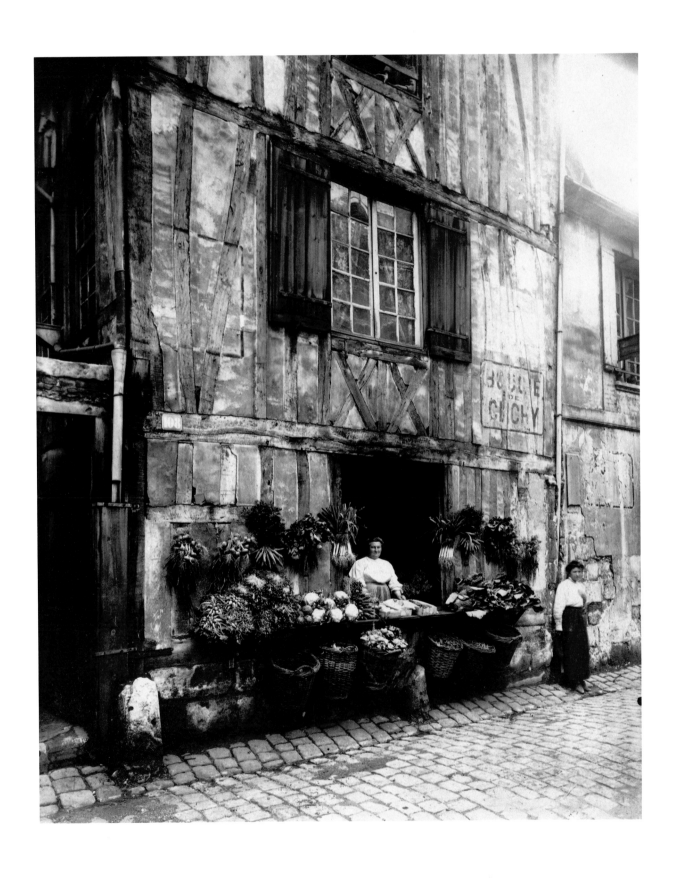

Pl. 85. Rouen. (1907?)

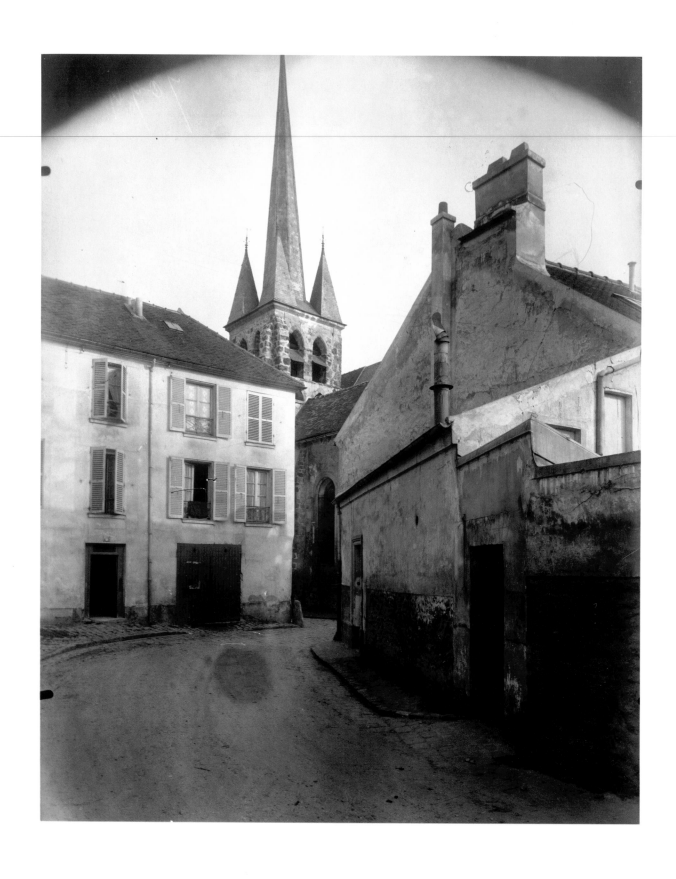

Pl. 86. Jouy-en-Josas, église. Juin 1925

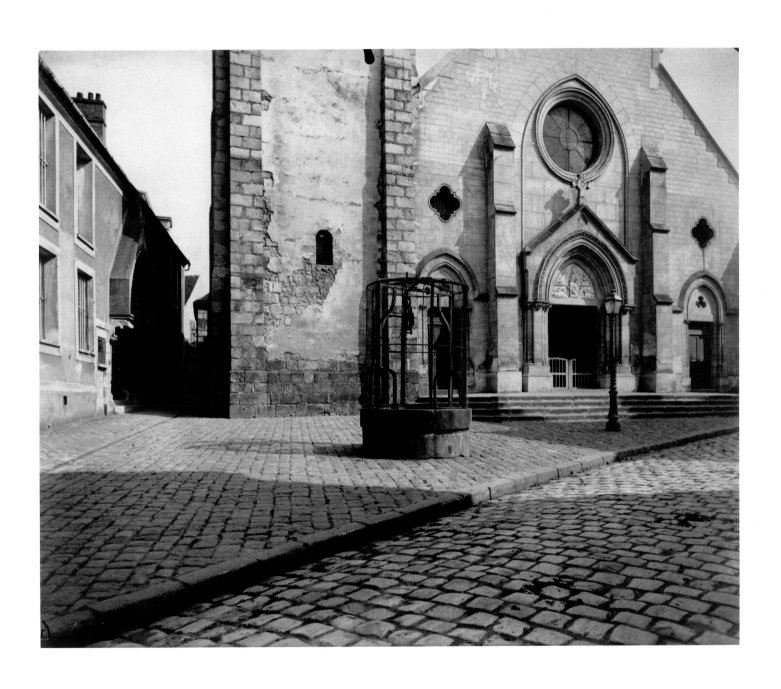

Pl. 87. Montlhéry, église, vieux puits. 1902

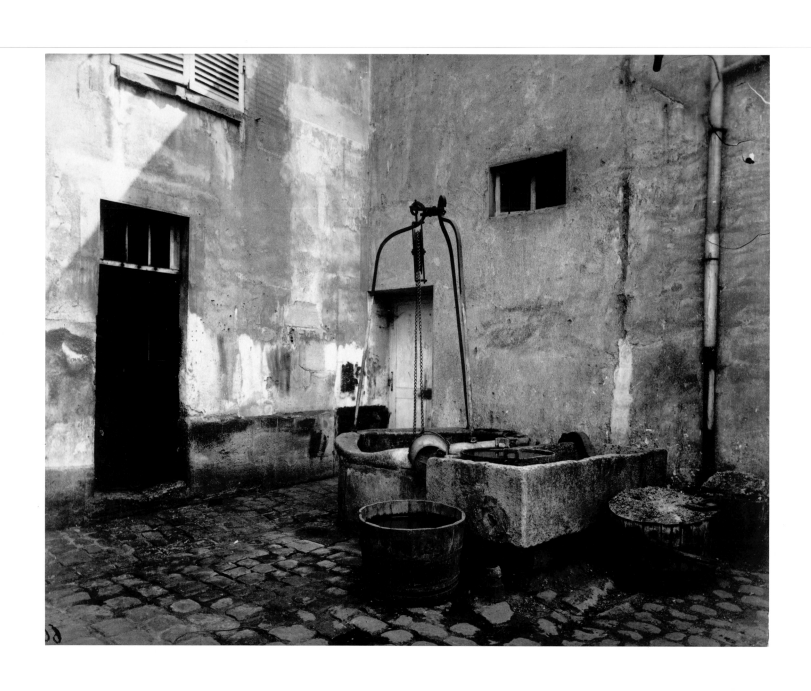

Pl. 88. Bourg-la-Reine, ferme [de] Camille Desmoulins. 1901

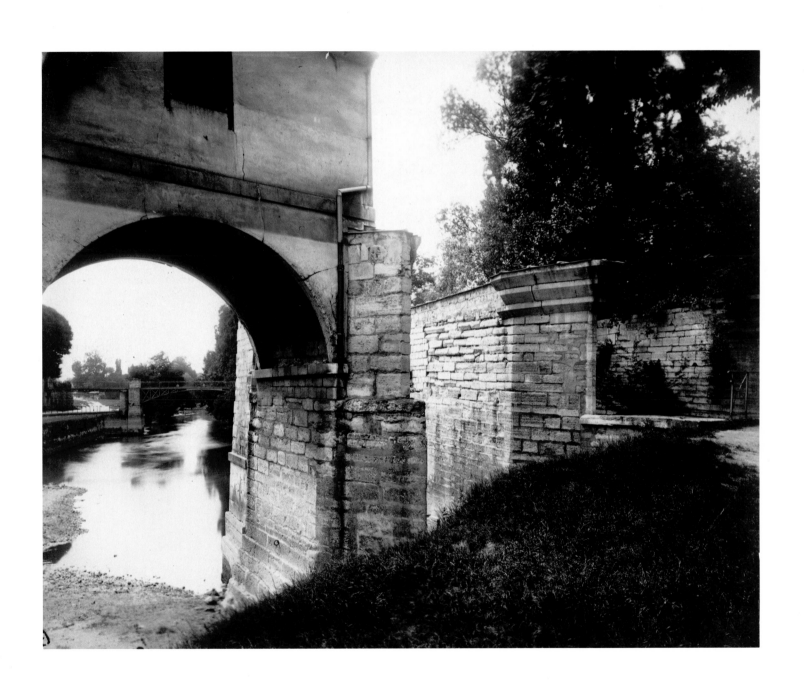

Pl. 89. Charenton, vieux moulin. (May–July) 1915

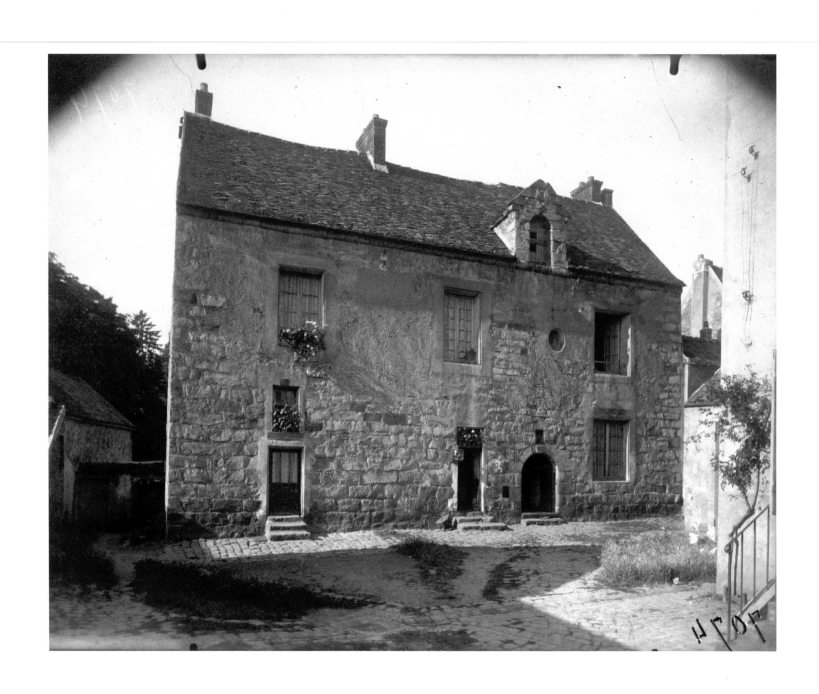

Pl. 90. Gif, vieille ferme. 1924

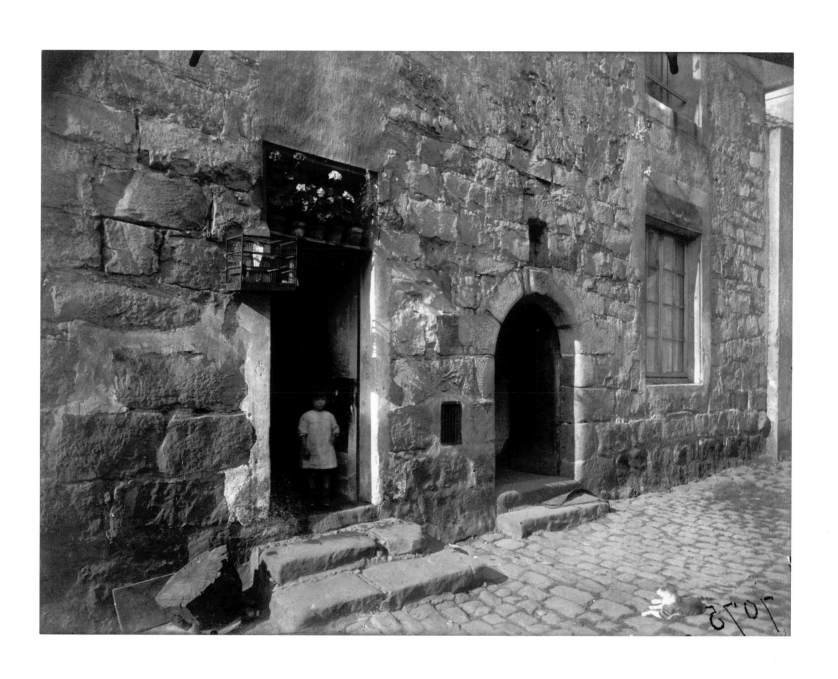

Pl. 91. Gif, vieille ferme. 1924

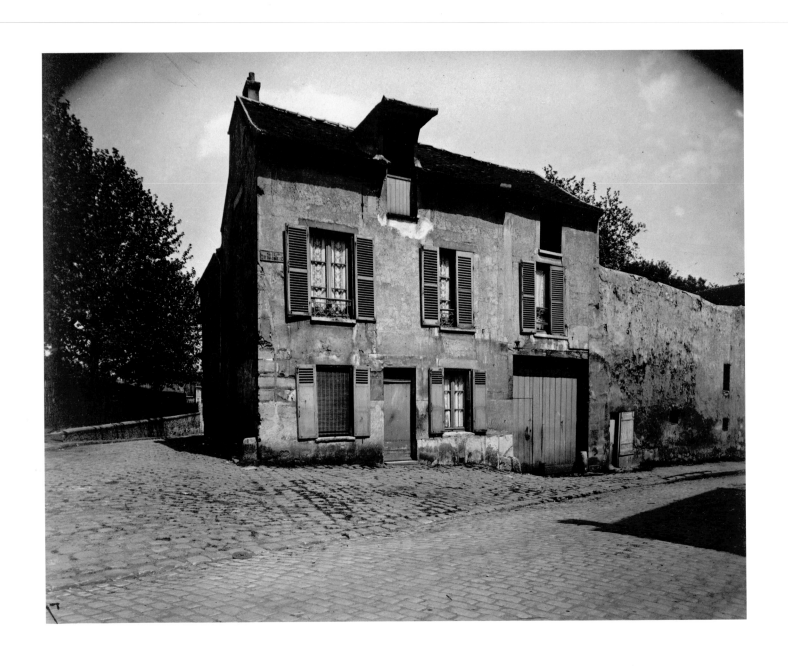

Pl. 92. Maison à Châtillon. (1915–19)

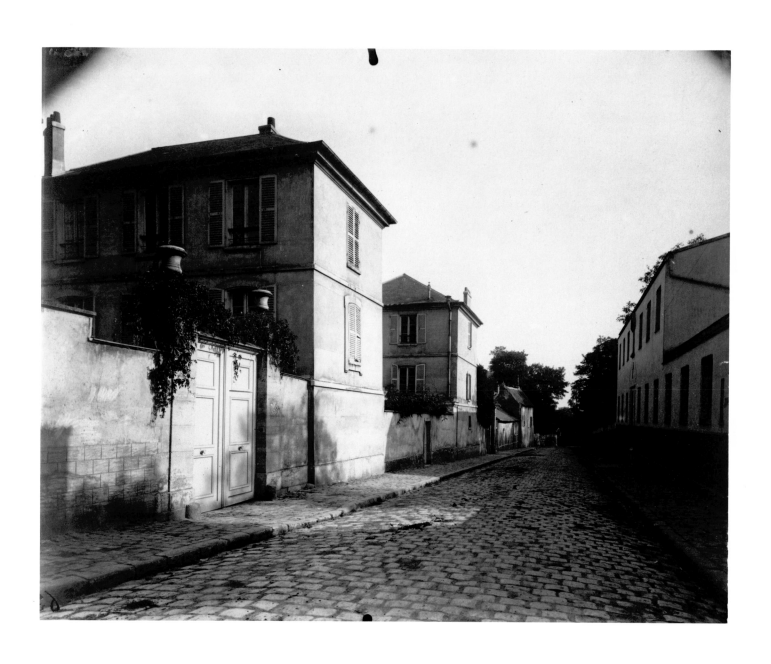

Pl. 93. Maison de Béranger, rue de Bagneux, Châtillon. 1901

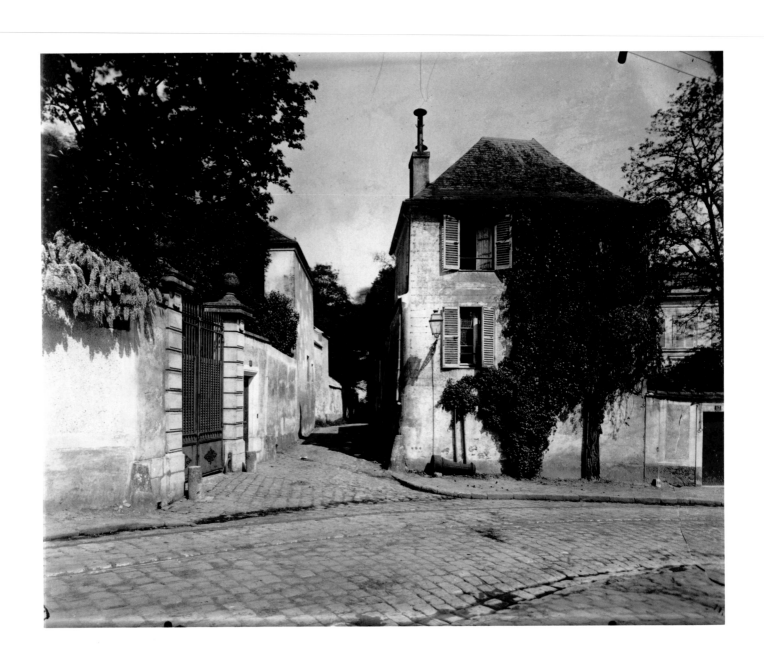

Pl. 94. Châtenay, un coin. 1901

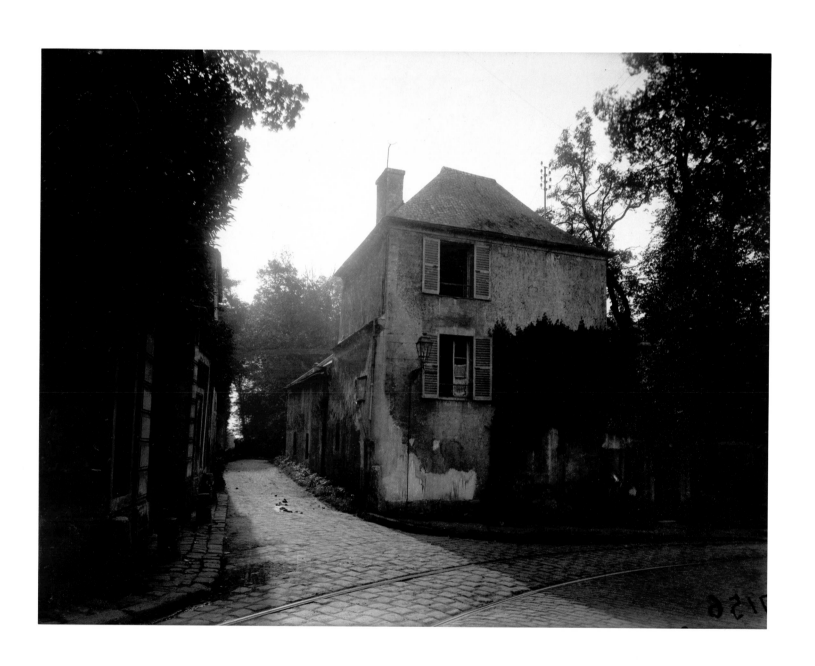

Pl. 95. Châtenay, vieille maison. (1925–27)

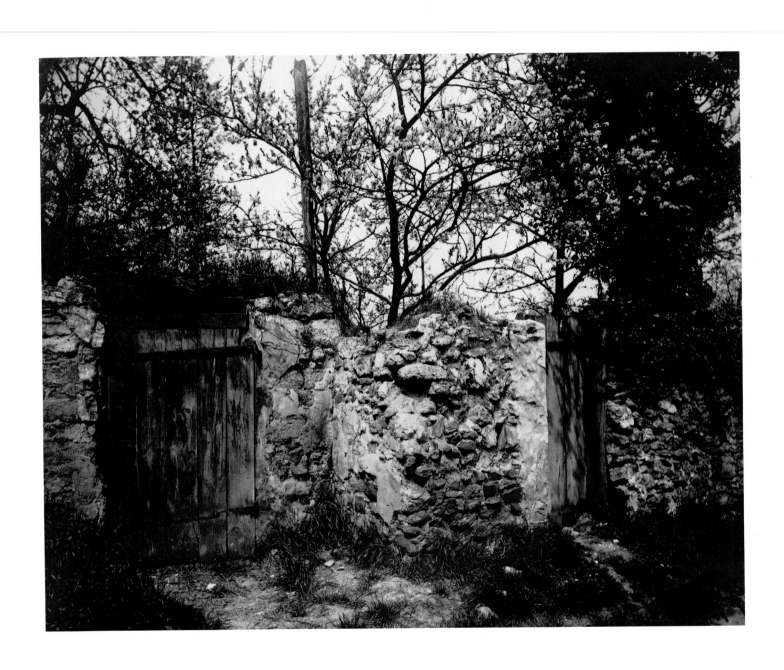

Pl. 96. Rue Perrotin. (1915–19)

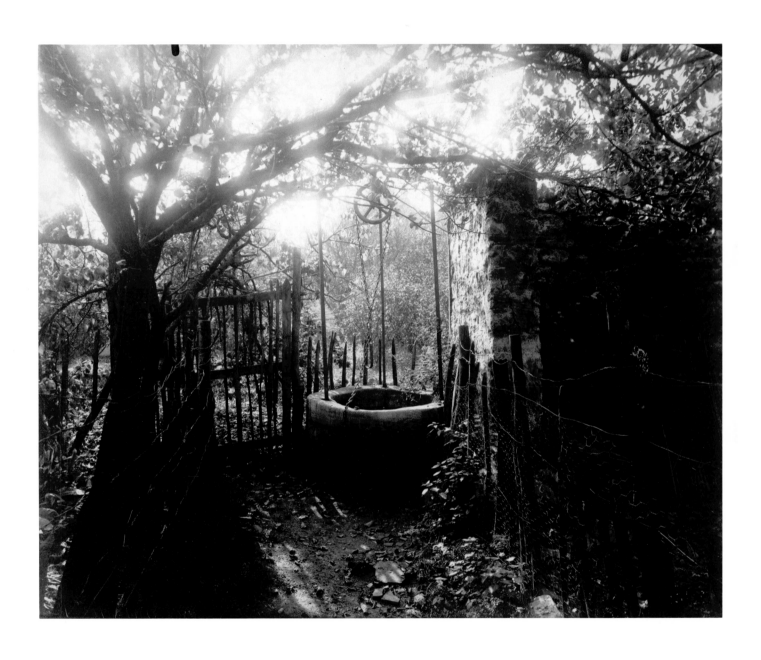

Pl. 97. Vieux puits, petit chemin, rue de la Gare, Châtillon. (October?) 1922

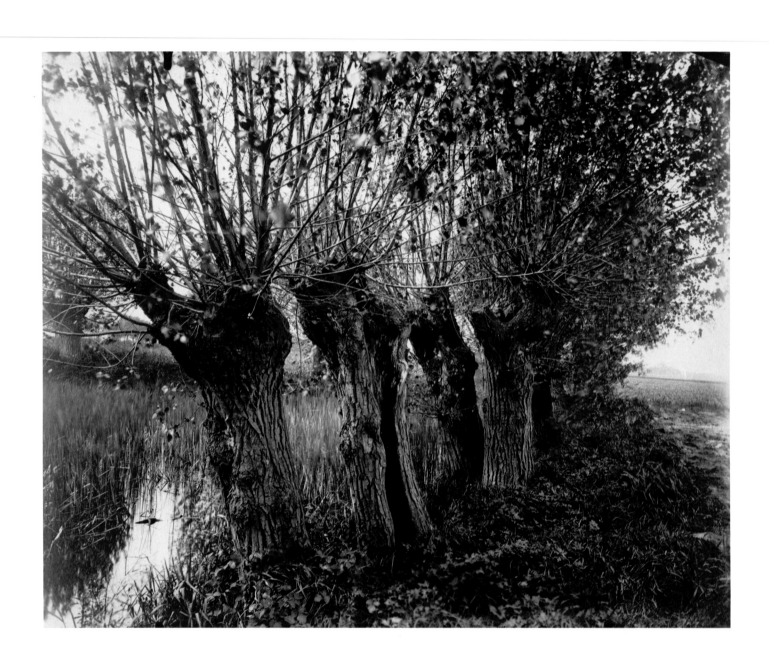

Pl. 98. Saules. (1919–21)

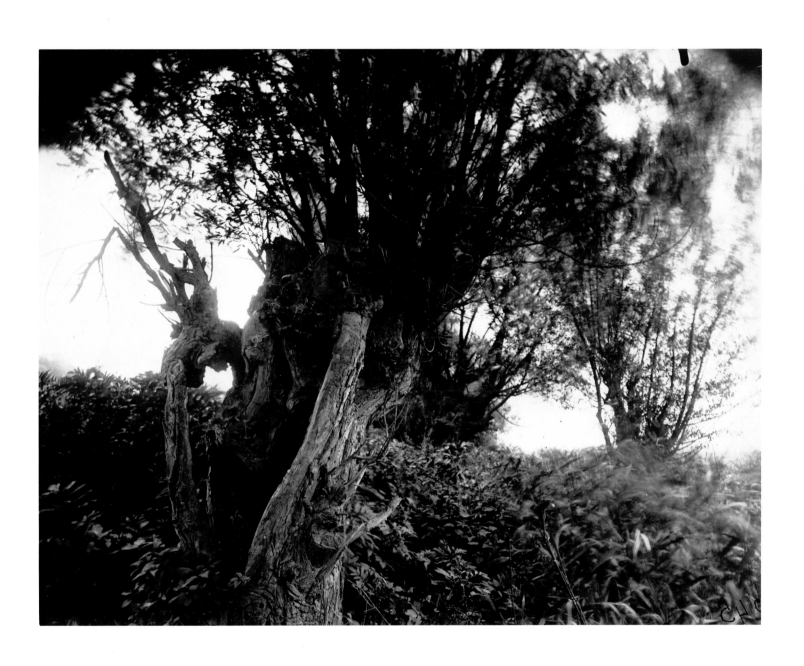

Pl. 99. Saules. (June–July) 1925

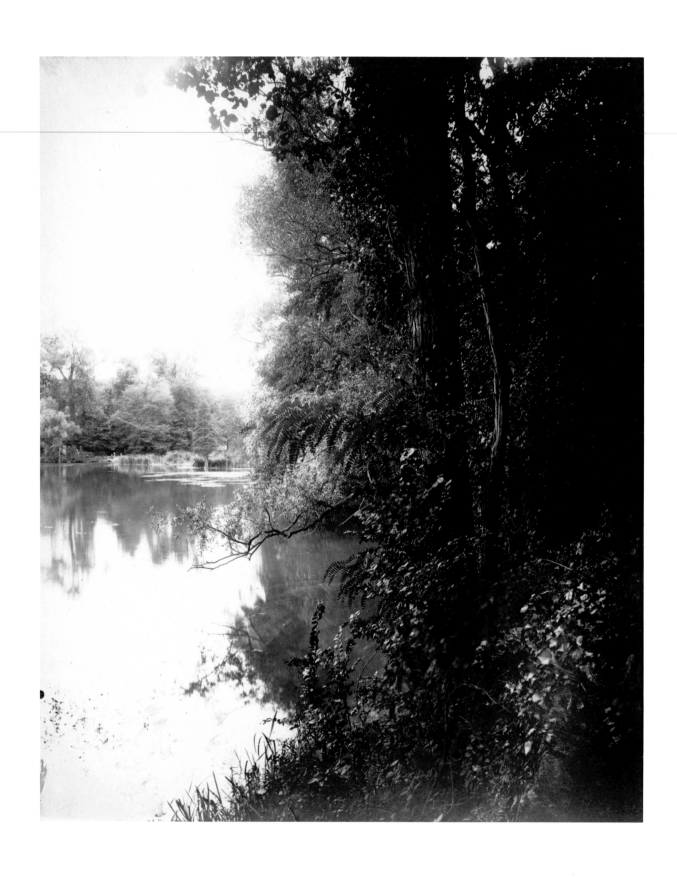

Pl. 100. Etang du Plessis-Piquet. (1919–21)

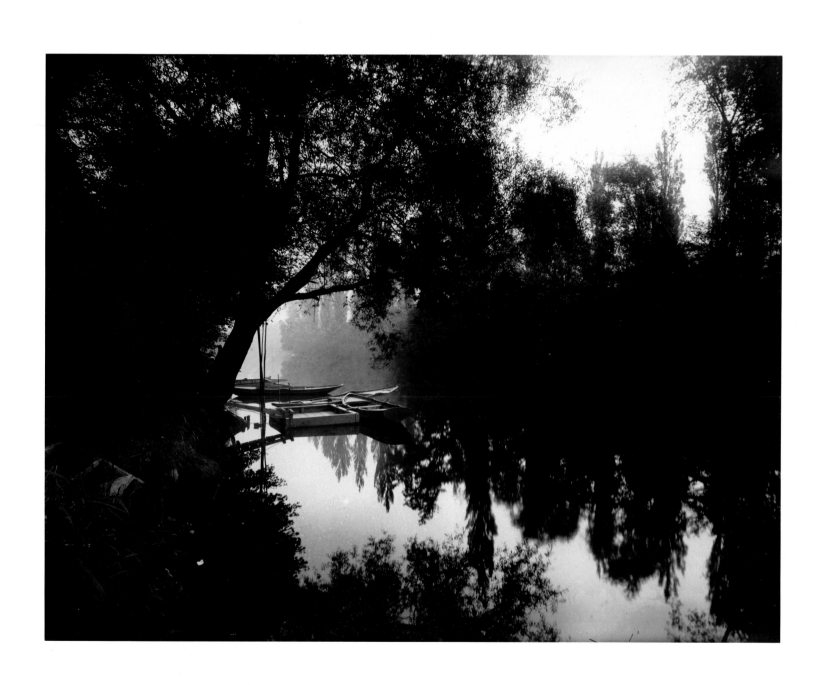

Pl. 101. La Marne à la Varenne. (1925–27)

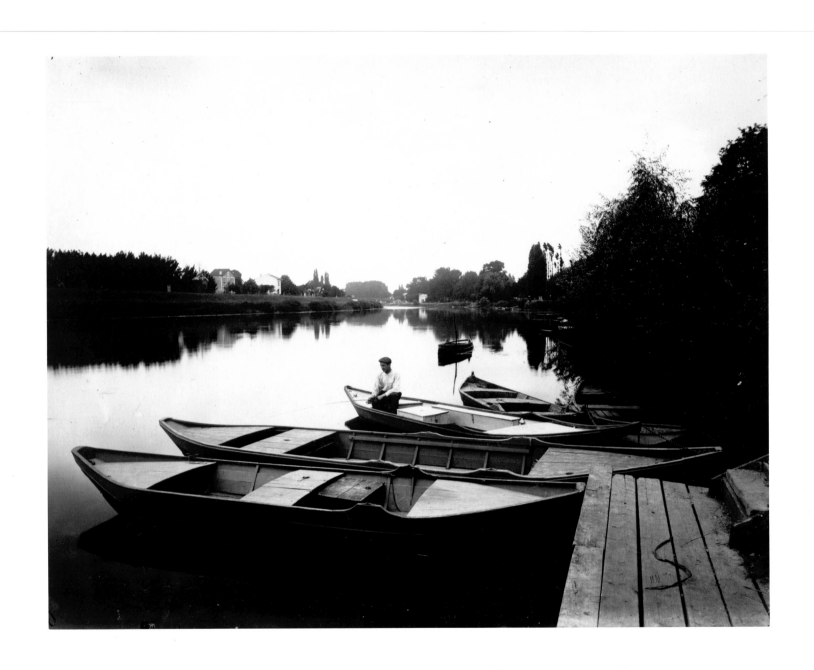

Pl. 102. Bords de [la] Marne. 1903

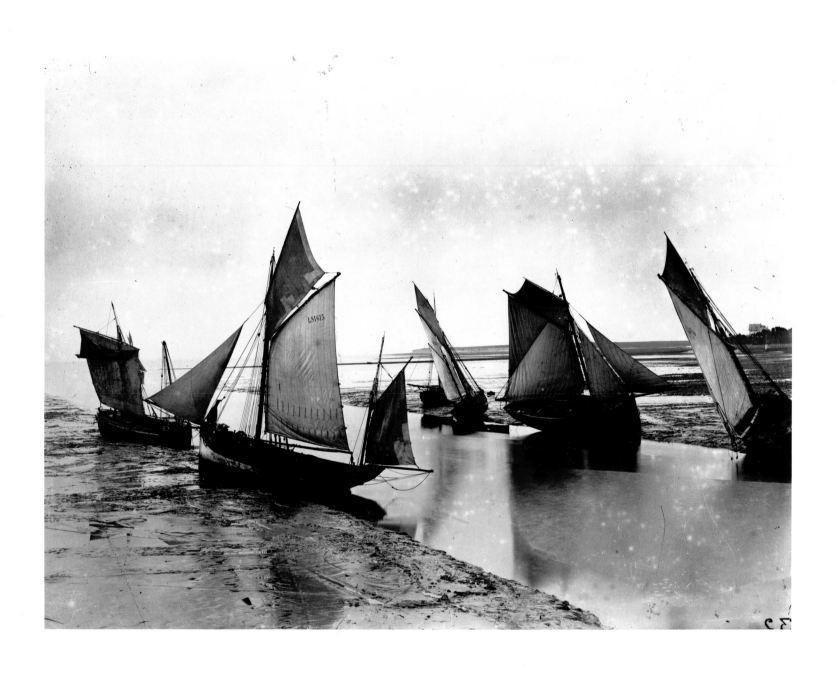

Pl. 103. La Rochelle. (1896?)

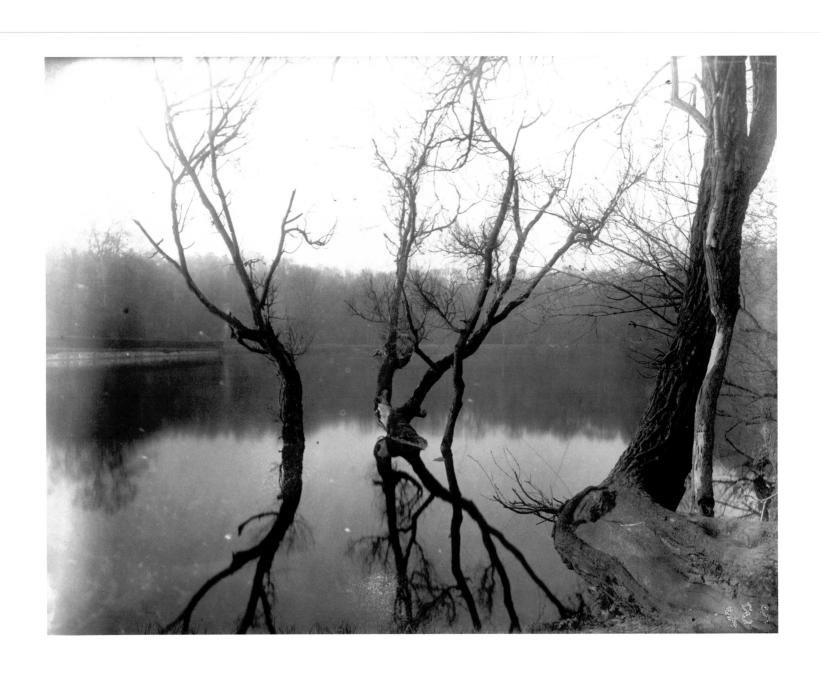

Pl. 104. Etang de Corot. Juin 1925

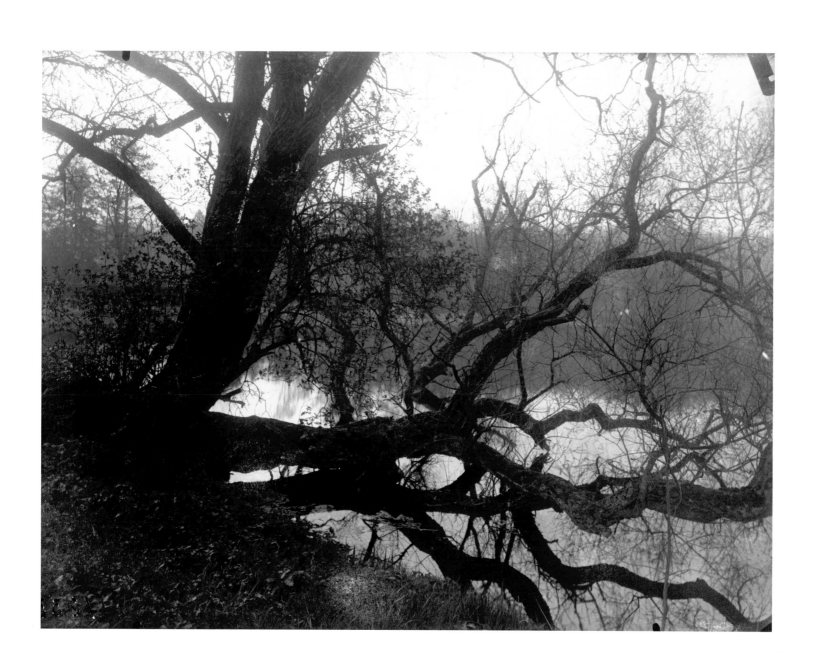

Pl. 105. Etang de Corot. Juin 1925

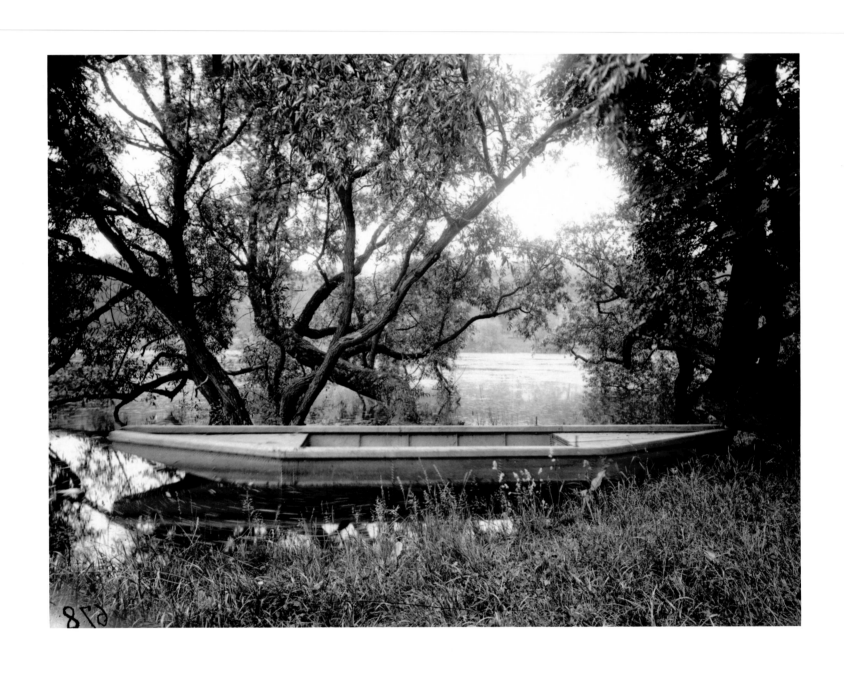

Pl. 106. Etang de Corot, Ville-d'Avray. (1900–10)

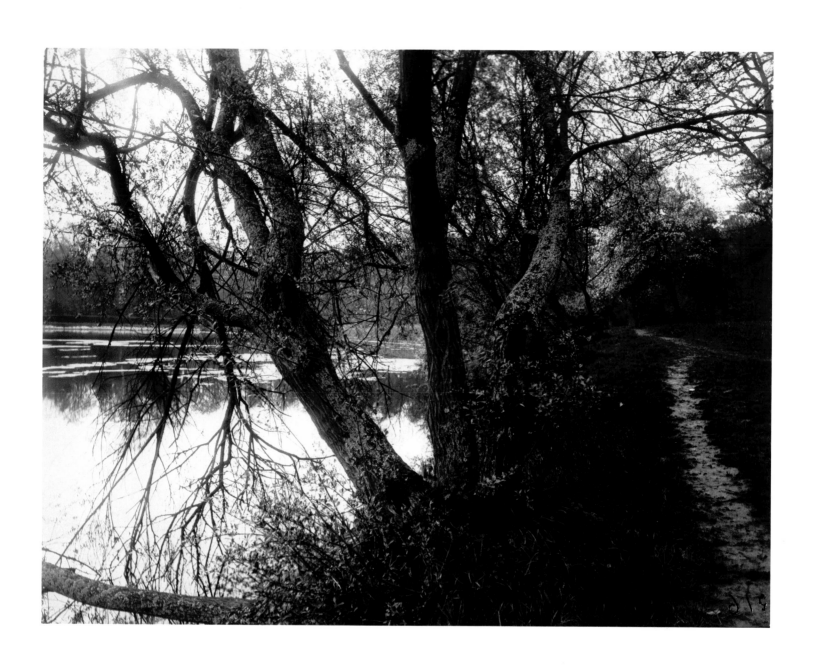

Pl. 107. Ville-d'Avray. (1923–25)

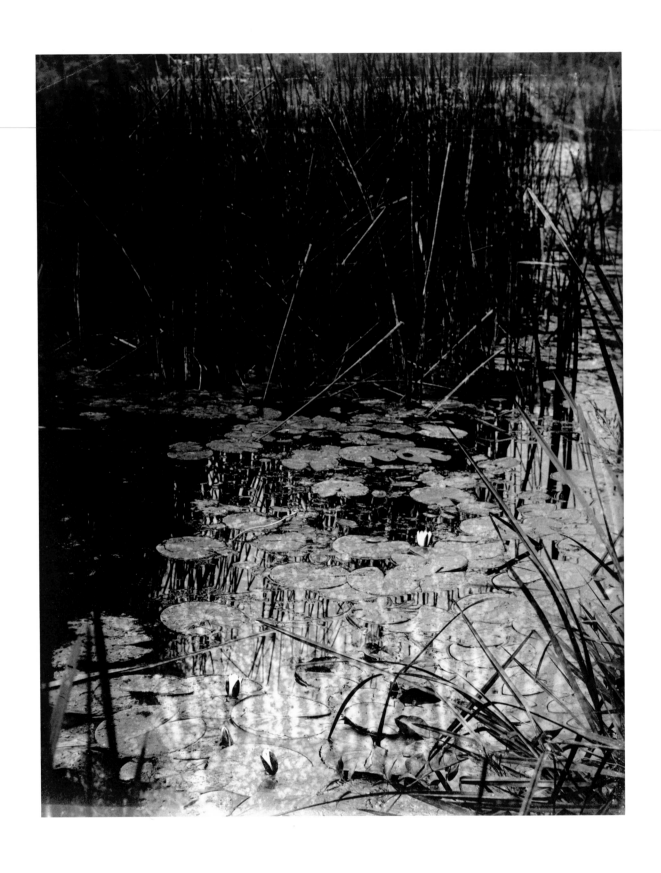

Pl. 108. Nénuphars. (Before 1900)

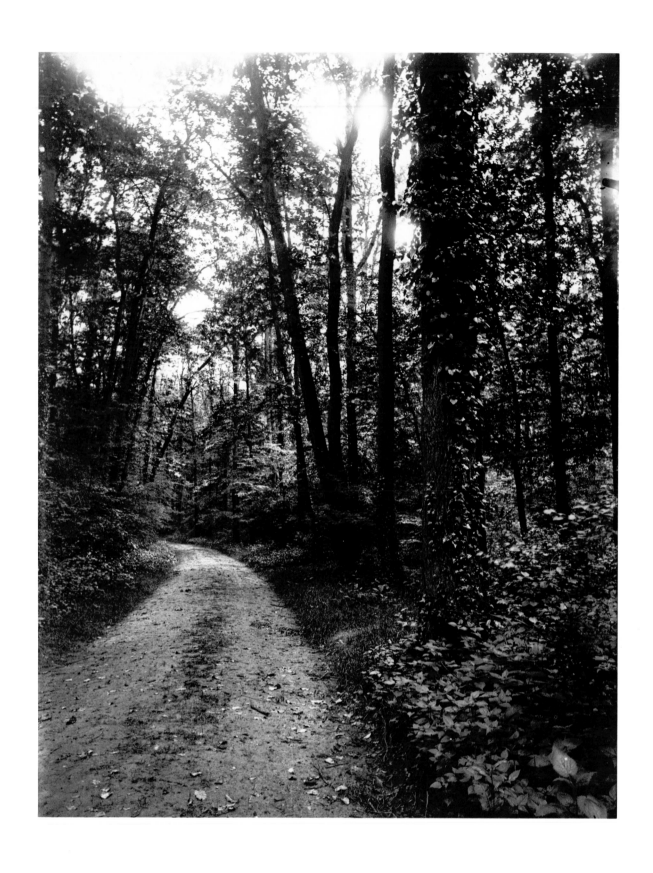

Pl. 109. Saint-Cloud. Mai 1923

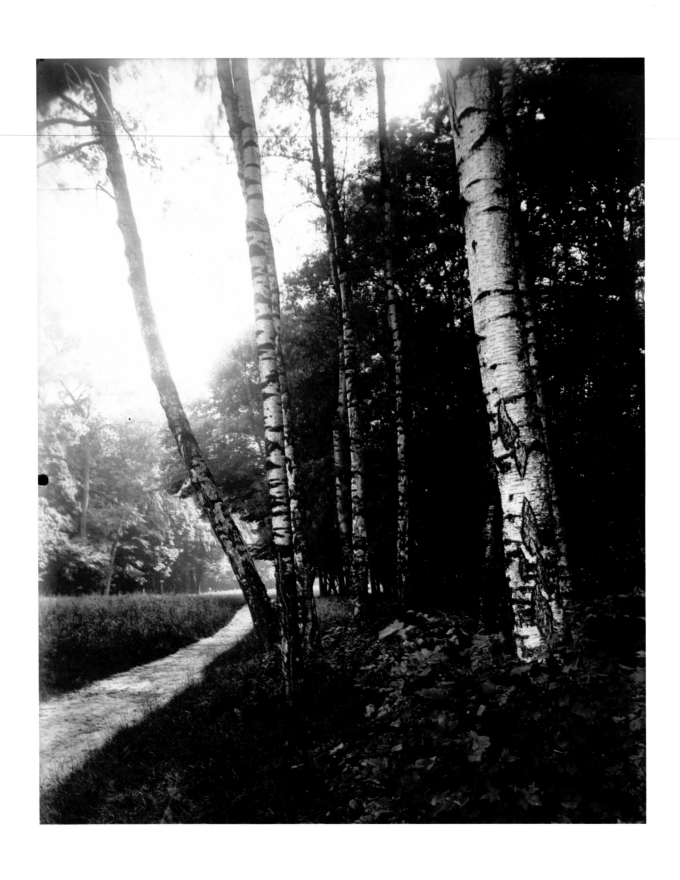

Pl. 110. Saint-Cloud. Juin 1926

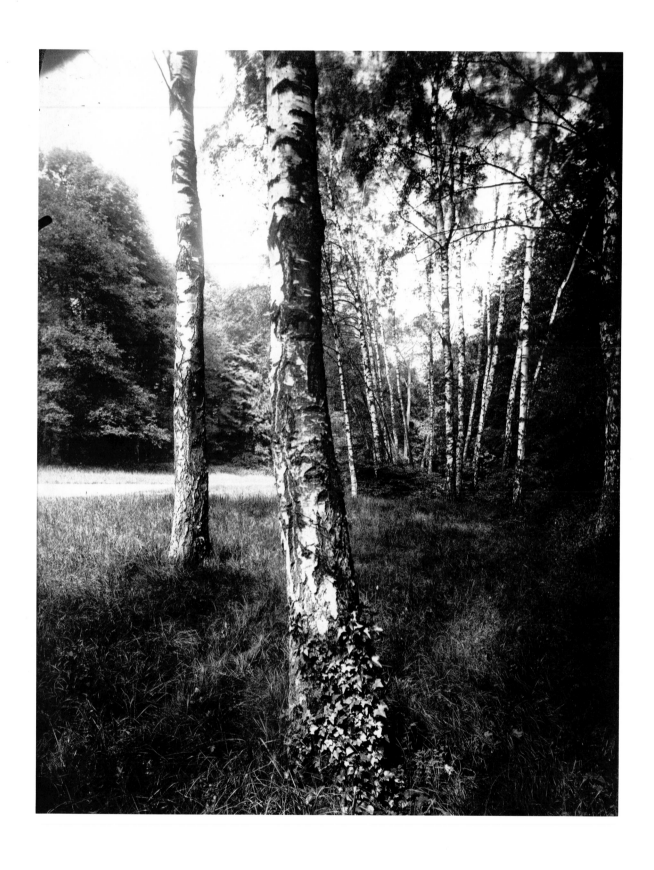

Pl. 111. Bouleau. (1919–21)

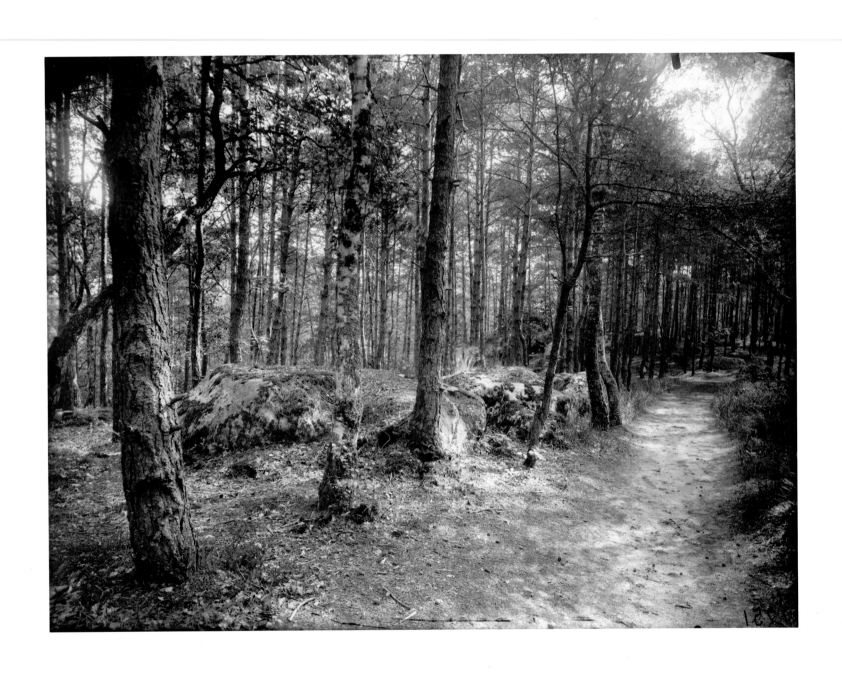

Pl. 112. Forêt, Fontainebleau. Juillet 1925

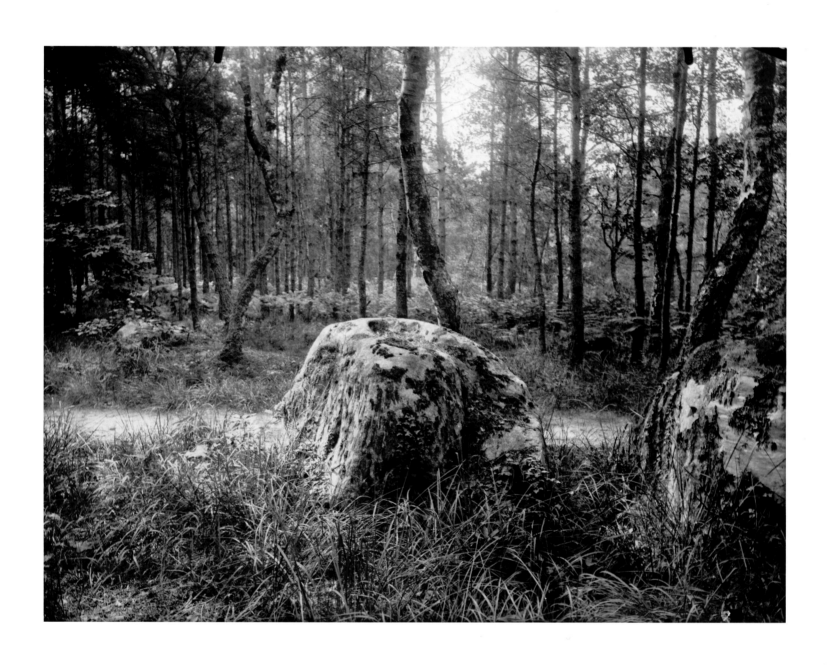

Pl. 113. Forêt, Fontainebleau. Juillet 1925

Pl. 114. Saint-Cloud. 1924

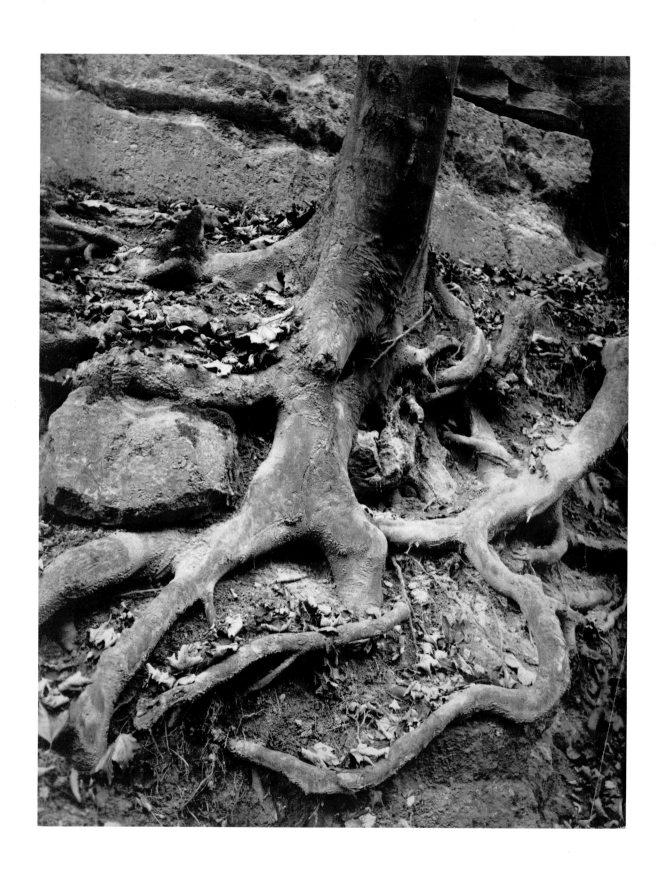

Pl. 115. Parc de Saint-Cloud. 1906

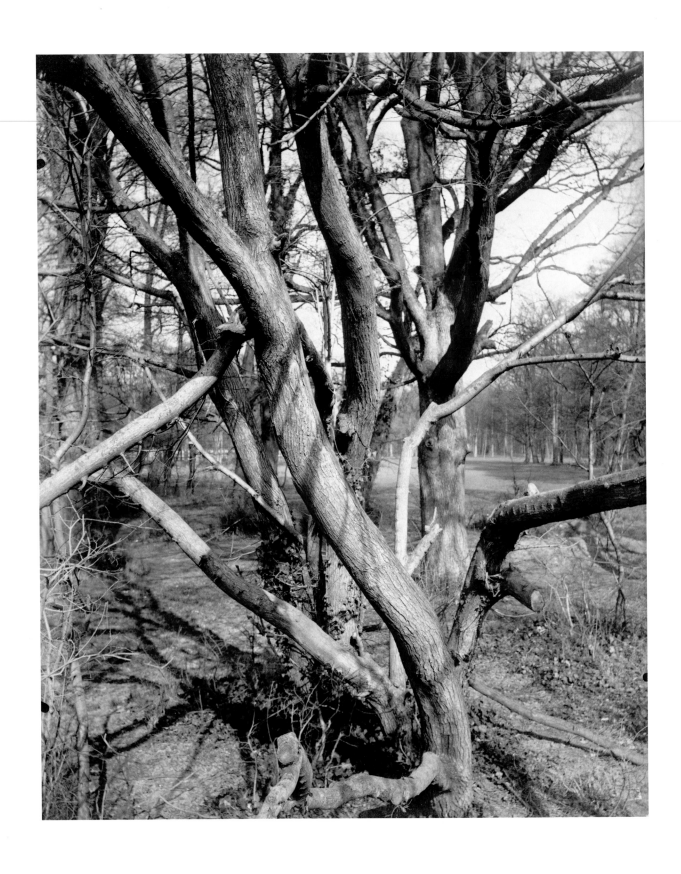

Pl. 116. Saint-Cloud. Mai 1922

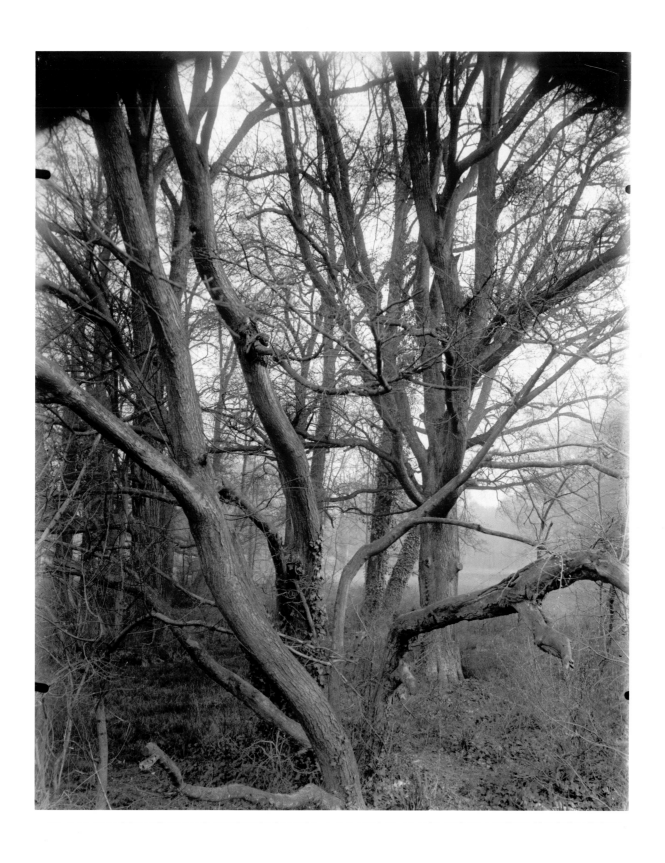

Pl. 117. Saint-Cloud. 9 h. 2 avril 1926

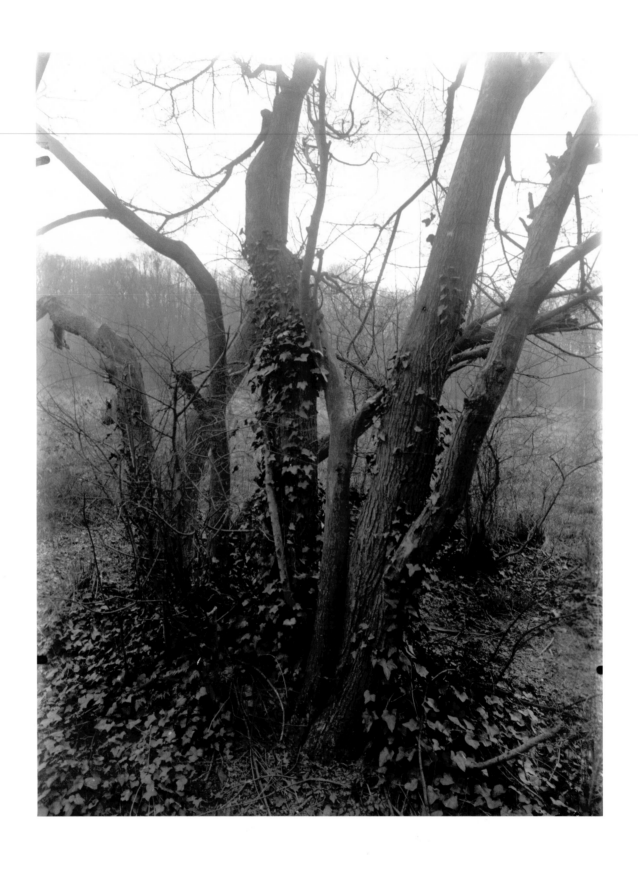

Pl. 118. Saint-Cloud. 1926

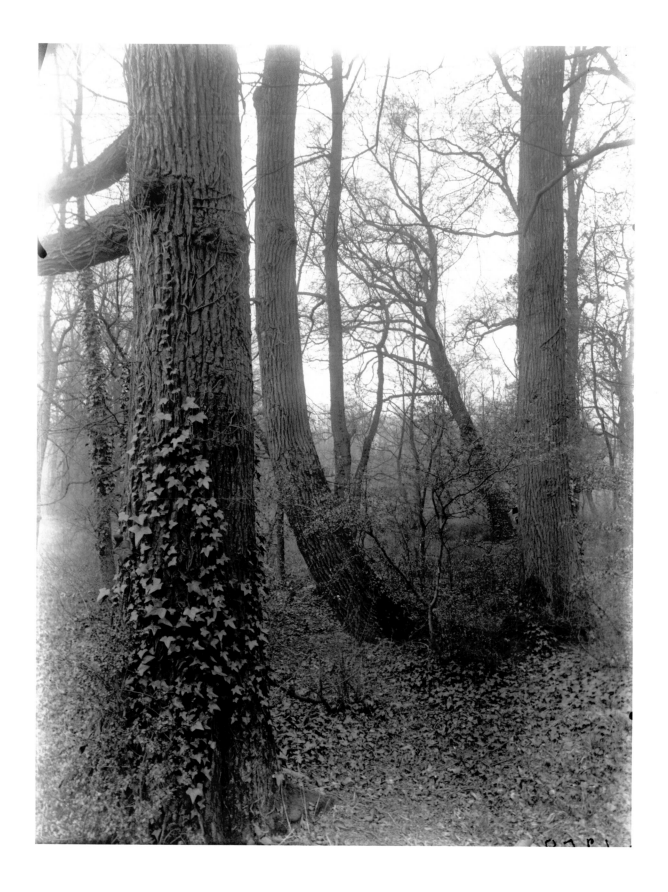

Pl. 119. Saint-Cloud. 1926

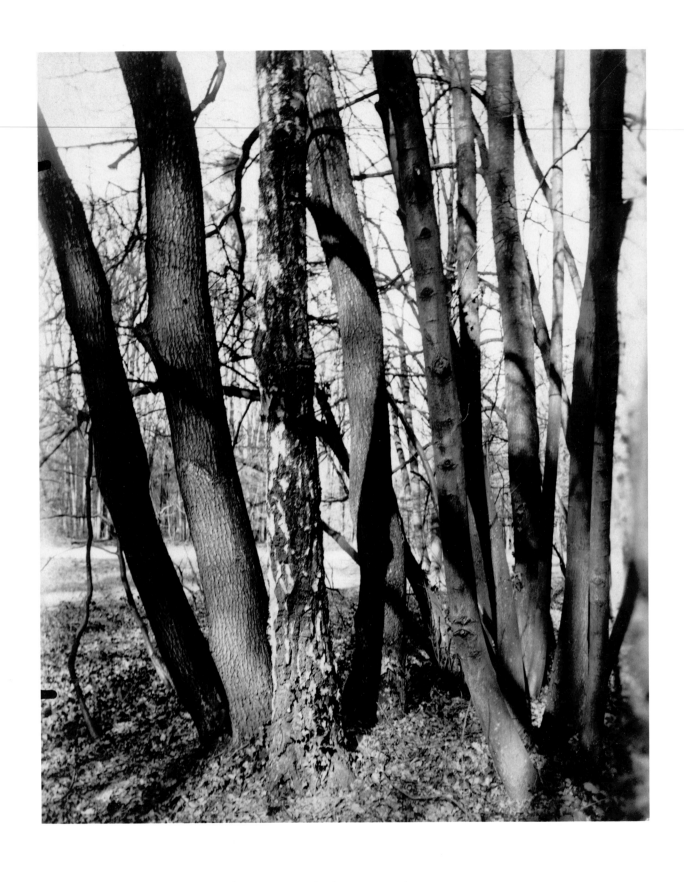

Pl. 120. Saint-Cloud. Fin mai, 7 h. soir, 1922

Notes

This, the first volume of *The Work of Atget*, represents a special section of Atget's oeuvre, his photographs of the countryside. Many of the pictures reproduced here have never been published or exhibited, and their collective subject, the rural foundation of French civilization, has never been recognized as a major theme in Atget's work. There are two principal reasons why this is so.

The first concerns the history of the pictures themselves. At Atget's death in 1927 the executor of his estate, André Calmettes, divided the work into two parts. He placed two thousand negatives in the care of the Commission des Monuments Historiques, the government agency that has administered the extensive archive of photographic negatives of the nation's artistic and architectural patrimony since the middle of the nineteenth century.* These negatives, together with others Atget had sold to the archive in 1920, have been conserved, printed, and recently exhibited and published.† Original prints from these negatives apparently were not donated to the archive, but over the years, as Atget had taken the pictures, he had sold large numbers of prints from these same negatives to various public collections, museums, and historical libraries. Therefore both the prints and the negatives of art and architecture have been accessible to the public, at least the French public, for half a century. However, Atget's photographs of the countryside—of flowers, trees, rivers, and farms—were not collected by these institutions, nor was the Monuments Historiques interested, evidently, in acquiring the negatives of such subjects. If Atget had a clientele for these pictures, it must have been largely private (since the pictures do not appear in the public collections), and probably quite heterogeneous, for the pictures might have appealed to artists, illustrators, and craftsmen of the various branches of the decorative arts. It was unlikely that Calmettes could find anyone within that group of former clients who would conserve the collection intact, and since there was apparently no archive interested either, he packed up the negatives (at least thirteen hundred) and all the original prints left in Atget's studio (approximately five thousand different pictures) and put them aside temporarily. Except for the stray prints that turn up in artists' albums from time to time,‡ the prints and negatives of the countryside might have dropped out of circulation altogether if Berenice Abbott had not had the foresight to find Calmettes and persuade him to let her buy the remainder of the estate in 1928.

During the ensuing forty years Miss Abbott brought Atget's work to the attention of a wide audience through articles, exhibitions, and books. As a working photographer, not a professional curator, she had neither the funds nor the time required to catalog the pictures, print the negatives, and realize her vision of a comprehensive publication project. Since she could not make the total collection visible, she selected from its riches, and while she chose some of the pictures reproduced here, many more of them necessarily remained in storage. Now, with the considerable benefits of a clearly cataloged collection and the time to study it, we can see that Atget's interest in the countryside was a broader and fuller commitment than previously was evident.

The second reason we may be unfamiliar with much of this work is correlative to the first: Atget has always been considered a photographer of Paris. Indeed, there is no doubt that Paris was his primary focus, and for that reason as well as for the quality of the pictures, there are two volumes in *The Work of Atget* whose subject is the city (volumes II and IV). However, long before his interest in Paris emerged, Atget was photographing in the countryside. This impulse ran deep beneath the whole of his long career.

It has been said of nineteenth-century Parisians that they all had one foot in the country. Although he assumed a professional identity as a specialist in views of Paris, Atget seems to fit the description. He was not born a Parisian. After he moved permanently to the capital around 1897 he made frequent excursions into the country, despite the physical effort and financial burden these trips entailed.§ It is evident from the work that Atget was not, like the typical urban citizen of his day, escaping the city for an occasional Sunday afternoon in the woods; on the contrary, his knowledge of the back roads and of the rhythms and traditional values of rural life suggest a real intimacy with the countryside. Not only did he revisit many of the sites, as the following notes illustrate, but after the war, when it appears that he was working more consistently for his own satisfaction, he made just as many photographs in the country as he did in

*It is likely that Atget directed Calmettes to offer the collection to the Monuments Historiques, since he had had earlier successful dealings with the agency. However, it is not clear whether Atget, Calmettes, or the Monuments Historiques selected the two thousand pictures for that archive. Furthermore, neither Calmettes's accounts nor the records of the Monuments Historiques make clear whether the negatives were donated or purchased.

†The original official count of the negatives is 4,621. Recent books published with selections of Atget's photographs from this archive are: Jean Leroy, *Atget, magicien du Vieux Paris* (Joinville-le-Pont: Pierre-Jean Balbo, 1975); Alain Pougetoux and Romeo Martinez, *Eugène Atget photographe, 1857–1927* (Paris: Musées de France, 1978); Klaus Honnef (ed.), *Eugène Atget (1857–1927): das alte Paris* (Cologne: Rheinland-Verlag, 1978); *Atget: Voyages en ville* (Paris: Chêne/Hachette, 1979, and Tokyo: Asahi Shimbun Publishing Co., 1979); Romeo Martinez, *Eugène Atget* (Milan: Electra Editrice, 1979); William Howard Adams, *Atget's Gardens* (Garden City, N.Y.: Doubleday, 1979). An exhibition of prints made by Pierre Gassmann from the negatives in the archive opened in Paris in 1977 and has circulated in France and abroad.

‡For instance, the Philadelphia painter Milton Bancroft acquired several of Atget's photographs when studying in Paris just before the turn of the century. They are pasted into his album of prints and reproductions, now in the collection of Daniel Wolf, Inc., New York.

§In a letter to the Victoria and Albert Museum, London, dated March 28, 1903, Atget pointed out that he charged more for photographs made outside Paris because they cost more to make and because there was not much demand for them. "J'espère, Monsieur, que ce prix n'est pas exagéré, étant donné les frais que comporte une collection en dehors de Paris et surtout (*malheureusement*) avec un debouché très restreint." (Copy of letter in Atget Archives, MOMA.)

the city.* Since it was evidently his own choice to work in rural sections, his motivation might be attributed to his interest in the subject matter, his assessment of the artistic opportunities it afforded, or a deep-seated personal pleasure in the natural world and village life—or, as seems likely, some combination of all these reasons.

This part of Atget's sustained investigation of French civilization deals with the roots of the nation as revealed in the ancient aspects and traditions of the countryside—there, still vital vestiges of "La Vieille France" had continued the past into the present. Atget depicted a people who live conservatively and close to the earth, upholding time-honored rustic virtues. Their society is not convivial and communal, but insular, self-sufficient, and essentially private. Almost everything is manifestly inward-oriented: villages congregate around churches in close medieval patterns; villagers are encountered in courtyards inside or behind their houses; even the gardens are closed off behind fences and walls. There are few town halls, schools, post offices, or war monuments,† for Atget's Old France is not a political unit; it is a timeless way of life, and its people are governed not by decree, but by centuries of local custom and by the cycles of the seasons. The gentle, fertile land has accepted cultivation and supported civilization gracefully; the Frenchman in turn has treated the countryside with respect and embellished it with taste. This history of mutual accommodation is perhaps the fundamental condition of Atget's Old France.

Although several early photographs were made in Picardy (see note to plate 6), most of the photographs in this volume were made in the Ile-de-France, a roughly circular region in north-central France with Paris at its center. This area was the cradle of the French monarchy, and the geographic center around which the other provinces coalesced to make the modern nation. In photographing the Ile-de-France, therefore, Atget was not studying an eccentric region, but the original French heartland, the one region able to represent the country as a whole.

During Atget's lifetime the Ile-de-France was undergoing rapid transformation. The population of Paris was expanding into the small towns immediately beyond the city limits, and an exodus of manufacturing from the courtyards of Parisian townhouses brought factories into the country as well. At the same time farming began to be mechanized and more specialized, and rapid transportation allowed produce from outlying regions, particularly the Midi, to replace that of the Ile-de-France in the markets of Paris. As the small towns were annexed as residential and industrial suburbs and the farmers lost their familiar labors, the environs of Paris lost their traditional character. Thus what Atget was photographing was beginning to disappear even as he worked, and there is no longer any trace of much that is reproduced here.

Atget's choice of sites is symptomatic of these developments. The overwhelming majority of his photographs were taken in the southern environs of Paris. One might suppose that this was less a matter of choice than of convenience, for Atget lived

near the southern rim of the city, only a block or two from the Montparnasse and Denfert stations from which the southern-bound trains departed, and not much farther from the southern tramway termini. While the location of his apartment surely facilitated access to his haunts, there were deeper reasons for his orientation. The railroads that served the southern environs, for example, the Ligne de Sceaux and the Ligne d'Arpajon, were short-haul or commuter lines. They consequently could not meet the demands of industry for extensive rail connections. Railroads of greater importance, linking Paris to big cities and other nations, used the Gare de l'Est and the Gare du Nord, and thus encouraged the building of factories and warehouses on the other side of the city. By 1900 towns in the northern environs, such as Aubervilliers and Clichy, were crowded with smokestacks and gas tanks, while villages in the southern environs, such as Bagneux, Châtillon, and Fontenay, were still drowsing in the unspoiled countryside as they had for the past century.

It was natural that Atget should avoid the industrialized suburbs; they were modern anachronisms in a study of Old France and the preeminent symptoms of its demise. It is perhaps equally natural that his choice should have respected the precedents set by nineteenth-century prints, painting, and photography. While we cannot document the direct influence of these three traditions on Atget's work, he was not exempt from their example. They identified the starting points, if not the end results, of his discovery of the countryside.

In the early part of the nineteenth century a large number of English artists with an interest in topographic detail and picturesque medieval sites visited the towns of Normandy, Picardy, and the Ile-de-France. Artists such as Samuel Prout, the Fielding brothers, Bonington, and Turner made drawings, paintings, and watercolors of the narrow animated streets and the Gothic buildings of Rouen, Beauvais, Amiens, Abbeville, and Paris, and their works became famous through woodcuts and especially lithographs, such as those by Thomas Shotter Boys.‡ The dissemination of these prints helped establish the mode of the Romantic topographic view and fixed the old towns and cities of northern France firmly in the galaxy of popular artistic subjects.§

Topographic views became a prevalent genre because the little pictures were unpretentious, inexpensive, and accessible,

*The differences (and reasons for them) between Atget's prewar and postwar motivation will be discussed in the next volumes of the book. See also the author's dissertation, "Eugène Atget, 1857–1927: The Structure of the Work" (Columbia University, 1980), pp. 327–57.

†When Atget did photograph civic institutions, it was apparently because they were housed in former châteaux and other notable buildings—e.g., *Villejuif, ancien séminaire, mairie*, 1901, E:6224, MOMA 1.69.1042, and *Lagny, Hôtel de Ville* (housed in a seventeenth-century abbey), 1906, E:6643, MOMA 1.69.1169.

‡See T. S. Boys, *Picturesque Architecture in Paris, Ghent, Antwerp, and Rouen* (London: Hullmandel, 1839).

§Atget's reproduction of such prints is discussed in the note to plate 85.

153

and they gratified the widespread taste for what was quaint and picturesque, for what was historic and old, and in the case of prints of distant places, for what was unknown. Baron Isidore Taylor's monumental compendium of topographic views, the *Voyages pittoresques et romantiques dans l'ancienne France* (1820–78), was the most ambitious publication of the entire century, but it was only the largest of hundreds of similar collections of views.*

During the first half of the century many artists such as Bonington, Daubigny, J.-B. Isabey, and Paul Huet, who helped illustrate the *Voyages pittoresques*, brought to their paintings their experience as descriptive topographers. It was partly a merging of this topographic tradition with the growing desire to paint modest, unheroic landscapes, some of which were sketched in oil directly from nature, that gave birth to the first large informal school of painters in France devoted to landscape and rural motifs, the Barbizon school. This group in turn established certain stylistic and iconographic precedents for the next generation. Although the Impressionists used the rural motifs differently, the motifs themselves, like the choice of sites, remained remarkably constant: country roads, village streets, farmyards, river scenes, ponds, rocks, trees, forest views, orchards, haystacks, and stiles.†

Photography grew up during the period when the Romantic topographic view and the painting of rural scenes and landscape were ascendant, and it assimilated characteristics of both genres. Around mid-century photographers set out to record what was famous and typical in certain provinces in much the same spirit as did the illustrators of the various *voyages pittoresques*. The "Missions héliographiques" of the Monuments Historiques, for example, sent Edouard-Denis Baldus, Gustave Le Gray, Henri Le Secq, and others to various regions in 1851. Their project was to make a photographic inventory of notable monuments undergoing, or in need of, restoration.‡ Photographers also made studies (*études* or *études d'après nature*) of indigenous, vernacular aspects of rural life and especially landscape views. Perhaps the best-known congregations of Second Empire photographers of this "sketching" persuasion were in the Forest of Fontainebleau (Charles Marville, Le Gray, the Cuveliers) and around Sèvres and Saint-Cloud (Victor Regnault, Louis Robert).

By the 1890s, when Atget began to photograph, these traditions of representation, and the tastes and values of the society which they embodied, had effectively prescribed certain sites and kinds of motifs for depiction. It was not that Atget was constrained to follow their lead, but that the examples were so pervasive he could scarcely fail to have been affected by them. He need not have seen and admired Pissarro's, Cézanne's, or van Gogh's paintings of Auvers, or Sisley's or Daubigny's paintings of the rivers of the Ile-de-France, to want to photograph the sites himself. Rather, as a younger member of the same society, Atget ineluctably inherited some of the values that made such sites interesting to the artists, and was naturally familiar with the prevalent modes of their depiction. Thus, when working in Abbeville, he followed in the footsteps of the Ro-

mantic lithographers and the photographers who had preceded him.§ Similarly, when he photographed at Ville-d'Avray, he recognized Corot's precedent there (see note to plate 104).

Had he recorded his reasons for choosing his sites, Atget, like van Gogh, might very well have written: "Auvers is very beautiful, among other things a lot of old thatched roofs which are getting rare. . . . really it is profoundly beautiful, it is the real country, characteristic and picturesque. . . . This in an almost lush country, just at the moment when a new society is developing in the old, is not at all unpleasing; there is so much well-being in the air. I see, or think I see, in it a quiet like a Puvis de Chavannes, no factories, but lovely, well-kept greenery in abundance."‖

The photographs in this volume span Atget's entire photographic career, a period of some thirty-five years. The pictures belonged to different categories or series, which will be discussed at length in the next volumes of the book; meanwhile the reader needs to know a little about the system to understand the following notes and make use of them.

Each of Atget's photographs has a negative number, often visible in the lower right-hand corner of the print. These numbers were identification tags assigned by Atget to identify and retrieve the prints and negatives from their series. At the end of his career there were five major series and many smaller subseries and groups, but in the beginning there was only one. Although it had no single consistent name, its number sequence was continuous and its essence never changed. In reference to its two most characteristic components, I call it the Landscape-Documents series. Its subject is the land—the fields, forests, and

* A long list of French publications of this sort was compiled by Jean Adhémar in *Les Lithographies de paysage en France à l'époque romantique* (Paris: Armand Colin, 1937).

† Painters congregated around Auvers and Pontoise; Ville-d'Avray, Saint-Cloud, and Sèvres; and the Fontainebleau Forest. This brief account of the interaction of the topographic view and French landscape painting is indebted to Robert Herbert's *Barbizon Revisited* (Boston: Museum of Fine Arts, 1962).

‡ See the catalog of the exhibition "La Mission héliographique" (Paris: Musées de France, 1980) and the forthcoming book on the art of French calotype by André Jammes and Eugenia Janis.

§ Atget's kinship with the Romantic lithographers and the mid-century photographers is suggested in a comparison of three images:

a) Lithograph after drawing by A. Duthoit, "Maison dite de François 1er, rue de la Tannerie à Abbeville," in Taylor et al., *Voyages pittoresques et romantiques dans l'ancienne France*, vol. 15: *La Picardie* (Paris: Firmin Didot, 1835).

b) Photograph by Charles Marville, "Maison de la rue de la Tannerie à Abbeville, habitée par François 1er en 1540," printed by Blanquart-Evrard in "Variétés photographiques," 1851–55. Collection Macqueron, Bibliothèque Municipale, Abbeville.

c) Photograph by Atget, *Maison à Abbeville* (before 1900), LD:72, MOMA 1.69.1766. The Metropolitan Museum of Art, New York, acquired the stairway in 1913.

‖ *The Complete Letters of Vincent van Gogh* (Greenwich, Conn.: New York Graphic Society, 1958), vol. 3, pp. 273, 275.

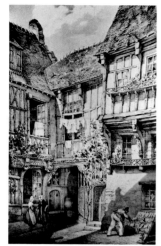

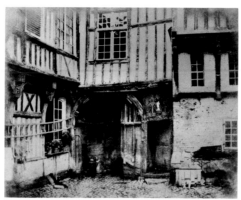

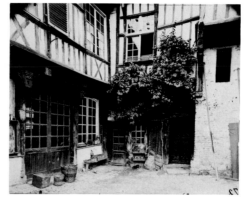

a) *Lithograph after drawing by*
A. Duthoit, before 1835

b) *Photograph by Marville,*
1851–55

c) *Photograph by Atget,*
before 1900

rivers of France—as well as its indigenous flora and fauna. Until 1900 it also contained photographs of farms, bridges, windmills, boats, and other man-made structures. After 1900 photographs of buildings located outside of Paris were put into a different category, the Environs series.

A little over half the plates are from the Landscape-Documents series. The rest belong to the Environs series except for three pictures from the Picturesque Paris series and a small handful from the Saint-Cloud subseries. In the reference photographs (the "figures") there are also some photographs from the Vieille France subseries. The initials LD, E, PP, SC, and VF, which form the prefix to each negative number, denote the series of a photograph.

The notes provide information for each photograph reproduced as a plate. Following the order of the reproductions, the notes list the title, date, serial designation and negative number, and the Museum of Modern Art acquisition number for each picture. The print which is reproduced is by Atget unless identified to the contrary. Later prints by Berenice Abbott, Richard Benson, and the Chicago Albumen Works (Joel Snyder and Doug Munson) are identified by the initials BA, RB, and CAW and are dated. If these prints duplicate existing Atget prints in the Museum's collection, the acquisition number of the Atget print is also cited (e.g., "same as MoMA 1.69.824").

The titles appear as they were written by Atget on the reverse of the prints. If there was no given title, a descriptive title has been provided within brackets.

The dates were either inscribed by Atget on the prints (rarely) or on the pages of the paper albums in which he filed the prints (Atget Archives, MoMA). Attributed dates based on a chronology compiled from these and other sources are enclosed in parentheses.

For the sake of clarity the initials of the series have been prefixed to the negative numbers, but it should be noted that Atget never inscribed these initials himself. He used only the negative number. In cases where Atget changed a negative number, the new number is given first, followed by the former numbers.

The Museum's acquisition number completes the information provided for each photograph. The numbers beginning "1.69 . . ." are given to pictures from the Abbott-Levy Collection, numbers ending ".50" were acquired by the Museum from Berenice Abbott in 1950, and numbers ending in ".80" are modern prints from negatives in the Abbott-Levy Collection.

Since the size of the prints is virtually constant, it has not been indicated except when unusual. The untrimmed size is normally 18×24 cm for horizontal images and 24×18 cm for vertical ones.

The technical information for the plates is followed by the technical information for related photographs, which are the "figures." The figures are sometimes reproduced from prints kept in the Study Collection of the Museum's Department of Photography. If the reproduced print—often poorly preserved —is by Atget, this is indicated by the words "MoMA Study Collection," and if it is a new print from Atget's original negatives, it is indicated as: "MoMA Study Collection. Print, 1978."

Comments on the relevant plates and figures follow this information in many cases. When the comments make reference to pictures in the Museum's collection which are neither reproduced as plates nor as figures, these photographs are indicated by Atget's negative number.

M.M.H.

155

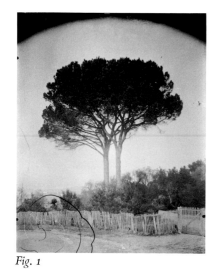
Fig. 1

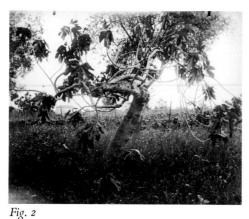
Fig. 2

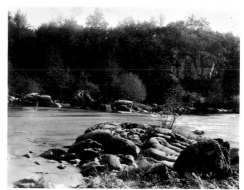
Fig. 3

Frontispiece. *Sceaux, ancien château.* 1923.
E:7010. MoMA 1.69.1970

The photograph does not represent the famous château of Colbert at Sceaux, but a wing of the Château des Imbergères. Built at the end of the sixteenth century by a counselor to the king, the manor had been home to aristocrats and courtiers, and then in the nineteenth century to various inhabitants, among them a famous actress of the Comédie Française and the heir to the Bon Marché department-store fortune. In the early twentieth century a wine merchant acquired it and—storing his casks in the once elegant salons—allowed the property to deteriorate. When Atget photographed the estate in 1922 and 1923, it was thus deserted and down-at-the-heels, and not far in spirit or in fact from the ruined Parc de Sceaux which he photographed with notable success in 1925.

Pl. 1. *Oranger.* (Before 1900.) LD:152. MoMA 1.69.622
Fig. 1. *Nice, pin parasol.* (Before 1900.) LD:150. MoMA Study
 Collection. Print, 1978
Fig. 2. *Figuier.* (Before 1900.) LD:160. MoMA 1.69.627

Early in his career Atget made many photographs of trees, plants, and flowers native to the Ile-de-France region (pls. 8, 9, 16, 20–22, 24). Appended to that group were a few photographs of tropical specimens taken near Cannes and Nice (pl. 1, figs. 1, 2). When the plants were depicted whole and isolated in the center of an open space (e.g., fig. 1), the photographs look like the easily readable drawings that illustrate botanical dictionaries; but when circumstances prevented that kind of clean delineation, the pictures usually do not succeed so well. Sometimes, however, they succeed in unconventional ways, for Atget was not afraid to take a new kind of picture as long as it transmitted the desired information (pl. 1, fig. 2). At this stage in his career Atget's boldness might be attributable to lack of experience, the acquisition of which only encouraged and continued his pictorial innovations.

Pl. 2. *Charrue.* (Before 1900.) LD:602. MoMA 1.69.1245

Atget filed this photograph together with several others reproduced here (pls. 3, 12, 18, 25, 26, 71, 106) in a single album: *1ère Série, paysages, documents divers* (later transformed to accommodate a different group of pictures and titled *Album n° 4, motifs décoratifs,* in the Atget Archives, MoMA). As with many of Atget's pictures, the subjects of these photographs are multivalent and thus difficult to name or group in categories. For Atget, this was a chronic problem, one he usually avoided either by grouping the pictures under simple, typological rubrics (trees, doors, fountains) or by using extremely broad categories, such as the Environs series (any man-made thing located in the outskirts of Paris). He tacitly acknowledged the impossibility of ever finding a single "right" category for his pictures by switching prints from one album or rubric to another, by assigning them to several categories at once, and by devising albums like the one discussed here, which might be translated as "Landscapes and Miscellany."

Pl. 3. *Terrain (Limoges).* (Before 1900.) LD:91. MoMA
 1.69.3458
Fig. 3. *Bords de la Vienne.* (Before 1900.) LD:95. MoMA
 1.69.1022
Fig. 4. *Châtaignier, Limoges.* (Before 1900.) LD:87. MoMA
 1.69.2048

Atget went to Limoges only once. It was far from the sites of most of his photographs, and the reasons for his visit there, like those that motivated his trip to Switzerland in 1901, remain unexplained. In Switzerland he photographed cities (Bern, Lucerne); at Limoges, primarily the countryside.

Pl. 4. *Ferme, Abbeville.* (Before 1900?) LD:765. MoMA
 1.69.1673
Fig. 5. *Untitled [Hut among Willows].* (Before 1900?) LD:764,
 formerly LD:874. MoMA 1.69.1175
Fig. 6. *Environs, Amiens.* (Before 1900?) LD:766. MoMA 144.50

157

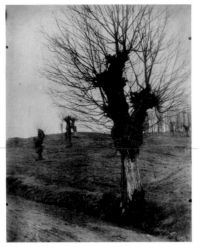

Fig. 4 *Fig. 5* *Fig. 6*

The small negative size of this photograph (13 × 18 cm) is unusual for Atget, who generally used the other popular standard-size plate (18 × 24 cm). Only about a dozen plates in the smaller format are known to exist (e.g., figs. 5, 6); all were taken in northern France, and several are datable to 1898 or before. The negative numbers of the small plates are LD:764–67, 866, 868, 871, 873, 884–86. Prints of LD:844–86 were acquired in 1898 by the Musée de Sculpture Comparée in Paris.

Pl. 5. *Untitled [Harness on Horse].* (Before 1900?) LD:255. MoMA 1.69.4175

Fig. 7. *Untitled [Sheep].* (Before 1900?) LD:275. MoMA Study Collection

Fig. 8. *Faucheur (Somme).* (Before 1900.) LD:858. MoMA 1.69.1493

In principle Atget's photographs of country people do not differ greatly from their Parisian counterparts; both are depicted as they pursue their daily work. But if the principle is similar, the pictures are not. The "Petits Métiers" (the small trades of Paris) inherited the hierarchical format of traditional print series, the "Cris de Paris," but the photographs of country scenes follow no set precedent. Some resemble rural genre paintings (fig. 8); others seem to be born with no representational conventions except photographic ones (pl. 5). If the pictures of farm animals and agricultural activities served as models for genre painters, their photographic eccentricities, if faithfully copied, would have produced some rather unorthodox paintings.

Pl. 6. *Abbeville (Somme).* (Before 1900.) LD:100. MoMA 1.69.1788

Fig. 9. *Montgeron.* (1925–27.) LD:1271. MoMA 502.80. Print by CAW, 1980

Many of Atget's early photographs were taken in the department of the Somme, in the ancient region of Picardy, which lies to the north of Paris, and of which Amiens is the capital. In his day its high rolling plateaus were dotted with windmills and orchards, and thatch-roofed cottages nestled in its wooded chalk glens. This photograph and the one reproduced as plate 14 depict two landscapes typical of the country. Atget lived in the region beginning in 1888 and may have remained there until 1892, when he was back again in Paris (see biographical sketch in next volumes). Once he had left Picardy, Atget apparently did not photograph haystacks again for about thirty years. Then, at the end of his life, he photographed stacks at Montgeron, south of Paris (fig. 9 and LD:1272). These he saw not as picturesque ornaments of the countryside, but as massive sculptures that shared their distinctive scratchy texture with the stubble left in the surrounding field.

Pl. 7. *Moulin (Somme).* (Before 1900.) LD:54. MoMA 1.69.1848

Fig. 10. *Moulin à Amiens.* (Before 1900.) LD:17. MoMA 1.69.3122

During his stay in northern France Atget photographed several windmills. Whether closely associated with a farmhouse (fig. 10) or isolated on a bluff, they were, with one or two exceptions, represented whole. This close-up view, one of the exceptions, shows the rotation device by which the miller turned the sails into the wind.

Pl. 8. *Pommier.* (1898 or before?) LD:894. MoMA 1.69.703
Pl. 9. *Pommier, fleurs.* (Before 1900.) LD:33. MoMA 1.69.1943

Compared with his photographs of the streets of Paris, Atget's photographs of trees are few; while the first category contained at least two thousand pictures, the second made up at most three hundred. The numbers would not seem to reflect Atget's degree of interest, however, for trees were one of the subjects that he investigated from one end of his career to the other, not only in photographs, but in paintings too. Mme Demoulin, who lived in the apartment above Atget's after the war, remembers that he often painted trees, and that the small panel he gave to her was pink and white and its subject was apple trees in bloom (conversation with Mme Demoulin, August 1978).

Pl. 10. *Villejuif, ancien château des comtes de Saint-Roman.* 1901. E:6215. MoMA 1.69.1038

Fig. 7

Fig. 8

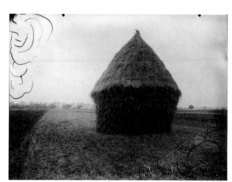
Fig. 9

Pl. 11. *Villejuif, ancien château du comte.* 1901. E:6217.
MoMA 1.69.4081

The photograph reproduced as plate 11 is not of the manor house, but of its *basse-cour*, or farmyard. The central importance of the farm, which provided the essential provisions for the seignorial household, was usually evident in its close proximity to the château. Following the age-old tradition, the Count of Saint-Roman incorporated his farm within the château walls (pl. 10), which, at the time Atget photographed them, served more to keep chickens in than enemies out.

Pl. 12. *Chemin à Abbeville.* (Before 1900.) LD:865.
MoMA 1.69.1331
Fig. 11. *Pommier.* (Before 1900.) LD:97. MoMA 1.69.640

The tasteful median in French landscape in the 1890s might be described as an undifferentiated mix of Corot's, Daubigny's, and Troyon's styles and motifs. Although Atget's early landscapes often emulated the painterly norms (pl. 14, fig. 11), at times his acceptance of the camera's peculiar vision subverted those expectations. This was the case, for instance, when he allowed the muddy road to dominate the picture reproduced as plate 12.

Pl. 13. *Untitled [Roofless Farmhouse, Somme].* (1898 or before?) LD:12. MoMA 1.69.3722
Fig. 12. *Picquigny (ruines).* (1898 or earlier.) LD:26.
MoMA 1.69.717

This farmhouse and the famous château at Picquigny (fig. 12) were among the first dilapidated buildings Atget photographed. The taste for ruins, which sprang from a belief in the power of nature to reclaim what man had civilized, pervaded nineteenth-century thought, and this Romantic concept was one of the abiding tenets in Atget's vision of the countryside. It did not inform his photographs of buildings undergoing demolition, however; their state was determined by social, financial, and political conditions, not by the slow, organic processes of time.

Pl. 14. *Abbeville (chemin).* (Before 1900.) LD:61.
MoMA 1.69.1847

Pl. 15. *Poirier en fleurs.* (1922–23.) LD:1178. MoMA 1.69.753
Fig. 13. *Poirier.* (1921–22.) LD:1038. MoMA 1.69.768

The photograph reproduced as plate 15 was one of four that Atget made in 1922–23 of the branches of a pear tree in bloom. A year or two previously when he had photographed similar branches in an orchard at Châtenay (fig. 13), the wind had blurred the blossoms in two of the pictures and the third was out of focus. If some part of Atget's intention was a clear, close-up depiction of a flowering pear, these pictures were unsatisfactory; therefore what prompted Atget to rephotograph pear branches may have been his desire to revise the earlier attempts.

Pl. 16. *Pommier.* (Before 1900.) LD:106. MoMA 1.69.608
Pl. 17. *Paysan de Châtillon.* (1922?) PP:24, formerly E:6371 or AP:6371. MoMA 1.69.931

Châtillon was one of several towns that Atget knew well. He explored the country lanes around it frequently (see pls. 29, 36, 97), and on one occasion encountered this peasant. The picture shows that the man evidently did not mind Atget's intrusion and that Atget, in turn, regarded him amiably. That his left foot had sprouted leaves and his stake had flowered like Aaron's rod were probably photographic surprises. Although they owed nothing to the peasant's agricultural powers, they do seem, like Demeter's sheaf of wheat, the appropriate attributes for a gardener.

Pl. 18. *Auvers (vieille maison).* (1900–10.) LD:681.
MoMA 1.69.1105
Pl. 19. *Auvers-sur-Oise.* 1922. E:6992. MoMA 1.69.3374
Fig. 14. *Auvers-sur-Oise (ferme).* 1922. E:6993. MoMA 1.69.1962

Many years after Atget took the photograph reproduced as plate 18, he returned to Auvers and sought out the same farmhouse again (pl. 19, fig. 14). Following a rural French custom, the owners had marked the facade with the date they took

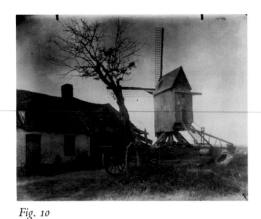
Fig. 10

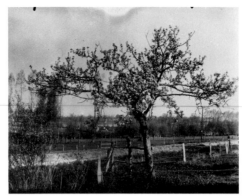
Fig. 11

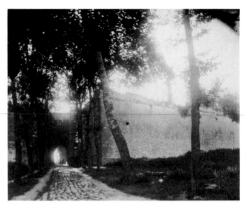
Fig. 12

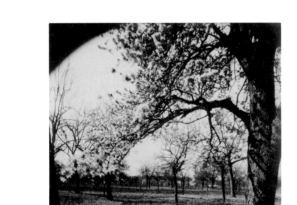
Fig. 13

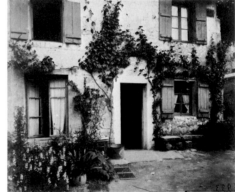
Fig. 14

Fig. 15

possession of the house, or perhaps the date of its last refurbishment. Since Atget's previous visit they had whitewashed the doorjamb, cemented the flagstones together, nailed up a horseshoe for good luck, and painted the initials MG over the smaller of the second-story windows, and MG, TG, and the dates 1920 and 1921 on the sill of the window below (fig. 14). Like a portraitist concerned with emotional timbre rather than cosmetic appearance, Atget evidently cherished these signs of domesticity, care, and age.

Pl. 20. *Lys.* (Before 1900.) LD:68. MoMA 1.69.638
Pl. 21. *Ombelles.* (Before 1900.) LD:67. MoMA 1.69.637
Pl. 22. *Soleil.* (1896?) LD:134. MoMA 1.69.1945
Pl. 24. *Roses trémières.* (Before 1900.) LD:846. MoMA 1.69.697
Fig. 15. *Oignons.* (Before 1900.) LD:823. MoMA 1.69.687

While Atget may have sold photographs of his botanical specimens to painters and illustrators, the photographs of flowers were especially popular with decorative artists. This was due to the prominence of Art Nouveau, which was primarily composed of stylized floral forms. Among those who bought the photographs were the library of the Union Centrale des Arts Décoratifs, today the Bibliothèque du Musée des Arts Décora-

tifs, and M. Jacques Grüber, an artist in stained glass (taped interview with Jean-Jacques Grüber, Atget Archives, MoMA). Atget did not photograph arrangements of cut flowers, but on several occasions he photographed the living bouquets that resulted when heavily laden stems were tied together for support (pls. 20, 24, fig. 15).

Pl. 23. *Capucines.* (1921–22.) LD:1090. MoMA 1.69.3231

In an early photograph of nasturtiums, Atget's high vantage point made them appear to be cascading down the fence rather than climbing up (LD:620). When he photographed another plant some twenty years later, his very low point of view revealed the delicacy of the stems and the thinness of the circular leaves that reach up to the light (LD:1091). Atget shot *Capucines* (pl. 23) from a closer vantage which disregarded the plant's overall configuration and its trellis support. Through judicious framing he simplified the plant's structure into an elegant pattern of illuminated wafers floating in one another's shadows.

Pl. 25. *Auvers-sur-Oise.* (1900–10.) LD:684. MoMA 490.80, same as MoMA 1.69.3372. Print by CAW, 1978.
Fig. 16. *Auvers-sur-Oise.* 1922. E:6994. MoMA 1.69.1394

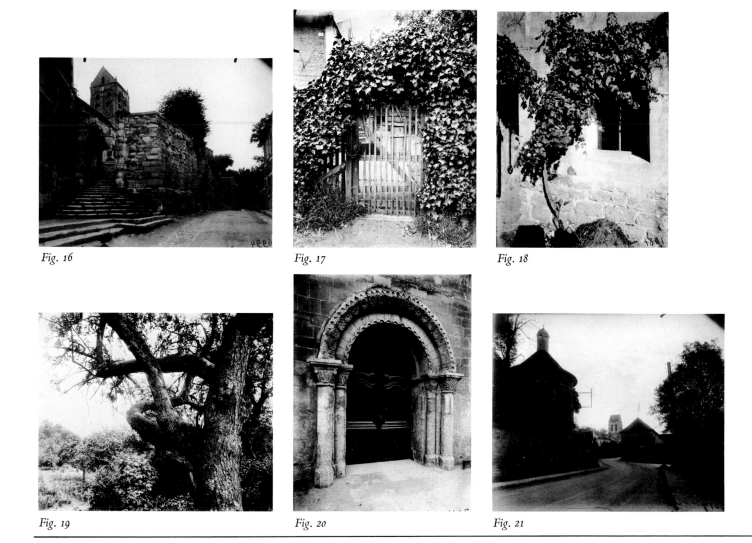

Fig. 16

Fig. 17

Fig. 18

Fig. 19

Fig. 20

Fig. 21

In addition to the company of other artists and the benevolence of the good Dr. Gachet, who befriended van Gogh among others, artists came to the town of Auvers for its picturesque charm. Its stone houses with thatched or tile roofs were built on streets that paralleled the Oise River. These streets were connected to each other by narrow steps that wove up and down the steep chalk slope. Atget photographed several of the stone staircases: the large one mounting to the church (fig. 16), another giving access to a private garden (LD:683), and the one in plate 25 leading up to a house and its garden beyond.

Pl. 26. *Ferme, Auvers (Oise).* (1900–10.) LD:680. MoMA 1.69.3375

Pl. 27. *Vigne.* (Before 1900.) LD:862. MoMA 491.80. Print by CAW, 1980, same as MoMA 1.69.676

Fig. 17. *Entrée du jardin.* (1919–21.) LD:952. MoMA 1.69.656

Fig. 18. *Vignes.* (1921–22.) LD:1081. MoMA Study Collection. Print, 1978. Same as MoMA 1.69.783

Atget photographed grape and wisteria vines frequently. Although their leaves are quite dissimilar and the plants take different shapes, they have in common their visual weight: both vines cover massively, and from their swags thick clusters of fruit or flowers hang down (e.g., LD:650 and pls. 27, 69). The

grapevine posed a specific pictorial problem because it was often the same all over—a thicket of leaves without evident trunk or crown. Atget construed this difficulty as an advantage in the photographs reproduced as plates 27 and 35. In the first case he contrasted the bulging, spreading forms of the vine with the flat wall and the right-angled window mullions, and in the other he let the leaves billow up to cover the picture's surface. While artists did buy such photographs (a print of LD:862, for example, was included in Bancroft's album cited in the footnote on p. 152), the number and variety of vines in Atget's collection (e.g., pls. 26, 34–37, 69, 71 and figs. 17, 18) suggest that his attention sprang from an impulse deeper than filling the needs of his clientele.

Pl. 28. *Verrières, coin pittoresque.* 1922. E:6986. MoMA 1.69.4074

Atget's use of the term *coin pittoresque* (picturesque corner) was irregular: it might be shortened to *coin* or applied to one print and not another from the same negative. *Vieux Puits, Châtillon* (pl. 97), for example, was called a *coin pittoresque* in *Album nº 9, environs,* but not on the print itself. Together, the pictures of rural subjects that at one time or another bore the designation show that the term generally referred to small enclosed areas,

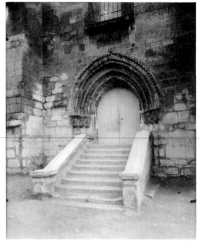
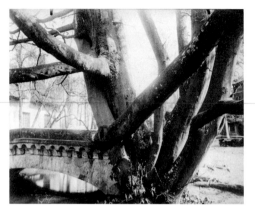

Fig. 22 Fig. 23 Fig. 24

often courtyards, which were decorated or graced with particular charm and had marked human associations. A row of wild roses against a wall, for instance, would not be picturesque, but if someone had trained the roses to grow on a trellis in a farmyard, it might be.

Pl. 29. *Entrée des jardins.* (1921–22.) LD:1046. MoMA 1.69.1198

According to a note in an unknown hand on the verso of the print, this photograph was taken in Châtillon.

Our evidence is too fragmentary to be certain, but it appears that Atget began his career as a maker of documents for artists. In the service of documentation, one could photograph material too ordinary, specific, partial, or insignificant to satisfy the demands made of a conventional work of art. Any subject, in other words, might produce a picture. It is possible that making documents helped bring Atget to this knowledge and that without that experience he might have admired this garden gate without ever imagining it as a picture.

Pl. 30. *Pommier (détail).* (1919–21.) LD:954. MoMA 1.69.642
Fig. 19. *Pommier.* (1919–21.) LD:957. MoMA 1.69.668

Atget made at least four photographs of this old apple tree near Fontenay-aux-Roses. The first two (LD:909, 910), which were taken from a distance and during the early spring, show the whole tree—its knotty trunk, tangle of thick branches, and delicate ribs of new growth. In the summer Atget returned to Fontenay to find the tree in full leaf and embedded in the surrounding undergrowth. This transformation altered the tree's photographic possibilities; whether for this or some other reason, such as Atget's tendency to shoot from a closer distance on later visits to the same site, in the summer he concentrated only on the branches (fig. 19). In the photograph reproduced as plate 30 he found a radically different vantage that untwisted the branches and opened their gesture to the light-filled sky.

Pl. 31. *Pommiers.* Septembre 1923. LD:1203. MoMA 1.69.864
Fig. 20. *Saint-Ouen-l'Aumône, portail XIIe siècle.* 1923.
 E:7014. MoMA 1.69.4287

Fig. 21. *Saint-Ouen-l'Aumône.* 1923. E:7017. MoMA 1.69.3106
Fig. 22. *Rieux-Angicourt.* 1923. E:7047. MoMA 1.69.1362

In *Album no 3, fleurs, arbres, paysages, jardins* this photograph was titled "Pommiers, paysages, Rieux-Angicourt, 7bre 1923."

There is no way of knowing why Atget went to Rieux-Angicourt, a small town in the Oise Valley. He may have gone to visit a friend there, or perhaps he knew there were orchards in the surrounding countryside which, since it was then September, would be full of fruit, or maybe he intended to photograph the village church. There is no evidence to support either of the first two theories, but since Atget was photographing provincial twelfth- and thirteenth-century churches in 1923 (e.g., figs. 20, 21, pl. 64), and since he did photograph the church at Rieux (fig. 22), the third hypothesis is, at the least, not to be rejected. Whatever his intention, it is suggestive that he made only one picture of the church, and it is not particularly distinguished, while he made three fine photographs in the apple orchard (see also pl. 42).

Pl. 32. *Verrières, vieux logis.* 1922. E:6984. MoMA 1.69.1405

When Atget shifted the focus of the Environs series in 1922 from examples of artistic decoration to the description of the towns of the Ile-de-France, the first place he photographed was the little town of Verrières in the Chevreuse Valley. The pictures he made there (pls. 28, 32, 33) are quite different from the preceding photographs in the series (e.g., E:6982, a picture of an impressive wrought-iron gate in Sèvres). They are private, not public, and concern the simple adornments and daily organization of individual people, not the elaborate decorations of elite institutions and ennobled classes.

Pl. 33. *Femme de Verrières.* (1922?) PP:26. MoMA 478.80.
 Print by CAW, 1978

The photograph was probably made when Atget photographed the farmhouse in Verrières (pl. 32), because the 1922 visit was his only recorded visit to the town, and because, like many photographs made immediately after the 1922 subject shift,

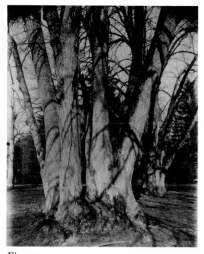

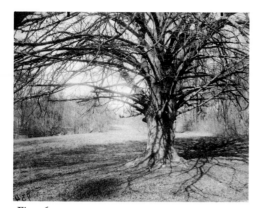

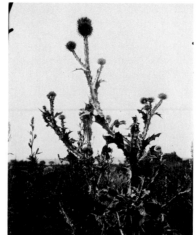

Fig. 25 Fig. 26 Fig. 27

this one deals with the picturesque aspects and the vernacular architecture of the country (e.g., pls. 19, 46, 58, 97). If imposed by some other vision, the precise adjustments of each person's and object's position within the picture might have produced something rigorously formal and inanimate, like a still life; but Atget's picture is suspended between that absolute, immutable order and a warm, earthy vitality that radiates from the ample woman standing beside the evidence of her industry.

Pl. 34. *Gif, vieille maison.* 1924. E:7076. MoMA 1.69.1483
Pl. 35. *Vigne.* (Before 1900.) LD:625. MoMA 1.69.792
Pl. 36. *Entrée pittoresque, Châtillon.* (1921–22.) LD:1045. MoMA 1.69.1101
Pl. 37. *Houblon.* (1900–10.) LD:652. MoMA 484.80. Print by CAW, 1978

If the relationship between the man-made and the natural seems closer in the country than in the city, this may be due to the combination of local construction materials, rustic setting, and organic decoration (pls. 34, 35); but it also owes something to the slower rhythms of the countryside, which allow nature to reappropriate what men temporarily had claimed (pls. 36, 37).

Pl. 38. *Etude (sapin).* (1900–10.) LD:703. MoMA 1.69.707
Fig. 23. *Arbre, Trianon.* (1910–15.) LD:731. MoMA 1.69.14
Fig. 24. *Trianon.* (1910–15.) LD:732. MoMA Study Collection. Print, 1978. Same as MoMA 1.69.15

When Atget photographed tree trunks, details of bark, and branches in the Trianon Gardens, he sometimes called the results *études*, or studies. *Etude (sapin)* is the earliest photograph in the Abbott-Levy Collection with the title of *étude*. In nineteenth-century painting the term described rapid sketches from nature that served either as motifs to be incorporated into more ambitious paintings or as practice for the artist's hand and eye. Atget's *études* (and other similar pictures without the distinction of the name, e.g., figs. 23, 24) looked nothing like the usual photographs of the Trianon's famous old trees; they were partial views shot from unusual angles and under special conditions of light. If these notations of original, very specifically

photographic perceptions were intended as studies for painters, it is likely that they were not as useful to them as they were stimulating to Atget's own vision. His use of the term and of other qualifiers (e.g., *effet de soleil*, or effect of the sun, pl. 41) suggests his awareness of their nonconformity. As far as we can determine, Atget did not apply the terms retrospectively, but used them around the time that he was actually making the pictures. Photographs bearing such titles are printed on Atget's standard paper, not a postwar paper (e.g., LD:703, 706, 743), and the titles are inscribed fluidly, with no evidence of afterthought.

Pl. 39. *Acacia.* (1922–23.) LD:1198. MoMA 1.69.762

Atget's notation on the page of *Album n° 3, fleurs, arbres, paysages, jardins*, where this picture was cataloged, reads "Acacia amérique sept (Bobinier commun)." Presumably he thought that this botanical information, probably lifted from the small plaque at the base of the tree, was warranted by the exotic nature of the specimen.

Pl. 40. *Hêtre.* (1910–15.) LD:735. MoMA 131.50
Fig. 25. *Tilleuls (Trianon).* (1910–15.) LD:720. MoMA 1.69.6
Fig. 26. *Villeneuve-l'Etang.* (1910–15.) LD:734. MoMA 1.69.2236

Perhaps the first time Atget photographed the web of shadows cast by a tree's bare branches onto its trunk was in the Trianon Garden (LD:719 and fig. 25), and subsequently he saw a similar shadow net on the trunk of an old beech at Villeneuve-l'Etang (fig. 26 and pl. 40). In the earlier photographs of the two lindens at the Trianon, the trees are of primary importance and the pattern of shadow is a secondary surface ornament. When he confronted the beech, however, Atget saw the shadow not so much as a pattern but as the significant surrogate for the tree's ramification. In the photograph reproduced as plate 40 Atget gave condensed form to this idea: the trunk and adherent shadow are seemingly indivisible; they represent the whole tree both in substance and in insubstantial aspect.

163

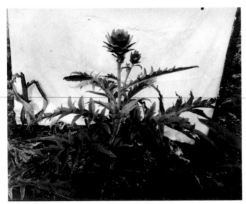

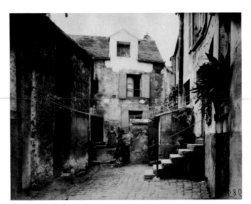

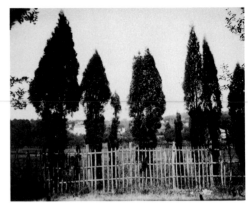

Fig. 28　　　　　　　　*Fig. 29*　　　　　　　　*Fig. 30*

Pl. 41. *Trianon, marronnier, effet de soleil.* (1910–15.)
 LD:743. MoMA 1.69.18
See note to plate 38.
Pl. 42. *Pommier.* (1922–23.) LD:1201. MoMA 1.69.862
Pl. 43. *Pommier (détail).* (1922–23.) LD:1174. MoMA 1.69.723
Pl. 44. *Artichauts, fleurs.* (Before 1900.) LD:636.
 MoMA 1.69.801
Fig. 27. *Chardons.* (1919–21.) LD:960. MoMA 106.50
Fig. 28. *Artichauts.* (Before 1900.) LD:161. MoMA 1.69.628

Unless taken to the studio, plants and flowers presented special problems for the photographer. Although those who specialized in plants worked indoors, Atget did not; instead he sought out plants in the botanical gardens and public parks of Paris and in the countryside nearby. Because he photographed them *in situ*, he could show them as they actually grew, but unless he silhouetted them against the sky (fig. 27), the results usually compromised the clean description of the plant. It was evidently to avoid this that Atget carried with him a white cloth which he installed as a backdrop behind the plants (fig. 28). The device produced, in this case, a better artichoke, but it made for odd pictures. Sometimes Atget managed to photograph plants so that the results were as compelling as pictures as they were useful as documents, but this was rare. *Artichauts, fleurs* is not one of those rare exceptions, as the plants are too difficult to extricate visually from the wire screen and distant trees of the botanical garden. However, Atget's willingness to mesh the plants and their setting into a prickly optical fabric despite the loss of clarity suggests that he sometimes preferred to ignore the documentary challenge in the interest of making a good picture.

Pl. 45. *Sceaux-les-Chartreux, ferme.* 1924. E:7059.
 MoMA 1.69.1517
Fig. 29. *Sceaux, rue Voltaire.* 1922. E:6989. MoMA 1.69.2722

Beginning in 1922 Atget came into greater contact with villagers than he had when photographing artistic decoration (see

note to pl. 32). Since his new subject matter reflected the values, tastes, and informal life-style of the country folk, it seems fitting that Atget should have included them in the pictures. Occasionally they took the main role (pls. 17, 33), but more often they formed a cast of supporting characters (pl. 45, fig. 29).

Pl. 46. *Auvers-sur-Oise.* 1922. E:6991. MoMA 1.69.1312

This barn bears two kinds of inscriptions. In the stone lintel over the door adults carved in Gothic letters a permanent motto or memento, unintelligible to us and almost certainly of no concern to the children who left their ephemeral messages on the door below. With the gentle, often unintentional irony of photographic documents, the picture has reversed the importance of the inscriptions: the careful, permanent, and serious legend is now illegible, but the casual, evanescent, and gay scrawls will be considered and deciphered as long as the photograph exists.

Pl. 47. *Cyprès.* (1921–22.) LD:1054. MoMA 1.69.781
Fig. 30. *Cyprès (Fontenay).* (1919–21.) LD:992.
 MoMA 1.69.3218
Pl. 48. *Route, Amiens.* (Before 1900.) LD:31. MoMA 1.69.721
Fig. 31. *Amiens, calvaire.* (Before 1900.) LD:15.
 MoMA 1.69.3121

Atget photographed two shrines in the region of Amiens. One was a crucifix in the middle of a semicircle of carefully pollarded trees in a graveyard (fig. 31); the other was a wayside chapel seven kilometers from Amiens (pl. 48). The chapel has no apparent mortuary purpose, but the picture, with its emphasis on the tortured limbs and gnarled trunk of the old tree, is as expressive and poignant as the symbolic crucifix.

Pl. 49. *Untitled [Broken Tree].* (Before 1900.) LD:861.
 MoMA 492.80. Print by RB, 1980
Fig. 32. *Marronnier.* (1919–21.) LD:1009. MoMA 1.69.232

In the early part of his career Atget often photographed things that were typical of their kind: his apple trees, for example, look

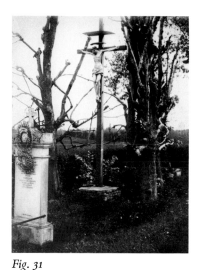
Fig. 31

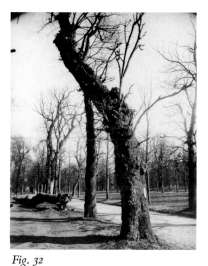
Fig. 32

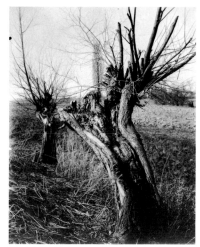
Fig. 33

like the apple trees in our mind's eye (pls. 8, 9). The more he photographed, however, the more he avoided the normal and generalized in favor of the particular and specific. This is true both of his subject matter and of his vision of it. This early photograph of a peculiarly damaged tree is thus unusual, but it presages Atget's later interest in exceptional specimens—for example, *Marronnier* (fig. 32), where, from the closed and rhythmic ranks of chestnuts at Saint-Cloud, Atget chose to photograph a fallen tree and a remarkably misshapen one.

Pl. 50. *Saules.* (1921–22.) LD:1030. MoMA 1.69.244
Pl. 51. *Saules.* (1921–22.) LD:1029. MoMA 1.69.764
Fig. 33. *La Varenne, saules.* (1921–22.) LD:1027.
 MoMA 1.69.778
Fig. 34. *Saule.* (June–July) 1925. LD:1244. MoMA 1.69.878

The ancient aspect of willows is something of a fiction; had they been olives they might have been as old as they looked, but willows grow rapidly and die relatively young. Although they appeared to be dead hulks, the willows at La Varenne (pls. 50, 51, fig. 33) were probably quite vigorous. Their shoots had been amputated, to make wicker baskets perhaps, but it is likely that the hollow, stunted trunks would bring forth new branches with the spring (cf. fig. 34 and pl. 99).

Although Atget had photographed willows when he lived in Picardy (e.g., LD:27 and fig. 5), he did not return to this subject until after he had made his *études* of varying aspects of many kinds of trees (e.g., pls. 38, 40, 41, figs. 23, 24). Around 1919 he began photographing willows more frequently: the marked idiosyncrasies of the results would seem to owe as much to the aptness and perspicacity of Atget's vision as to the different forms and conditions of the trees themselves. See also plates 98 and 99.

Pl. 52. *Châtillon, chemin des Pierrettes.* Août 1919. LD:900.
 MoMA 493.80. Print by CAW, 1980
Pl. 53. *Ballainvilliers, entrée du village.* Juin 1925. E:7105.
 MoMA 494.80. Print by RB, 1980

Fig. 35. *Ballainvilliers.* Juin 1925. E:7104. MoMA Study
 Collection

Atget photographed the road in plate 52 on at least three separate visits between 1915 and 1921 (LD:786, LD:900 and 901, LD:997). There is evidence to suggest that the road was not the Chemin des Pierrettes, but the nearby Rue Perrotin, which was a scenic but indirect back road that led from the train station past an old walled estate planted with cedar trees and into the center of town. Atget could have walked directly into Châtillon by the main street, but with his affinity for quiet rustic places and his conservationist's instinct, he repeatedly chose instead this old path that was slated to be transformed into the "Avenue de la République." When he composed *Album nº o, environs* (sic) sometime after 1919, Atget noted that the so-called Chemin des Pierrettes had already disappeared.

The insistently graphic structure of the picture is partly due to the coincidence of the shadow with the edge of the road. Seemingly as solid and stable as the wall, this shadow and the unbroken wedge shapes of the rest of the photograph interlock like the pieces of a puzzle to make a picture of firm and lucid constitution. While *Ballainvilliers, entrée du village* (pl. 53) contains similar wedge shapes, its formal coherence does not derive from the symmetry of those graphic shapes, but from the fact that they are offset by the atmospheric rendering of the church in the luminous distance. See also figure 35.

Pl. 54. *Vitry.* (1925–27.) E:7119. MoMA 1.69.1273
See note to plate 72.
Pl. 55. *Villejuif, vieille rue.* 1901. E:6223. MoMA 1.69.1043
Pl. 56. *Sceaux-les-Chartreux, coin.* 1924. E:7058.
 MoMA 1.69.2263
Pl. 57. *Sceaux-les-Chartreux, ferme.* 1924. E:7068.
 MoMA 1.69.2733
Fig. 36. *Eglise, Sceaux-les-Chartreux.* 1924. E:7057.
 MoMA 1.69.2729

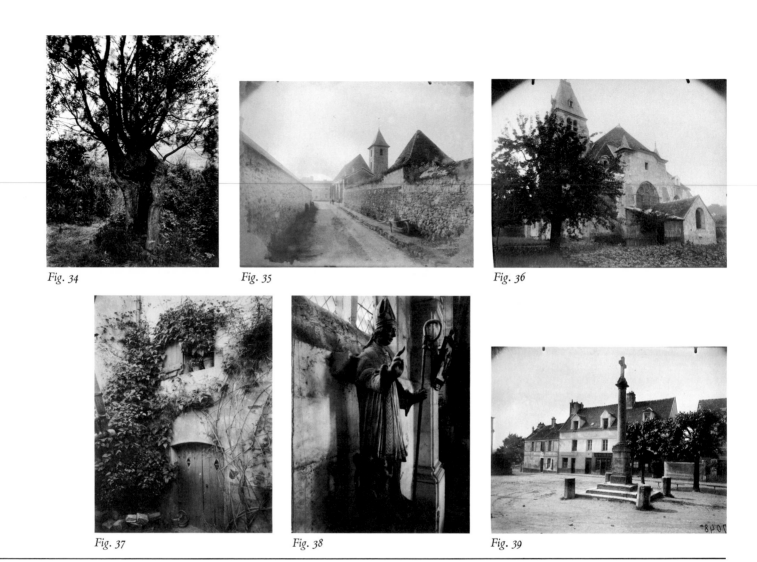

Fig. 34

Fig. 35

Fig. 36

Fig. 37

Fig. 38

Fig. 39

Fig. 37. *Sceaux-les-Chartreux, coin, vieille maison*. 1924.
E:7069. MoMA 1.69.2350

This is not the town where the Parc de Sceaux was located. Like Ballainvilliers (pl. 53) and Montlhéry nearby (pls. 79, 87), Sceaux-les-Chartreux was too far south to be considered a suburb of Paris. Atget photographed there twice, both times in 1924. The subjects of the six pictures (pls. 45, 56, 57, E:7056, figs. 36, 37) are so representative of the latter part of the Environs series (1922–27) that the little group may serve as an archetype of Atget's work in small towns after the war. Although he took more photographs in other towns, he rarely enlarged upon the basic glossary of subjects that the group represents. There were two main categories. The church was the central focus of the first, as it was of the town itself; Atget usually photographed the approach to it, the space around it, and many of the adjacent old streets. The second category was the village house, with its exterior decoration, courtyard, well, garden gate, potted plants and espaliered trees, and—either by implication or direct depiction—its inhabitants.

Pl. 58. *Sceaux, coin pittoresque*. 1922. E:6990. MoMA 1.69.2732
Pl. 59. *Dammartin-en-Goële, ancien Hôtel-Dieu*. Juillet 1921.
E:6945. MoMA 1.69.1543

Fig. 38. *Goussainville, saint Nicolas*. 1921. E:6929.
MoMA 1.69.1347

In November 1920, when corresponding with Paul Léon about the possible purchase of some negatives, Atget asked for authorization to photograph inside churches of the Ile-de-France for his series "L'Art dans les environs." Apparently he procured a permit, for during the next summer he photographed the decorative art both on and in the village churches (fig. 38, E:6949). The statue in Dammartin was not in a church but mounted on the wall of the former hospital.

Pl. 60. *Bièvres, place de l'Eglise*. 1924. E:7050. MoMA 1.69.1361
Pl. 61. *Bièvres (église)*. 1924. E:7051. MoMA 1.69.1458
Fig. 39. *Bièvres, place de l'Eglise*. 1924. E:7048.
MoMA 1.69.1460
Fig. 40. *Bièvres, place de l'Eglise*. 1924. E:7049.
MoMA 1.69.1467

Because they are mechanically made and produced whole, photographs do not usually bear traces of the creative thought that brought them into existence. It is fortunate, therefore, that some of Atget's photographs are linked in sequences—where each picture is recognizable as a discrete critical decision within

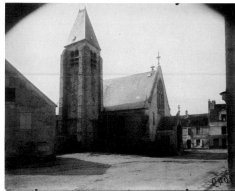

Fig. 40

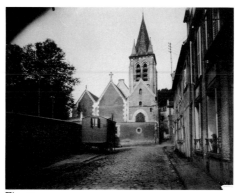

Fig. 41

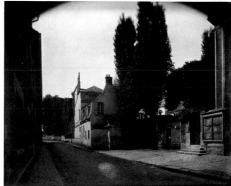

Fig. 42

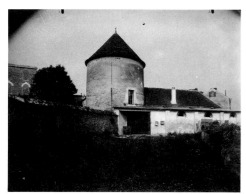

Fig. 43

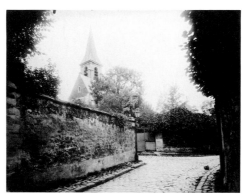

Fig. 44

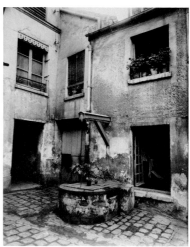

Fig. 45

a prolonged creative session. The Bièvres sequence is particularly rewarding because it shows that Atget identified totally different subjects coexisting in the same place and that these were not premeditated selections but an intuitive seizing of different visual truths that the town square offered when seen from different positions.

Pl. 62. *Provins, remparts.* 1923. E:7046. MoMA 1.69.1398

Capital of Brie, home of the Counts of Champagne, and site of a famous fair, Provins was among the most prosperous and populous cities in medieval France. The octagonal tower visible in the photograph is not part of the ramparts, as Atget thought, but a twelfth-century keep, the "Tour de César," built on the site of a Roman fort.

Pl. 63. *Châtenay, rue Sainte-Catherine.* 1901. E:6032.
 MoMA 1.69.1262
Fig. 41. *Châtenay.* (1925–27.) E:7155. MoMA 1.69.3200

See note to plate 74, and for another photograph of the church taken from the rue Sainte-Catherine, see figure 41.

Pl. 64. *Igny.* 1923. E:7034. MoMA 1.69.4082
Fig. 42. *Igny.* 1923. E:7035. MoMA 1.69.1401

In *Album n° 9, environs,* above the picture here reproduced as plate 64, Atget called the structure a Romanesque belfry: "Clocher roman, Igny, 1923." Although he had captioned the plates to his unpublished book *L'Art dans le Vieux Paris* (Atget Archives, MoMA) with similar broad stylistic distinctions, it was rare in his later work that he identified the architectural style of a building. Given that the other photographs of village churches in the album were dated to the century (e.g., fig. 20), the album caption for plate 64 probably does not indicate a special interest in the church's style, but served perhaps, in the absence of more precise dates, to indicate the period of the structure. For another view of Igny, see figure 42.

Pl. 65. *Palaiseau.* Juin 1925. E:7101. MoMA 1.69.3402

In *Album n° 11, environs* Atget noted the trains and trams that took him to the villages he photographed. For his photographs of Ballainvilliers (E:7102–05, pl. 53) he took the "Tramway d'Arpajon [which left Paris from the] Porte d'Orléans"; for those of Marly-la-Machine (E:7114–17), the "Tramway de Saint-Germain, Porte Maillot"; for those of Stains (E:7121–24), the "Chemin de Fer du Nord, ligne de Paris à Creil." To reach most of the villages represented in this album, however, Atget

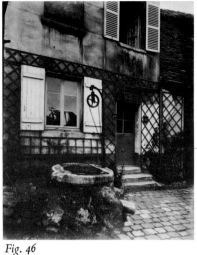
Fig. 46

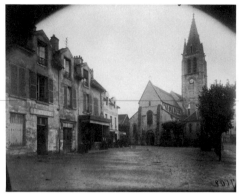
Fig. 47

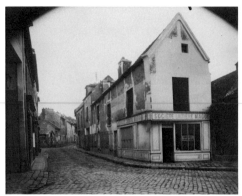
Fig. 48

took the Chemin de Fer de Sceaux, which departed from the station at the Place Denfert-Rochereau, a few blocks from his apartment on the Rue Campagne-Première. In addition to noting that he arrived at Palaiseau by that train, he captioned the scene reproduced as plate 65: "pourtour de l'église," or the area around the church.

Pl. 66. *Bures (église).* 1924. E:7071. MoMA 1.69.1450
Fig. 43. *Bures, ferme de l'ancien château.* 1924. E:7073.
 MoMA 1.69.1208

If one could believe that Atget's photographs told the whole truth about the place depicted, one would assume that Bures had been built by a race of men who required structures and spaces to be arranged and ordered geometrically: the church is made of rectangles, triangles, and half-cylinders (E:7070 and pl. 66), and the cylindrical pigeon coop of the old château (fig. 43) was walled into a box of space. In fact Bures is probably no more rigorously organized than any of the other towns Atget photographed; rather it was where Atget stood that served to clarify the structure of this place.

Pl. 67. *Bagneux, vieille rue.* Juin 1901. E:6067. MoMA 1.69.3117
Fig. 44. *Eglise de Bagneux.* (1919–21.) LD:991. MoMA 1.69.1295

Atget took this photograph when he was in the midst of discovering the visual richness of the gardens of Versailles. Perhaps for the first time he saw hedges and trees as dark masses that could greatly alter the spatial and expressive organization of the picture (e.g., E:6074 in vol. III). It was probably this experience that allowed him to see that the dark foliage could have an important function in *Bagneux, vieille rue.* Twenty years later Atget rephotographed the church from approximately the same angle, but closer (fig. 44).

Pl. 68. *Carrières-sur-Seine, retable XII*ᵉ *siècle.* Juillet 1921.
 E:6953. MoMA 1.69.1380

Atget concentrated on photographing sculpture in 1921. On March 4 he acquired a card to study in the Cluny Museum, famous for its collections of medieval decorative arts and sculp-

ture (his Carte d'étude nᵒ 495 is in the collection of Valentin Compagnon, Paris). Subsequently, in March and April, he photographed many pieces of sculpture in the courtyard of the Ecole des Beaux-Arts. He was preoccupied with the same subject in the suburbs as well (see note to pl. 59). Like the other examples pictured in the series "L'Art dans les environs," this fine early Gothic altarpiece—showing the Madonna and Child enthroned, flanked by the Virgin's Annunciation and the Baptism of Christ—was made by artists of the Ile-de-France. However, since the altarpiece had been in Paris since 1915, Atget did not go to Carrières-sur-Seine to photograph it; he just went to the Louvre. His permit to work there, from July to September 1921, is reproduced in Jean Leroy, *Atget, magicien du vieux Paris* (Joinville-le-Pont: Pierre-Jean Balbo, 1975), n.p.

Pl. 69. *Châtillon, glycine.* (1919–21.) LD:918. MoMA 495.80.
 Print by CAW, 1980. Same as MoMA 1.69.649

Many of Atget's photographs of trees and plants had two-part titles composed of the plant's location and its common name, here *glycine,* or wisteria vine. Usually the form of the title varied according to the picture's content: if the plants depicted were various or were subsumed in a landscape, the plant names were omitted and the picture was labeled with the locale only, but if the plant's setting was minimally indicated, the photograph carried the plant name alone.

Pl. 70. *Vanves, vieille cour.* (1925–27.) E:7140. MoMA 496.80.
 Print by RB, 1980
Fig. 45. *Châtillon, cour, rue de la Gare.* 1922. E:6998.
 MoMA 1.69.1092
Fig. 46. *Clamart (vieille maison).* 1923. E:7012. MoMA 1.69.1093

After the war, when Atget was photographing picturesque village houses, he often photographed their wells (e.g., figs. 45, 46, pls. 45, 97). During the very last years of his life, however, he no longer did so. Whatever the reasons for the change, it is probably not coincidental that when the wells disappeared from his repertory, there appeared pictures such as *Vanves, vieille*

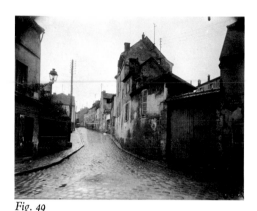
Fig. 49

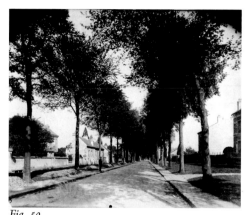
Fig. 50

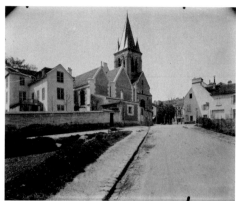
Fig. 51

cour, where the charming properties of the place are less obvious than the elliptical quality of the vision.

Pl. 71. *Glycine.* (1900–10.) LD:675. MoMA 1.69.819

In *Album n° 2, premiers plans, fleurs,* Atget noted that this vine grew at 9, rue de Bagneux, Fontenay-aux-Roses.

Pl. 72. *Vitry, vieille rue.* (June–July) 1925. E:7113.
 MoMA 497.80. Print by RB, 1980
Fig. 47. *Vitry (église).* (June–July) 1925. E:7108.
 MoMA 1.69.1489
Fig. 48. *Vitry, vieille rue.* (June–July) 1925. E:7112.
 MoMA 1.69.1297

The photographs Atget made in Vitry in 1925 illustrate one kind of problem raised by his negative-number system: it allows us to follow Atget's movements imaginatively, but it ultimately frustrates our attempts to map them precisely. Often we are reduced to speculation, perhaps plausible but impossible to substantiate.

The pictures fall into two groups numbered E:7106–13 and E:7118–20. We do not have enough evidence to know whether the two groups were produced contiguously or were separated by the photographs of Marly-la-Machine, whose numbers fall in between. Evidently Atget began photographing at Vitry around 8:30 in the morning near the tramway station, for the clock on the belfry in E:7106 reads 8:35. At that hour the streets were damp and the light feeble. As Atget continued to work (in fig. 47, the clock reads 8:45), he gradually moved out from the center of town. The cobblestones dried, the sun shone through momentarily (E:7111), and the dairy and bakery were open for business (fig. 48, pl. 72). The second group of photographs was also taken in the early morning, when the shutters were closed and garbage pails awaited emptying (E:7118, 7120) in Vitry's sleepy streets (pl. 54).

Pl. 73. *Vanves, vieille rue.* (1925–27.) E:7132. MoMA 1.69.1277
Fig. 49. *Vanves, vieille rue.* (1925–27.) E:7133. MoMA 1.69.1278

Atget did not consistently record the names of village streets; he titled these two pictures of streets in Vanves, as well as many other photographs, with the name of the town followed by *vieille rue*, or "old street" (e.g., pls. 55, 67, 72, 83). Similarly, he rarely identified village churches by their saint's name, as they appeared in guide books; he just wrote *église*. These generic titles point up what the pictures confirm: Atget was not an antiquarian in the pedantic sense; he was an ardent collector of the visibly old, a real "amateur" of Old France.

Pl. 74. *Châtenay, place Voltaire, maison de Voltaire, né à Châtenay.* 1901. E:6035. MoMA 498.80. Print by RB, 1980
Fig. 50. *Châtenay, route de Versailles.* 1901. E:6031.
 MoMA 1.69.1261
Fig. 51. *Châtenay, l'église.* 1901. E:6034. MoMA 1.69.1256

The group of photographs Atget took at Châtenay in 1901 are typical of his documentation of small towns in the first years of the Environs series (1901–03). Generally he focused on the church and central square, picturesque old houses and farms, and the historic sites and famous buildings that the town boasted. In Châtenay he photographed the approach to town (fig. 50), the main street and the church (pl. 63), an old house (pl. 94), the church itself (fig. 51), the town square (pl. 74), and the house where Voltaire was born (E:6036). When Atget documented small towns again between 1922 and his death, he photographed the same kinds of sites but omitted all the historic monuments that had played so large a role in the early period (e.g., pls. 74, 79, 88, 93).

Pl. 75. *Pontoise, place du Grand-Martroy.* 1902. E:6338.
 MoMA 1.69.1051
Fig. 52. *Pontoise, ancien Palais du Tribunal (musée).* 1902.
 E:6357. MoMA 1.69.1052
Fig. 53. *Châtillon, vieilles maisons.* 1922. E:7000.
 MoMA 1.69.1494

Compared with the villages Atget usually photographed, Pontoise was a large town (see also fig. 52). Its importance is evident from the buildings that framed the main town square

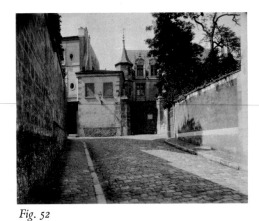

Fig. 52

Fig. 53

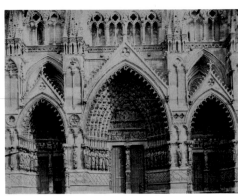

Fig. 54

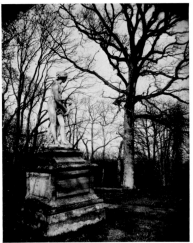

Fig. 55

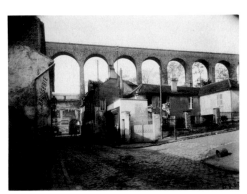

Fig. 56

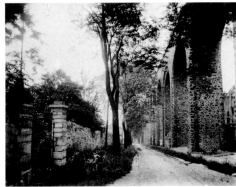

Fig. 57

where much of the activity of the provincial capital was concentrated. Clustered around the church of Saint-Maclou were a variety of stores offering wine, tobacco, baked goods, clothing, shoes (wooden), sweets, and housewares. The square was usually animated, the more so on market day, but Atget preferred it empty and quiet—a perfectly detailed stage ready for the play to begin. While he mastered this kind of exemplary stage set early in his career, Atget continued to rework it in dozens of variants (e.g., pl. 57, fig. 53) for the rest of his life.

Pl. 76. *Amiens, portail*. Septembre 1921. E:6979.
 MoMA 1.69.1497
Fig. 54. *Amiens, portail*. (Before 1900.) vf:1117.
 MoMA 1.69.3143

Together with the churches of Saint-Riquier and Saint-Vulfram at Abbeville, the cathedral of Amiens was among the first buildings that Atget documented in depth. He depicted the facade (fig. 54) in a standard documentary fashion (rare in Atget's oeuvre), and also made details of the portal sculpture (e.g., vf:1134) and the carved choir screens and stalls in the interior. He returned to the cathedral in 1921, apparently to finish his catalog of the quatrefoil bas-reliefs of the left portal,

which he had begun at least twenty years earlier. The medallions, perhaps the most famous of their kind, are a mirror of medieval science: the top row depicts the intellectual or psychic calendar, symbolized by the signs of the zodiac, while the bottom row depicts the seasonal activities appropriate to each sign. The photograph reproduced as plate 76 represents the medallions for March and April. At the left appear Aries and a farmer working his leafless vines; at the right, Taurus and a peasant surrounded by the new vegetation of spring.

Pl. 77. *Arcueil-Cachan*. (May–July) 1915. E:6813.
 MoMA 1.69.1559
Pl. 78. *Marly-le-Roi*. (1922?) PP:25. MoMA 499.80. Print by RB, 1980
Fig. 55. *Parc Sardou à Marly-le-Roi*. 1905. E:6558.
 MoMA 1.69.1171

In the nineteenth century the château at Marly-le-Roi had been razed, and the smaller pavilions which remained were inhabited by artists and writers, among them Atget's friend the popular dramatist Victorien Sardou. It may have been Sardou's presence that initially brought Atget to the site (note the title to fig. 55), but his interest, which outlived Sardou (d. 1908), was appar-

Fig. 58

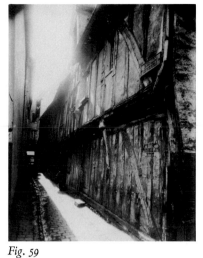
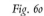
Fig. 59

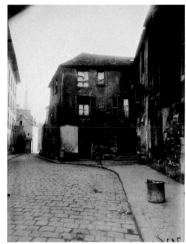
Fig. 60

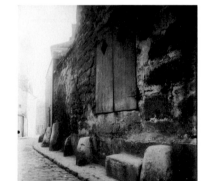
Fig. 61

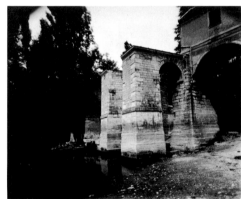
Fig. 62

Fig. 63

ently nourished by the historical associations linking Marly with the Bourbon kings. When Louis XIV wanted to escape from court life at Versailles, he often went to his hunting lodge at Marly, arriving by the impressive Grille Royale visible in the photograph (see also E:6983, E:7115). After the Revolution this hunting domain remained a preserve of the state, and the gate keepers, game wardens, and forest guards continued to perform essentially the same duties as their antecedents. Perhaps Atget thought this old *garde champêtre* was a fitting complement to the elaborate gate behind him: both were vestiges of an earlier epoch that linked twentieth-century Marly to its splendid past. Atget photographed there in 1905, 1906, 1911, 1922, and 1925.

Pl. 79. *Montlhéry.* 1902. E:6304. MoMA 1.69.1439

This tower is all that remains of a castle that stood on a rocky butte overlooking the Paris-Orléans road. During the twelfth century the Counts of Montlhéry in effect controlled the road through regular ambushes of the royal couriers. A peace of sorts was finally achieved when the King of France (Philippe I) arranged a marriage between the two families. The story of the marauding counts, the prominence of the tower, and its panoramic view still attract sightseers, for amidst numerous châ-

teaux and churches, the tower of Montlhéry is a rarity in the Ile-de-France, and thus in Atget's work as well.

Pl. 80. *Arcueil-Cachan.* (1925–27.) E:7147. MoMA 1.69.1284
Fig. 56. *Arcueil, rue.* (1925–27.) E:7146. MoMA 1.69.3119
Fig. 57. *Arcueil-Cachan.* (1925–27.) E:7154. MoMA 1.69.1288

A Roman aqueduct at Arcueil once supplied water for public baths in Paris, today the Palais des Thermes. In the early seventeenth century a new aqueduct was begun. It is visible in the photograph reproduced as plate 80 as the classically detailed masonry of the lower level of the structure, erected by Marie de Médicis to fill the fountains in the garden of her new palace (the Luxembourg). The tall arches of the upper level (pl. 80 and figs. 56, 57) were added in the nineteenth century to bring more drinking water to an expanding Parisian population.

Pl. 81. *Beauvais, ruelle Nicolas-Godin.* 1904. E:6530.
 MoMA 1.69.1507
Fig. 58. *Beauvais, coin, place [de l']Hôtel-de-Ville.* 1904.
 E:6524. MoMA 1.69.1763
Fig. 59. *Beauvais, rue des Cuvettes.* 1904. E:6552.
 MoMA 1.69.1508

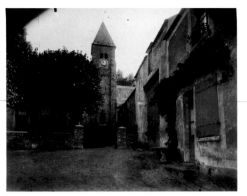

Fig. 64

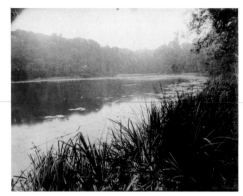

Fig. 65

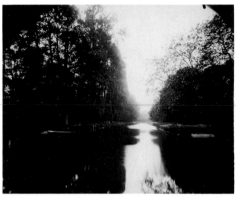

Fig. 66

Like the photographers who had worked in Beauvais before him, such as Le Secq and Mieusement, Atget photographed the cathedral and the Gothic and Renaissance houses for which the city was famous (fig. 58 and E:6544). He appears to be the first one, however, to penetrate and photograph the narrow back streets and damp alleyways where pedestrians had to negotiate sewage-filled gutters even at the turn of the century (fig. 59). The street in plate 81 was a little wider than the alleys, but the ranks of protective curbstones suggest that it could barely accommodate horse-drawn carriages. For photographs of Beauvais by Atget and others see the exhibition catalog *Beauvais par ceux qui l'ont vu* (Beauvais: Musée Départemental de l'Oise, 1977).

Pl. 82. *Vanves, rue du Chariot.* (1925–27.) E:7127.
 MoMA 1.69.1078
Fig. 60. *Vanves, vieille rue.* (1925–27.) E:7126. MoMA 1.69.1079
Fig. 61. *Vanves, rue du Chariot.* (1925–27.) E:7128.
 MoMA 1.69.1077

If Atget had used roll film, the filmstrips would map his progress from place to place in a linear fashion. The numbers of Atget's negatives do allow us to trace his movements within fairly narrow limits, but since they were scratched into the emulsion after development, we seldom know whether we are following his actual movements or a sequence he established in the darkroom. Occasionally, as in the three photographs of the Rue du Chariot in Vanves, we can see that the progression of numbers does indeed reflect the order in which the negatives were taken. The movement of the sunlight on the distant white wall proves that Atget made E:7126 first, E:7127 next, and E:7128 last.

Pl. 83. *Bagneux, vieille rue.* Juin 1901. E:6069. MoMA 1.69.1181
Pl. 84. *Vanves, un coin de vieux Vanves.* 1901. E:6144.
 MoMA 1.69.1124

Vanves was famous for its pure water. To protect that special resource a sign admonished the citizens not to wash laundry, rinse vehicles, or water horses in the fountain.

Pl. 85. *Rouen.* (1907?) LD:333. MoMA 1.69.2859

The photographs of Rouen stand apart from the rest of Atget's work for two reasons. They were not cataloged in the Environs series, as were most other photographs of architecture made outside Paris between 1901 and 1927, but in a section of the Landscape-Documents series reserved entirely for them. Atget may have done this because the group included several copyprints of nineteenth-century engravings and photographs, which he generally filed as "documents" (e.g., LD:353, *Rouen, vers 1820,* copyprint of a wood engraving after a drawing by L. Read, 1811). Second, the photographs of Rouen are unique because they are the only group in which the same person repeatedly appears. The man was perhaps a guide, but if we may judge from Atget's usual self-reliance and from the pictures themselves, he was more probably a friend. Their complicity is suggested in LD:322, where the man smilingly points to what appears to be a watch in his hand. The meaning of the gesture would seem to involve the long exposure, which turned the unaware passersby into ghostly streaks in the picture. The majority of the photographs, some fifty-five in all, record the architecture of old Rouen.

Pl. 86. *Jouy-en-Josas, église.* Juin 1925. E:7094. MoMA 1.69.1085
Pl. 87. *Montlhéry, église, vieux puits.* 1902. E:6307.
 MoMA 1.69.1855

At Montlhéry Atget found his subjects in and around the sites that guidebooks indicated as the principal points of interest: he photographed the famous doorjamb figures symbolizing fever and leprosy at the hospital (E:6303) and the cylindrical keep of the ruined fortress (pl. 79). While *Montlhéry, église, vieux puits* does represent the historic center of town, the actual subject of this picture is nevertheless difficult to identify. The photograph is certainly *of* the church and the old well, as Atget's title states, but its effect resides in the way the layering of sun and shadow articulates the space and the framing integrates it with the structures. The result is a discrete and unified visual locution that has no name; it simply is the picture's subject.

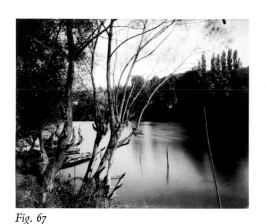

Fig. 67

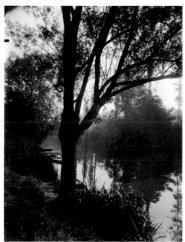

Fig. 68

Fig. 69

Pl. 88. *Bourg-la-Reine, ferme [de] Camille Desmoulins.* 1901.
E:6039. MoMA 1.69.1951

It is likely that Atget was drawn to this farm initially by its historic political associations. The fame of the revolutionary journalist Desmoulins was based not only on his speeches and pamphlets, which led directly to the storming of the Bastille, and on his and his wife's martyrdom on the guillotine, but also on the dramatic telling of their story by Jules Claretie in *Camille Desmoulins, Lucille Desmoulins* (1875).

Pl. 89. *Charenton, vieux moulin.* (May–July) 1915. E:6808.
MoMA 1.69.1071
Fig. 62. *Vieux moulin, Charenton.* (May–July) 1915. E:6807.
MoMA 1.69.3113
Fig. 63. *Châtillon, puits à carrier.* Mai 1916. E:6838.
MoMA 1.69.1523

The photograph reproduced as plate 89 has a Cubist look because the framing truncates in unexpected ways the things represented in the photograph, and because the strong tonal contrast tends to reduce them to light and dark shapes. The Cubism is not like Picasso's Analytic or Synthetic mode; it is more like the style as practiced by nonbelievers—for example, by Matisse, who adopted the stringency but not the form of the style during the same period. For them Cubism was not a perception of the multiple facets or aspects of their subject, nor was it a restructuring of them; it was something akin to a moral stance: it involved a compositional rigor, a rejection of frivolity (either coloristically or in the selection of a motif), and a propensity for the linear, angular, and abstract. If defined in this more lenient way, Cubist is perhaps a useful word to describe the several pictures that Atget produced during the war which display the stark vision and compelling formal coherence of the photograph of the old mill at Charenton. See also figures 62, 63, plate 92, and E:6808.

Pl. 90. *Gif, vieille ferme.* 1924. E:7074. MoMA 1.69.3120
Pl. 91. *Gif, vieille ferme.* 1924. E:7075. MoMA 1.69.1961
Fig. 64. *Gif, place de l'Eglise.* 1924. E:7077. MoMA 1.69.1468

Pl. 92. *Maison à Châtillon.* (1915–19.) LD:787. MoMA 1.69.1209

A duplicate print in the Museum's collection is titled *Rue de Bagneux*.

Pl. 93. *Maison de Béranger, rue de Bagneux, Châtillon.* 1901.
E:6225. MoMA 1.69.1044

Pierre-Jean de Béranger (1780–1857) was a lyric poet famous for the republican and Bonapartist sentiments he set to popular melodies, and for the imprisonment he twice suffered as a result.

Pl. 94. *Châtenay, un coin.* 1901. E:6033. MoMA 1.69.1255
Pl. 95. *Châtenay, vieille maison.* (1925–27.) E:7156.
MoMA 1.69.1289

On one of his last photographic trips into the Environs Atget rephotographed a house in Châtenay that he had photographed on one of his earliest excursions. The pair of pictures is remarkable not so much for their shared motif as for the radically different visions they embody. If the subject of the earlier picture can be described in terms of physical facts—the view from the main road down a paved alley lined with old, vine-covered stone houses—the subject of the other picture is almost devoid of them: it captures an unsettling moment when the light strips away the darkness and leaves the blank-windowed old house mysteriously vulnerable.

Pl. 96. *Rue Perrotin.* (1915–19.) LD:777. MoMA 1.69.1411

Given the confusion about which streets Atget photographed in Châtillon (see note to plate 52), it is open to question whether this photograph actually depicts the Rue Perrotin or the Chemin des Pierrettes.

Pl. 97. *Vieux puits, petit chemin, rue de la Gare, Châtillon.*
(October?) 1922. E:7002. MoMA 1.69.48

Running water was rare in the country around Paris before World War I, and in some tiny outlying villages the spigot is still not pervasive. Thus the country wells that Atget photographed

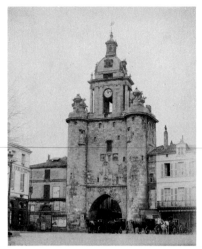
Fig. 70

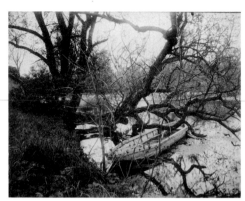
Fig. 71

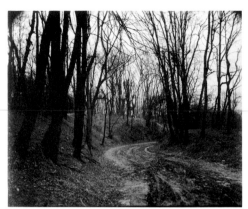
Fig. 72

were not quaint relics but much-used dispensaries for the house-holds. Often the wells were surrounded by utensils and para-phernalia—washtubs, buckets, watering cans, and potted flowers—that formed an accidental decoration evidently dear to Atget's heart. The well in this photograph was not so embellished. Its masonry and tackle were old, and the depression in its stone rim recalled the hauling of numberless buckets over its lip. These signs of age might have drawn Atget like a magnet under any conditions, but on this particular day he was blessed with a transfiguring light that gilded the fencing wires and gave the well and its little alley the preternatural radiance of Biblical miracles.

Pl. 98. *Saules.* (1919–21.) LD:922. MoMA 1.69.665
Pl. 99. *Saules.* (June–July) 1925. LD:1245. MoMA 1.69.879

See note to plates 50 and 51. According to the notation in *Album nº 2*, *les arbres, forêts, bois, parcs, vallées, arbres fruitiers*, the photograph reproduced as plate 98 was made near Lozère, a small town between Palaiseau and Bures (pls. 65, 66) on the banks of a stream called the Yvette.

Pl. 100. *Etang du Plessis-Piquet.* (1919–21.) LD:968.
 MoMA 1.69.1178
Fig. 65. *Saint-Cucufa.* (1925–27.) LD:1280. MoMA 1.69.2948
Fig. 66. *Le Parc de Rambouillet.* (1919–21.) LD:944.
 MoMA 1.69.3477

Atget photographed several ponds in the environs of Paris, notably those at Le Plessis-Piquet, Ville-d'Avray (pls. 104–07), Saint-Cucufa (fig. 65), and La Ferté-Alais (LD:1205). The picture of Le Plessis-Piquet is distinguished from the others by its decisive separation of the land on one side from the water and sky on the other. While it shares its bold massing with other contemporary pictures (e.g., LD:931, 934, and fig. 66), it appears that this was the first instance when Atget cleanly divided a picture on the vertical axis and that he managed to retain much small-scale detail and texture without destroying the huge light-dark dichotomy.

Pl. 101. *La Marne à la Varenne.* (1925–27.) LD:1289.
 MoMA 1.69.1424
Pl. 102. *Bords de [la] Marne.* 1903. E:6428. MoMA 1.69.1244
Fig. 67. *La Varenne, bords de [la] Marne.* (1919–21.) LD:1003.
 MoMA 1.69.1409
Fig. 68. *La Varenne.* 1925. LD:1249. MoMA 1.69.1197

Just before it joins the Seine, the Marne River describes a nearly perfect circle on the plain of Brie. To avoid the long circum-navigation, a canal was built to bypass this loop, which has therefore remained unspoiled—inadvertently preserved for oars-men, fishermen, and picnickers (cf. Henri Cartier-Bresson's photographs "Banks of the Marne," 1935)—despite its proxim-ity to Paris. Atget photographed that idyllic bend in the river between 1919 and 1921 (fig. 67), and returned there at least three times during the last two years of his life (fig. 68, LD:1260, pl. 101).

Beyond La Varenne, where the Marne joins up with the canal, the river banks were lined with hotels and outdoor res-taurants not unlike those painted by Renoir and Monet at Argenteuil. Although considerably less animated than the Im-pressionists' paintings, Atget's pictures of this stretch of the river (pl. 102, E:6429, 6432) are always inhabited. The early photographs depict the river as it might have been experienced by a fisherman or someone strolling along the river's edge, while the later photographs represent the river as it might have been regarded by someone in a less active, more contemplative mood. Perhaps Atget photographed the Marne at Le Perreux and Bry in 1903 and near La Varenne at the end of his life because the respective activity and quiet of the sites reflected something of his own attitudes and predispositions early and late in his career.

Pl. 103. *La Rochelle.* (1896?) LD:132. MoMA 1.69.2373
Fig. 69. *Etaples.* (Before 1900.) LD:854. MoMA 1.69.1410
Fig. 70. *La Rochelle, beffroi.* (1896?) VF:1157. MoMA 1.69.1147

Atget took the few seascapes and studies of boats that exist in

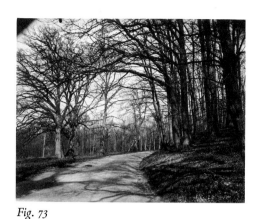

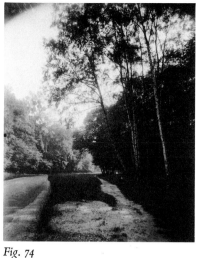

Fig. 73 Fig. 74 Fig. 75

his collection early in his career at Boulogne-sur-Mer and nearby Etaples on the English Channel, and at La Rochelle, on the Atlantic coast. We know that the painter Georges Maronniez commissioned Atget to go to Boulogne to make unposed studies of sailors sometime before 1892 ("Petit Bleu du modèle," *Art et Critique*, no. 89, 1892, pp. 78–79); perhaps the seascapes of Boulogne and Etaples in the Abbott-Levy Collection (e.g., fig. 69) were taken at that time. While he made no pictures of those towns, at La Rochelle Atget photographed not only the harbor but also the noteworthy buildings in town. Compared with the architectural pictures, the marine studies have a special, salient grace (cf. fig. 70 and pl. 103), due perhaps to the first-hand experience of ships and sailing that Atget had gained as a cabin boy on a large sailboat.

The architectural photographs of La Rochelle can be dated to about 1896 because in the picture reproduced as figure 70, a poster which advertises the serialization of Zola's novel *Rome* in the newspaper *Le Petit Journal* is visible. (The installments appeared between December 21, 1895, and May 8, 1896.) The marine studies may have been made at approximately the same time. Atget's stay in La Rochelle perhaps overlapped that of his companion Valentine Compagnon, who was acting there between 1897 and 1902. (See Henri Lyonnet, *Dictionnaire des comédiens français* [Geneva: Bibliothèque de la Revue Universelle Internationale Illustrée, 1912], vol. 1, p. 478.)

Pl. 104. *Etang de Corot.* Juin 1925. LD:1232. MoMA 1.69.3717
Pl. 105. *Etang de Corot.* Juin 1925. LD:1233. MoMA 1.69.1293
Pl. 106. *Etang de Corot, Ville-d'Avray.* (1900–10.) LD:678.
 MoMA 485.80. Print by CAW, 1978
Pl. 107. *Ville-d'Avray.* (1923–25.) LD:1216. MoMA 1.69.1021
Fig. 71. *Etang, Ville-d'Avray.* (1923–25.) LD:1215.
 MoMA 1.69.1019

Atget photographed the pond at Ville-d'Avray on at least three occasions. The first time, between 1900 and 1910, he took two pictures, one of a big oak tree and the other of a rowboat (LD:677 and pl. 106). In each case he composed the scene so that

the shoreline was approximately parallel with the picture plane, the major motif was in the middle distance, and the pond and distant bank formed a parallel horizon in the background. When Atget returned to the pond between 1923 and 1925, he found the same boat (or another of the same sort), but visibly aged and littered with dead leaves. The three pictures he took (fig. 71, pl. 107, and LD:1217) show that, like the boat, Atget's vision also had changed. The pictures in this group describe neither the boat nor the trees in the simple, declarative terms of the earlier photographs; they describe the oblique suturing of land, water, and trees. In June 1925, when he visited Ville-d'Avray again, he produced yet another kind of picture (pls. 104, 105 and LD:1234, 1235). Working when the light was gray and the air spongy with humidity, Atget photographed trees that overhung the water and dead trees in the water. The tortuous limbs, reflections, and palpable atmosphere of these pictures create a romantic, meditative mood, both serene and wistful, that also characterizes the photographs of the Parc de Sceaux from exactly this period (see vol. III).

The photographs of Ville-d'Avray distinctly recall Camille Corot's paintings of the pond, especially his canvases of the late period, such as *Pond at Ville-d'Avray with Leaning Tree*, c. 1873 (Musée des Beaux-Arts, Reims). During Atget's adult life, paintings such as this, with their dreamy, silvery atmosphere and idyllic settings, were Corot's most admired works. Since the painter had lived at Ville-d'Avray and since the pond was his preferred motif, people referred to it as "Corot's pond." Atget's several visits to Ville-d'Avray and the beauty of the photographs he made there suggest that this site held for him, as it had for Corot, a particular interest and resonance.

Pl. 108. *Nénuphars.* (Before 1900.) LD:835. MoMA 1.69.1953
Pl. 109. *Saint-Cloud.* Mai 1923. SC:1175. MoMA 1.69.307
Fig. 72. *Saint-Cloud.* Février 1923. SC:1170. MoMA 1.69.301
Fig. 73. *Saint-Cloud.* Mars 1923. SC:1171. MoMA 1.69.302

The records Atget kept in his albums are far from consistent; for some photographs he wrote down the day and month they

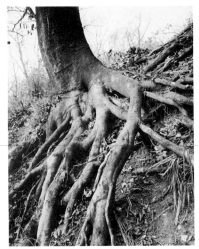

Fig. 76 Fig. 77

were taken, for others only the year, and for most no reference to any date at all. The albums which contained the postwar production of the Landscape-Documents series were somewhat more systematic in their notation of dates than the earlier albums, but they were still erratic. It might be argued that the dates of three pictures of Saint-Cloud (pl. 109, figs. 72, 73) were jotted down for no particular reason—in an exceptionally conscientious moment—if the photographs did not follow each other so closely in sequence, and if they did not depict roads in the Parc de Saint-Cloud seen under different seasonal conditions. As this is the case, the dates seem to imply a meaningful temporal relationship among the pictures: in February (fig. 72) the park road is muddy and the trees are damp and black; in March (fig. 73) the still leafless trees cast fragile shadows over the bare ground; and in May (pl. 109) the scene is dappled with sunshine and enveloped in leafy vegetation.

Pl. 110. *Saint-Cloud*. Juin 1926. SC:1279. MoMA 1.69.426
Pl. 111. *Bouleau*. (1919–21.) LD:925. MoMA 1.69.650
Fig. 74. *Saint-Cloud*. Juin 1926. SC:1280. MoMA 1.69.427

The photographs reproduced as plates 110 and 111 were made in the Parc de Saint-Cloud in approximately the same place. Although the site and motif are similar, Atget constructed the two pictures in quite different ways. *Bouleau* (birch) is a neat, compact picture that is divided vertically by the birch and horizontally on its left side by the road. With the exception of the sky, which occupies very little surface area, there is not a single expanse of uniform tone; the picture is composed of hundreds of tiny bits of information and texture which give it a shimmering surface energy that the strict vertical and horizontal elements control or organize. In these aspects *Bouleau* closely resembles *Etang du Plessis-Piquet* (pl. 100). In contrast,

Saint-Cloud (pl. 110) has denser, broader, more unified tonal areas that absorb detail into mass. The tonal organization as well as the diagonal thrust toward a glowing but partly obscured light recalls *La Marne à la Varenne* (pl. 101). That the two photographs of Saint-Cloud should resemble the water scenes is not a coincidence, for the pairs are close contemporaries. The relative consistency of Atget's vision within a given period is also illustrated by the other photographs he made on the road in Saint-Cloud (LD:926, SC:1277, and fig. 74).

Pl. 112. *Forêt, Fontainebleau*. Juillet 1925. LD:1251.
 MoMA 500.80. Print by RB, 1980
Pl. 113. *Forêt, Fontainebleau*. Juillet 1925. LD:1252.
 MoMA 501.80. Print by RB, 1980
Fig. 75. *Fontainebleau, rochers*. (Copyprint of No. 823, title unknown, effaced by Atget in his copynegative.) (1923–25.) LD:1227. MoMA 1.69.3341

On two occasions between 1922 and June 1925 Atget made copyprints of photographs, signed by Neurdein Frères, of the forest of Fontainebleau (e.g., LD:1164, a copyprint of No. 647, "Forêt de Fontainebleau, étude des chênes, X Phot," and fig. 75). Although the photographs that he copied were stylistically consistent with his own early vision, it is not clear whether he was pirating pictures or had originally taken the negatives and subsequently sold them to the Neurdeins, who distributed them under their marks "X Phot" and "ND Phot." In any case, after making the copyprints and perhaps finding them insufficient, provocative, or both, Atget went to photograph in the forest in July 1925.

Pl. 114. *Saint-Cloud*. 1924. SC:1228. MoMA 1.69.323
Pl. 115. *Parc de Saint-Cloud*. 1906. E:6605. MoMA 1.69.374

176

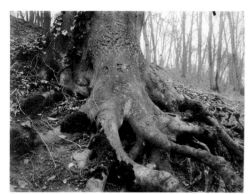

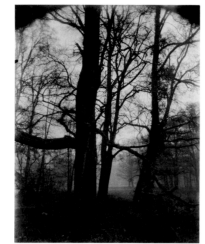

Fig. 78 *Fig. 79*

Fig. 76. *Grand Trianon (escalier)*. 1905. E:6589.
 MoMA 1.69.2826

Fig. 77. *Saint-Cloud*. 1924. SC:1229. MoMA EL 59.366. Print
 by BA, 1929–37

Fig. 78. *Saint-Cloud*. 1924. SC:1234. MoMA 103.50

Sometimes it is hard to follow the progress of Atget's idea because it is obscured in the enormous mass of the oeuvre. Such is the case with the pictures of tree roots at Saint-Cloud. They appeared suddenly in 1906, heralded neither by Atget's earlier photographs of the park, which were views of staircases and ponds, nor by his photographs of trees in other places. This startling departure would seem then to be a new idea for Atget, but in fact is perhaps logically derived from his treatment of decorative ornament in the Art in Old Paris and Environs series.

Although he had made details of wrought-iron doorknockers and grills for several years, in 1905–06 Atget concentrated more narrowly on elaborate interlace moldings and stair railings and on a variety of carvings and sculptures (AP:5301, E:6570, and fig. 76). Many of these subjects lay at waist level or below and thus required Atget to lower his usual camera placement. They were also characterized by a twisting organic line and a very shallow space that limited the description of volumes to bas-relief. Perhaps because he had been focusing on those kinds of decoration, themselves transformations of botanical forms, and because he was shooting them from a low angle, Atget conceived the tree roots as the subject of a photograph. His choice of the particularly serpentine examples in 1906 may have been indirectly due to the contemporary enthusiasm for Art Nouveau. He did not always select roots of this sort, however; late in his career he framed gnarled or tendinous roots against sloping horizons and thus emphasized the necessity of their vital grip to the tree's survival (pl. 115, figs. 77, 78).

Pl. 116. *Saint-Cloud*. Mai 1922. LD:1111. MoMA 1.69.264

Pl. 117. *Saint-Cloud*. 9 h. 2 avril 1926. SC:1267.
 MoMA 1.69.421

Pl. 118. *Saint-Cloud*. 1926. SC:1259. MoMA 1.69.416

Pl. 119. *Saint-Cloud*. 1926. SC:1258. MoMA 1.69.1944

Fig. 79. *Saint-Cloud*. 9 h. 2 avril 1926. SC:1266.
 MoMA 1.69.420

After the war one of Atget's preferred terrains was the vast Parc de Saint-Cloud. He photographed the Grande Cascade and the several reflecting pools (see vol. III) dozens of times, and also repeatedly photographed in certain areas of the forest that surrounded the more formally landscaped areas. Sometimes when he photographed the same place, this is readily apparent (e.g., pls. 116, 117); at other times the shifts of vantage and changes of atmospheric conditions so alter the pictured configuration of branches and trees that it is difficult to recognize that the site is the same. This is the case with the photograph reproduced as plate 118, which represents the same thicket of trees as in plates 116 and 117, but seen from the other side. Close study of the trees in SC:1257, 1258, 1265–67 (e.g., fig. 79) shows that the photograph reproduced as plate 119 was taken only a few yards from the other three pictures. Thus, the four photographs (pls. 116–19) were taken in the same area of the park but on three separate visits. The overlapping locales reflect Atget's method: when he found a place with what seemed to him a rich endowment of pictorial possibilities, he returned, sometimes repeatedly, to investigate that potential.

Pl. 120. *Saint-Cloud*. Fin mai 7 h. soir, 1922. LD:1105.
 MoMA 1.69.258

The text for
THE WORK OF ATGET: OLD FRANCE
is set in Bembo monotype.
Type composition by The Stinehour Press
Design by Christopher Holme
Halftone negatives by Richard Benson
Printing by The Meriden Gravure Company
Binding by Publishers Book Bindery, Inc.